THE ART & DESIGN SERIES

For beginners, students, and working professionals in both fine and commercial arts, these books offer practical how-to introductions to a variety of areas in contemporary art and design.

Each illustrated volume is written by a working artist, a specialist in his or her field, and each concentrates on an individual area—from advertising layout or printmaking to interior design, painting, and cartooning, among others. Each contains information that artists will find useful in the studio, in the classroom, and in the marketplace.

BOOKS IN THE SERIES:

Carving Wood and Stone: An Illustrated Manual
ARNOLD PRINCE

Chinese Painting in Four Seasons:
A Manual of Aesthetics & Techniques
LESLIE TSENG-TSENG YU/text with Gail Schiller Tuchman

The Complete Book of Cartooning
JOHN ADKINS RICHARDSON

Creating an Interior
HELENE LEVENSON, A.S.I.D.

Drawing: The Creative Process
SEYMOUR SIMMONS III and MARC S.A. WINER

Drawing with Pastels
RON LISTER

Graphic Illustration: Tools & Techniques
for Beginning Illustrators
MARTA THOMA

How to Sell Your Artwork:
A Complete Guide
for Commercial and Fine Artists
MILTON K. BERLYE

Ideas for Woodturning
ANDERS THORLIN

The Language of Layout
BUD DONAHUE

Nature Drawing: A Tool for Learning
CLARE WALKER LESLIE

Nature Photography: A Guide
to Better Outdoor Pictures
STAN OSOLINSKI

Painting and Drawing: Discovering Your
Own Visual Language
ANTHONY TONEY

Photographic Lighting: Learning to See
RALPH HATTERSLEY

Photographic Printing
RALPH HATTERSLEY

Photographing Nudes
CHARLES HAMILTON

A Practical Guide for Beginning Painters
THOMAS GRIFFITH

Printmaking: A Beginning Handbook
WILLIAM C. MAXWELL/photos by Howard Unger

Silkscreening
MARIA TERMINI

Silver: An Instructional Guide
to the Silversmith's Art
RUEL O. REDINGER

Teaching Children to Draw:
A Guide for Teachers and Parents
MARJORIE WILSON and BRENT WILSON

Transparent Watercolor:
Painting Methods and Materials
INESSA DERKATSCH

Understanding Paintings:
The Elements of Composition
FREDERICK MALINS

Woodturning for Pleasure
GORDON STOKES/revised by Robert Lento

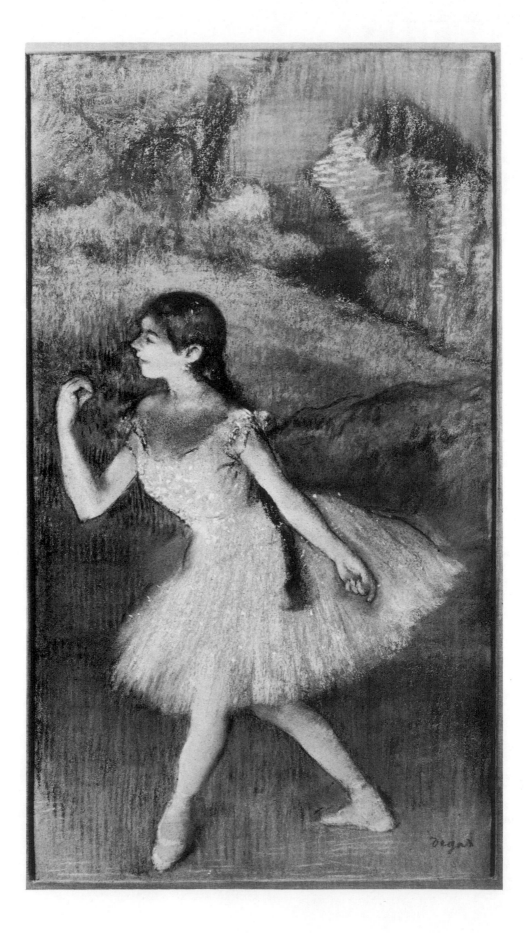

RON LISTER

Drawing with
PASTELS

A SPECTRUM BOOK PRENTICE-HALL, INC., Englewood Cliffs, N.J. 07632

Library of Congress Cataloging in Publication Data

Lister, Ron.
 Drawing with pastels.

 (Spectrum art and design series) (A Spectrum Book)
 Bibliography: p.
 1. Pastel drawing. I. Title. II. Series.
NC880.L48 1982 741.2′35 81-8565
 AACR2

ISBN 0-13-219303-5

ISBN 0-13-219295-0 {PBK.}

This book is dedicated to my mother,
Sylvia Lister, for the many years and countless
ways she has encouraged me in my art.

THE ART & DESIGN SERIES.

Cover illustration:
RON LISTER
Pears

Frontispiece:
EDGAR DEGAS
Danseuse
Courtesy Museum of Fine Arts, Boston

This Spectrum Book is available to businesses and organizations
at a special discount when ordered in large quantities. For
information, contact Prentice-Hall, Inc., General Book Marketing,
Special Sales Division, Englewood Cliffs, N.J. 07632

EDITORIAL/PRODUCTION SUPERVISION
BY KIMBERLY MAZUR
PAGE LAYOUT BY DIANE KOROMHAS
COLOR INSERT DESIGNED
BY CHRISTINE GEHRING WOLF
MANUFACTURING BUYER: CATHIE LENARD

Prentice-Hall International, Inc., *London*
Prentice-Hall of Australia Pty. Limited, *Sydney*
Prentice-Hall of Canada, Ltd., *Toronto*
Prentice-Hall of India Private Limited, *New Delhi*
Prentice-Hall of Japan, Inc., *Tokyo*
Prentice-Hall of Southeast Asia Pte. Ltd., *Singapore*
Whitehall Books Limited, *Wellington, New Zealand*

Contents

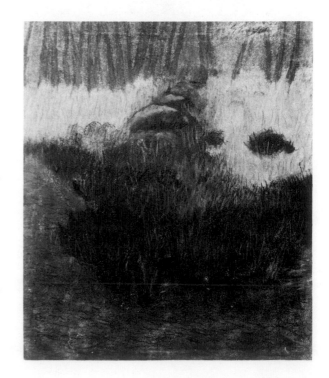

Preface

Pastels are not technically difficult to master, which makes them a great vehicle for learning. At the same time, they are among the most versatile of all art forms when basic fundamentals are observed. In the 18th and 19th centuries, pastels enjoyed immense popularity and respect. In recent years, however, they have become associated with sentimental portraits and overly pretty pictures, a result of particular artists and of popular fashions. True, pastels can produce these effects, but what is important is that they can also produce countless other effects as well. As in all art forms, it is the artists who are responsible for the content and expression of their work in any given medium.

The purpose of this book is to explore and define the many attributes of pastels. In the course of doing so, I hope that my own deep affection for pastels comes through until the marvel of working in color becomes your own labor of love.

There are few dogmatic rules to follow in working with pastels, but do not be misled. If you read this book thoroughly, I believe you will make many discoveries that will help you save time and frustration.

I have found in teaching that most students, especially beginners, have aspirations that exceed their immediate capabilities. In order to limit frustration, it is necessary to maintain a degree of respect for the medium itself. I believe that art is a language, and that each artist communicates in a manner unique to that individual. This assertion is easy to see in the classroom or workshop. Any number of students may paint a still life of the most simple dimensions, yet never do any two of them read the information in front of them in the same manner. No two people can be in the same place at the same time, nor can any two people have the same interests or physical attributes. I mention this fact because too many artists are overly concerned with expressing their exact intentions. Instead, I maintain that it is best to start out learning as much as possible about the "vocabulary" of art; expression will then follow naturally. Besides, the more we know about the principles involved, the more likely we will be to choose a manner of expression that comes close to our true intentions.

There are many possibilities ahead, so keep your eyes open. Try not to let your mind overrule what your eyes see. In art, the railroad tracks do meet.

Author's note: Whether to label pastels as *paintings* or *drawings* has long been a problem for museum catalogers and authors alike. Throughout this book, I have used both terms freely and interchangeably. At times, specific remarks will be made about the technical differences between a *painting* and a *drawing,* or *sketch,* but as general reference terms, I feel that these labels are quite suitable. As we will see, pastels are actually a combination of painting and drawing rolled into one.

Acknowledgments

Now that the body of this work is complete, I would like to thank some of the people without whose help this undertaking would certainly have been more of a struggle and less of a joy.

My grateful thanks go to Dick Fishman at the Museum of Fine Arts in Boston for his help and generosity in procuring the numerous historical photographs. I am also grateful for the help and cooperation of all the people at Prentice-Hall, especially Mary Kennan. I am indebted also to Anatoly Dverin not only for his two fine demonstrations but also for his friendship and advice.

I would like to thank all the members of the Pastel Society of America for their support and Esther Geller and Berta Golahny for their contributions. It has been a pleasure to meet so many fine pastelists.

Thanks to Jean Coulombre for the great job of typing and generally making sense of my manuscript. Finally, thanks to Jan for putting up with me during this project.

THE ORIGINS OF SOFT PASTEL are roughly two hundred and fifty years old; however, colored chalks have been used for thousands of years. Prehistoric cave paintings in southern France, northern Spain, and South Africa reveal that early man used red, white, and ochre earth pigments along with burnt bone to produce the colors in their paintings. These chalks were dug straight from the ground in stick form and applied directly.

The Italian masters of the Rennaissance used red chalk extensively in their architectural and engineering drawings. Guido Reni (1575–1642) produced the earliest paintings done in a variety of colored chalks. Unfortunately only one drawing has survived through the ages.

The chemistry of soft pastels will be discussed in the following chapter, but the credit for their invention is generally attributed to Johann Alexander Theile (1685–1752) in the early eighteenth century.

CARRIERA

Although the history of pastels centers around France, it was Rosalba Carriera, born in Venice in 1675, who became the first popular

CHAPTER ONE

The history of pastels

master of the new medium. Following recognition in her home country, Carriera traveled to France, where under the Regency of Louis XV, she became the most fashionable pastelist in Paris. Thus, she became one of the first female artists to reach prominence before the nineteenth century. Her free use of rubbing and blending gave her pastels a soft, delicate feeling that reflected the current Rococco style. In every way, Carriera's portraits mirrored the light-weight sophistication that her wealthy patrons desired.

LIOTARD

By the time of Carriera's death in 1758, pastels were the fancy of southern Europe. From Switzerland came one of the most sought after pastelists, Jean-Étienne Liotard. His portrait of "François Tronchin (Figure 1.1), a prominent member of society in Geneva, shows remarkable polish. His portraits were respected for their truth, brilliant textures and finished quality. In fact, this painting is so "finished" that it is difficult to identify as a pastel.

Figure 1.1
JEAN ETIENNE LIOTARD
François Tronchin
Courtesy The Cleveland Museum of Art (purchase, John L. Severance Fund)

PASTELS IN FRANCE

LATOUR

The greatest name in pastels was without question Maurice Quentin de LaTour (1704–1788). He was born in St. Quentin but left at an early age to study in Paris. His first success came with a portrait of Voltaire, and recognition grew steadily. In time, most of the great names of the day sat for him, including Marie Antoinette and King Louis XV.

LaTour changed forever the nature of pastel painting. His works were not soft and delicate like Carriera's nor overly polished like Liotard's. Instead, they showed the highest degree of assurance, clarity, and detail, combined with a freedom of handling that still seems remarkable today.

Using brilliant colors and textures, he constructed his pastels into formidable paintings, bringing a new-found range to the medium.

In "Portrait of Jean-Charles Garnier, Seigneur d'Isle" (Figure 1.2) we see the master draftsman at work. We can also see why LaTour was so popular. Being a master technician enabled him to capture the full grandeur of the Baroque era, with all its laces, silks, and in this case, satin. Any portrait artist today can appreciate that the times have changed favorably. The problems involving such detail and ornamentation in eighteenth-century Paris must have been enormous.

The great pastel frenzy in Paris lasted over four decades, during which time thousands of Parisians alone had taken it up. This included many already established painters like Watteau, Le Brun, Prud'hon, Boucher, and Perroneau. Most

4

important of all, thanks to LaTour, pastel was accepted on equal ground with oil painting, which in itself insured its future success.

CHARDIN

Of the many great masters of the period, Jean Baptiste Simeon Chardin (1699–1779) has become one of the most studied and admired painters. He was a master of both color and composition. Most striking is the use Chardin made of common kitchen items: utensils, bowls, cups, and his simple arrangements of fruit, bread, rabbit, and fish. Remember that this painting occurred during the Rococo age of high fashion.

In the middle period of his life, Chardin gave in to popular opinion and painted more "respectable" subjects—genre scenes and portraits. But being a simple man, he longed to return to an easier way, and in his last years he did. Switching to pastels, he painted several exquisite portraits, including that of his wife, Marguerite Pouget, in 1776 (Figure 1.3). This is a loving study, simple, direct, and surprisingly candid. It is an honest impression devoid of embellishments. I can think of no other artist that inspires me more than this great Frenchman. When I say that pastels can produce a *lifelike* quality of spontaneity and freshness that no other medium can attain, I am thinking of Chardin.

The history of France took some drastic turns at this time, as this sea shanty of the time aptly points out:

> *King Louis was the king of France . . .*
> *Before the Revolution*
> *Way haul away, we'll haul away Joe.*
> *But then he got his head cut off . . .*
> *Which spoiled his constitution . . .*
> *Way haul away, we'll haul away Joe . . .*

It would be seventy-five years before another wave of popularity in pastels would occur.

Figure 1.2
MAURICE QUENTIN DE LATOUR
Portrait of Jean-Charles Garnier d'Isle
Courtesy Fogg Art Museum, Harvard University (bequest of Grenville L. Winthrop)

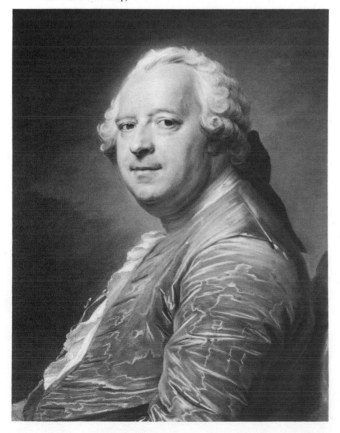

Figure 1.3
JEAN BAPTISTE CHARDIN
Marguerite Pouget
Courtesy of the Art Institute of Chicago

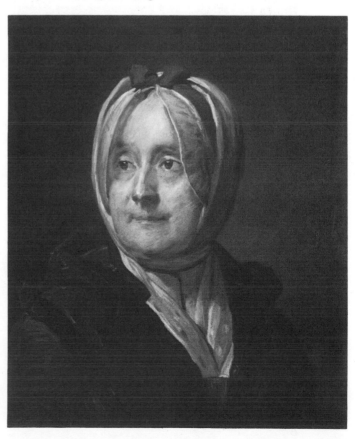

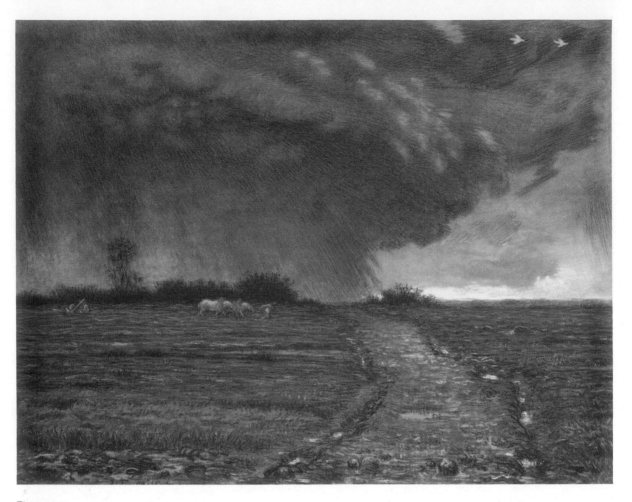

Figure 1.4
JEAN-FRANÇOIS MILLET
The Coming Storm
Courtesy Museum of Fine Arts, Boston (bequest of Mrs. M. Brimmer)

Figure 1.5
JEAN-FRANÇOIS MILLET
Shepherdess
Courtesy Museum of Fine Arts, Boston (Shaw Collection)

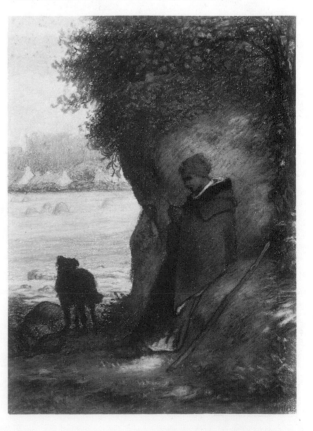

MILLET

However, one name deserves attention from this period, Jean-François Millet (1814–1875), who lived his whole life in the country. His eye never wandered far away from the poor field laborers or the shepherds with their flocks. Today he is most remembered for his sentimental oils, like "The Sowers" in 1850 or "The Gleaners" in 1857. Overlooked are dozens of pastels like "The Coming Storm" (Figure 1.4), "Shepherdess" (Figure 1.5), or "Summer, The Buckwheat Harvest" (Figure 13.3). Though they sometimes lack refinement, these works give us an intimate description of a way of life that probably would have been unobtainable from someone outside these communities. Like van Gogh, Millet shared his life with these people, and like them he worked hard at his task everyday. It is said that Millet never missed a day's work, including the day his mother died.

6

MANET

By the end of the 1860s, the course of art was again changing. This time, Realism was being replaced by Impressionism, but like all changeovers, it was not accomplished without a fight. It was Edouard Manet (1832–1883) who first battled public opinion. His free strokes and loose handling were disturbing to the Academy painters as well as to the public. His full figures, devoid of background and even ground, were very radical. In his sketch, "René Maizeroy" (Figure 1.6), Manet's style has already been reduced to a rough image of his vision.

Although he led the way for the coming generation of painters, Manet did not show with them at the first "Impressionist" exhibition in 1874. It would take another year for him to fully accept the new doctrine of light and air being developed by Monet, Pissarro, and the others.

Of the original thirty members, Camille Pissarro (1830–1903) and Alfred Sisley (1839–1899) chose to paint with the discipline of this early period of Impressionism throughout their lives. They never ventured beyond, as did Cézanne, and thus their recognition has gradually declined. But in effect, these were the men that

Figure 1.6
EDOUARD MANET
Portrait of Rene Jean Maizeroy
Courtesy Museum of Fine Arts, Boston
(presented in memory of Robert Jordan by his wife)

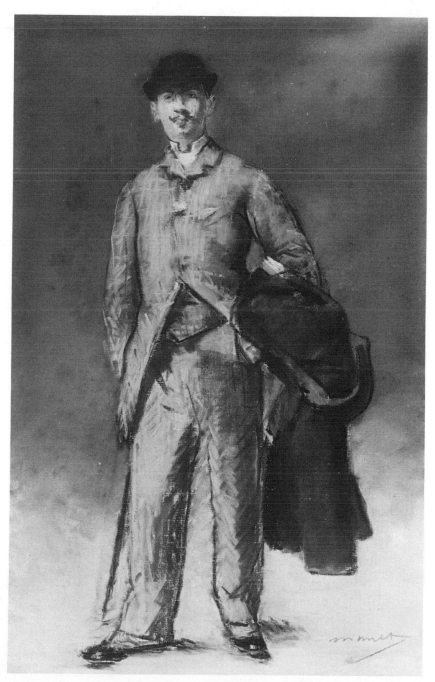

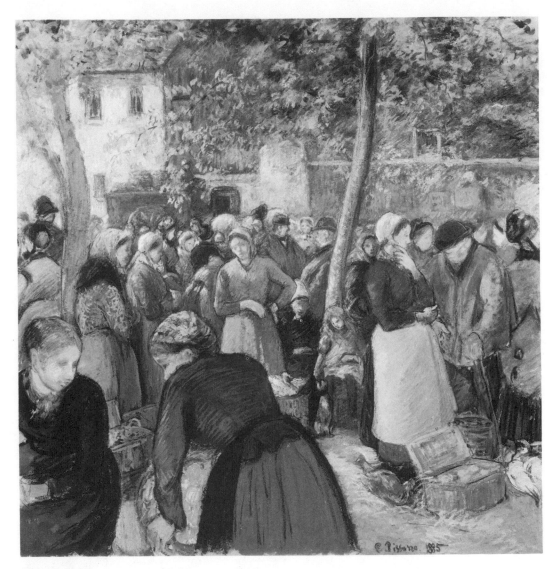

Figure 1.7
CAMILLE PISSARRO
Market Place
Courtesy Museum of Fine Arts, Boston (bequest of John T. Spaulding)

remained "pure" Impressionists, and without whose input the movement would surely have been lessened.

There were others, like Pierre-Auguste Renoir, who decided to return to the basics of drawing and composition, temporarily abandoning the movement for the old academic approach. Luckily for us, he later returned to Impressionism, combining discipline with color, light, and atmosphere as seen in "Woman with Black Hair" (Figure 1.8).

In "Les Canotiers" (Plate 1) we see two freely handled figures that still retain their overall shape and solidity. (In many works of this period, the Impressionist stroke had dissolved form into light and color.) Thanks to the lasting quality of pastel we can still marvel at Renoir's color, and in this painting it is outstanding.

The composition uses several devices. A contrast of temperature between figures and background is accentuated by the value changes. The pastel colors are applied thinly in the cools of the atmosphere, allowing for a radiant transparent effect that sparkles with light. This is a superb example of color effects producing a natural feeling.

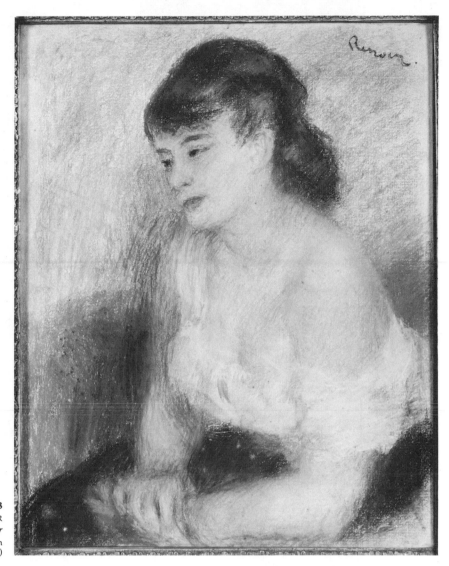

Figure 1.8
AUGUSTE RENOIR
Woman with Black Hair
Courtesy Museum of Fine Arts, Boston
(gift of Mrs. A. J. Beveridge)

DEGAS

Today, Edgar Degas (1834–1917) remains the most important painter whom we can study because no other artist has yet to achieve the total range of effects available with pastels.

Degas worked in oils until his midforties, when he underwent the most fundamental change of style in his long career. This change was influenced by both the camera and the importation of Japanese prints. The widespread use of the camera had an effect upon almost everybody. In "Race Horses" (Figure 1.9) Degas has cropped his composition much as a camera would, by severing any parts not deemed necessary to the overall design and also by leaving a large part of the picture surface devoid of subject.

Today we accept this style without hesitation, but it was quite new back in the 1880s. It is difficult to imagine just how different our own perception of the world would be without the invention of the camera.

"Race Horses" is typical of Degas in several ways. Whereas his contemporaries were interested in the science of light and air, Degas was interested in movement. Thus we see his two main themes, horses and dancers, serving a similar function.

Even more than the camera, the major influence on Degas at this time was the appearance of Japanese colored woodcuts by masters like Hokasai and Hiroshige. Their use of asymmetry, line, rich patterns, and flattened composition all appealed to Degas. Even his rather dull colors of previous years now became warm and radiant, especially in the reds and browns. In Figures 9.7 and 9.8, we see two ballet sketches, both reflecting

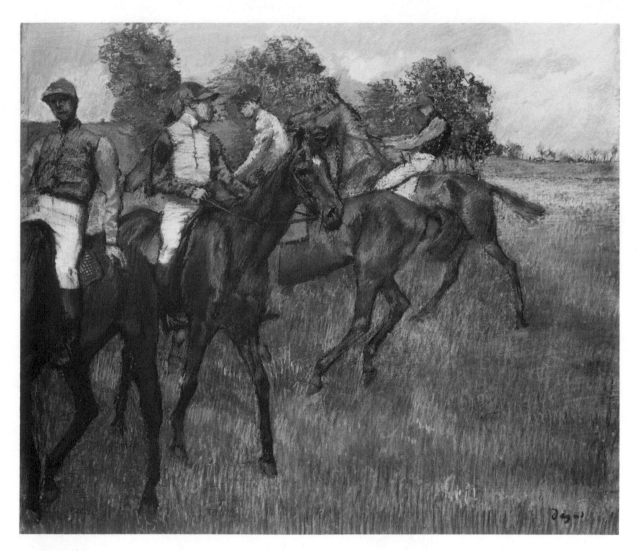

Figure 1.9
EDGAR DEGAS
Race Horses
Courtesy The Cleveland Museum of Art (bequest of Leonard C. Hanna, Jr. Collection)

in various ways Degas's new concern for these Eastern devices.

Many students have asked about Degas's techniques. To best understand them, we must look at some of his earlier experiments. Degas painted with distemper paint, a product of mixing color pigments with animal size and then heating the ingredients and applying them while still hot. He also tried *peinture à l'essence,* in which the oil was first dried out of the paint and the pigments then mixed with turpentine. Both methods are painfully slow and serve as an example of the patient nature of the artist.

In the 1880s, Degas began experimenting more with different crosshatch strokes and with the use of fixatives to help build his textures. More and more he began to attack the medium, pushing

in every direction as far as he could go. He tried countless surfaces, combining pastel with every conceivable medium. He painted on mounted papers, on cardboard, on canvas. He mixed pastel with gouache, watercolor, and even over monotype as in "Landscape" (Figure 1.10). He applied steam to the surfaces, softening the pigments and then used brushes to manipulate the colors. Preparing different solutions, he dipped the pastel sticks in them and fixed each layer as well.

Of all of these experiments, Degas's greatest contribution was his use of fixatives. His own recipe is still unknown, but his application of layer upon layer of pigment with fixing between each proved to be a monumental discovery. It also suited his own aims perfectly. He was able to draw and paint at the same time, while still

10

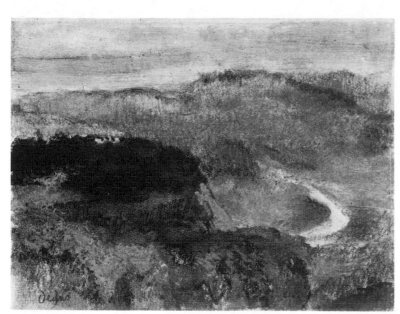

Figure 1.10
EDGAR DEGAS
Landscape
Courtesy Museum of Fine Arts, Boston (Ross
Collection, gift of Denman N. Ross)

working slowly, enabling him to construct his pictures as much as he desired but never losing the freshness that was necessary to illustrate movement.

By 1892, Degas was almost completely blind. His later works had become even more intense and dramatic than before. Eventually he was forced to give up pastels and turn to sculpture.

Today, when we look at the many effects that Degas achieved in his pastels, it is difficult to choose which one proved to be the most effective. More important, perhaps, is the degree to which these different approaches were carried out. Now we understand that pastels are not a fragile medium. We have his examples to guide us. I am not suggesting that we follow in Degas's wake, but we

should be aware of the possibilities. Each subject is unique in some way, and it seems a logical conclusion that some things can be portrayed best by utilizing different surfaces and techniques.

REDON

Odilon Redon was born only six years after Degas, but his work is normally labeled *Post-impressionist,* a rather general term, meant to help out art historians more than to define a specific movement. Whereas Monet and Pissarro painted what they saw around them, Redon painted visions that he saw within himself.

In his "Portrait of Mademoiselle Violette Heymann" (Figure 1.11) Redon painted a combination of subjects together that clearly reflect his

Figure 1.11
ODILON REDON
Portrait of Mademoiselle Violette Heymann
Courtesy The Cleveland Museum of Fine Art
(Hinman B. Hurlbut Collection)

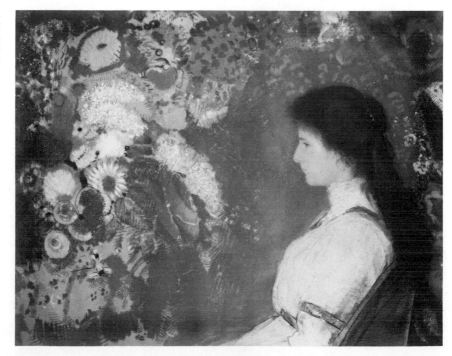

own fantasies. He wrote that in his dreams, these figurative visions would grow out of imaginative florals, much the same as what is seen.

In all of Redon's work there is a certain mystery. His themes ranged from Christ to Buddha as well as to his more remembered florals. In "The Large Green Vase" (Figure 1.12), a predominantly dark floral is silhouetted against a lighter background, a common device of the Impressionist movement. Most noticeable is the use of negative space which engulfs the floral. The vase rests somewhere on the surface plane, but exactly where we cannot say. Perhaps some interest is given here (in the subtle textures and strokes) but no special information that would define where we are as we view it. Normally if we wish to accent size, we bring the object closer to our vision, but here Redon has done exactly the opposite.

The floral itself is dreamlike, as if painted from memory instead of from nature. This impression is true of all Redon's works and the colors bear it out. In fact, Redon's colors are almost totally unique in the history of art, and that's quite a statement.

PASTELS IN AMERICA

For nearly two hundred years, the French dominated the history of painting. Now that period (1700–1900) is being reevaluated and a new interest in American painters has developed.

BASCOM

The widespread use of pastels in America did not occur until the mid–nineteenth century. However, one example of its individual use before this time was the work of Ruth Henshaw Bascom (1772–1830), a primitive portrait artist from Massachusetts. Without a formal art education, she adapted other methods to achieve her aims. Her most often used device is seen in "Profile of a Man" (Figure 1.13), where the light from a candle produced the silhouette of the figure. The heavy, flat volume of dark areas, accented by simple pencil line, creates a most dramatic effect.

It is understandable that the first Americans to produce art comparable to European standards were those trained in Europe.

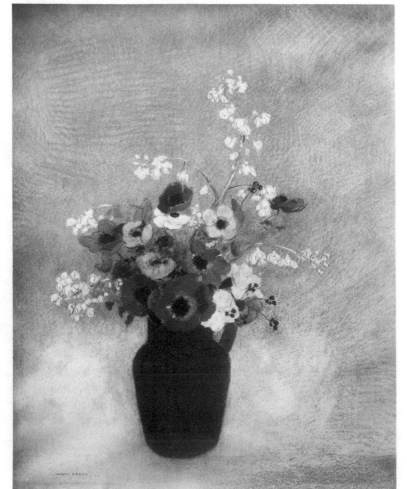

Figure 1.12
ODILON REDON
The Large Green Vase
Courtesy Museum of Fine Arts, Boston (bequest of John T. Spaulding)

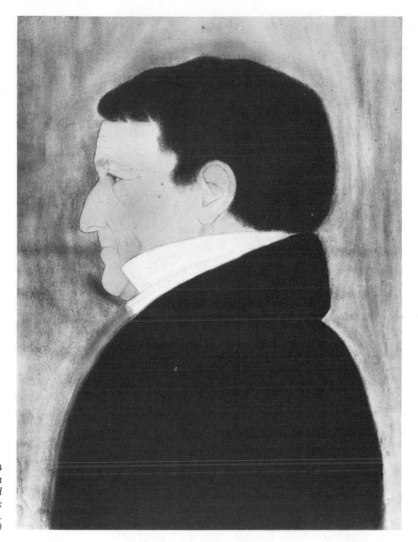

Figure 1.13
RUTH HENSHAW BASCOM
Profile of a Man with Short Hair and
White Stock
Courtesy Museum of Fine Arts, Boston (M. & M.
Karolik Collection)

WHISTLER

One of America's most celebrated artists is James Abbott McNeill Whistler (1834–1903), born in Lowell, Massachusetts. His family followed his father, an army major who worked as an engineer and surveyor for various railroads. In 1842, the family traveled to St. Petersburg, Russia, under a commission from Czar Nicholas I. While his father was building a railroad connecting Moscow and St. Petersburg, James attended art classes at the Imperial Academy of Fine Arts. The following year the major died, and the family moved back to America. James attended West Point but was expelled in his third year.

After the age of twenty-one, Whistler never returned to America. He studied in Paris and settled in England. However, his manners and temperament remained strictly American, and his whole life was filled with colorful drama.

In Paris, Whistler studied under Charles Gleyre, an academic Swiss painter who was not a particularly good colorist. However, as a draftsman, he taught his pupil well. Whistler too, remained a draftsman and not a colorist.

In "Portrati of Alma" (Figure 1.14), we see why he never became a fashionable portrait painter. He was far too interested in artistic problems to flatter his sitters. In fact, Whistler seldom flattered any of his subjects. He truly lived by his famous motto, "art for arts sake," which could be the theme of the whole of twentieth century art. But that did not help Whistler in 1878 when his famous trial against the critic John Ruskin took place. In that trial the artist had filed a libel suit against Ruskin for writing that his latest painting, "The Falling Rocket," was nothing more than "a pot of paint in the public's face." The painting in question was a night scene or Nocturne which represented the fireworks at Cremorne. It was done quickly (in two days) and was for sale at the price of two hundred guineas. The painting did not represent the fireworks display in the traditional manner. Instead, it was intended as

13

Figure 1.14
JAMES MCNEILL WHISTLER
Portrait of Alma
Courtesy Museum of Fine Arts, Boston

Whistler had defined a Nocturne as "an arrangement of line, form, and color." To all but a few Victorians, this method of painting was scandalous indeed. How could a painting so unflattering to its subject be considered worth two hundred guineas? After each side had called forth various artists and architects to support their positions, the jury hesitatingly gave the verdict to Whistler. However, damages of only one farthing were awarded to the painter and as further insult, Whistler and Ruskin were ordered to pay for the trial expenses equally. In the end Whistler was victorious but broke, and in 1879 he declared bankruptcy. Luckily he was rescued from a dismal future by the London Fine Art Society, which commissioned him to make twelve etchings of Venice. Whistler made very good use of the trip. He took to floating around the old city in a gondola with a box of pastels. Besides creating many of his finest etchings, he also produced some fifty beautiful pastels. Included were some of his most impressive but least seen works.

Although Whistler and his mother are both well known, it has taken a long time for most other Americans of the period to be recognized. This is especially true of the American Impressionists who called themselves The American Ten. This group, founded in 1898 by J. Alden Weir, consisted of a handful of unmemorable artists along with several others of considerable talent. Of these, John Twactman, Merit Chase, Ernest Lawson, and Childe Hassam deserve mention. The American Ten was a group of malcontented artists who intended not to be as revolutionary as their French counterparts, but rather to draw the attention of potential buyers of Impressionist paintings away from Paris. It was Weir's friend Mary Cassatt who had first expressed hope that such an American movement would develop. Perhaps the Americans never reached prominence because they were not very daring, tending to be more academic and illustrative than explorative in their art.

HASSAM

Childe Hassam (1859–1935) stayed several times in Paris and won a bronze medal at the Paris Exposition of 1889. He then settled in New England and painted the traditional churches of the area with which he is associated. Still later, he painted a series of flag motifs and local scenes of New York City in which he achieved his greatest artistic successes.

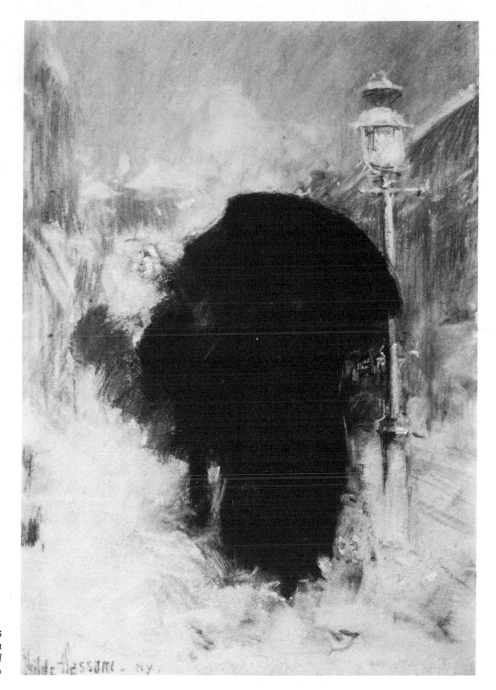

Figure 1.15
CHILDE HASSAM
New York Blizzard
Courtesy Isabella Stuart Garner Museum

CASSATT

Mary Cassatt was more of a European artist than an American one. Born in Allegheny City, Pennsylvania, in 1844, she received her first art education at the Academy of Fine Arts in Philadelphia. She traveled throughout Europe, studying in Paris and making several trips to St. Quentin to see the works of LaTour. She became associated with the Impressionists and exhibited with them for the first time in 1879. Degas influenced her the most, and like him she excelled at drafting.

Today Mary Cassatt is most remembered for her beautiful pastels of mother and child. She always used the same models, which resulted in a greater intimacy with her works. Her affection is clearly seen in "Mother and Child," 1892 (Figure 1.16), and in "Baby's First Caress," 1891 (Figure 9.4). Her technical skills were admired by her contemporaries, especially her ability to create rounded forms with the use of straight strokes.

Almost as important as the pastels was the promotion of Impressionism that Mary Cassatt carried out in the United States. Her counseling of the Havemeyer family on their art purchases is very well known, and we have many paintings in private and public galleries which we can now appreciate.

15

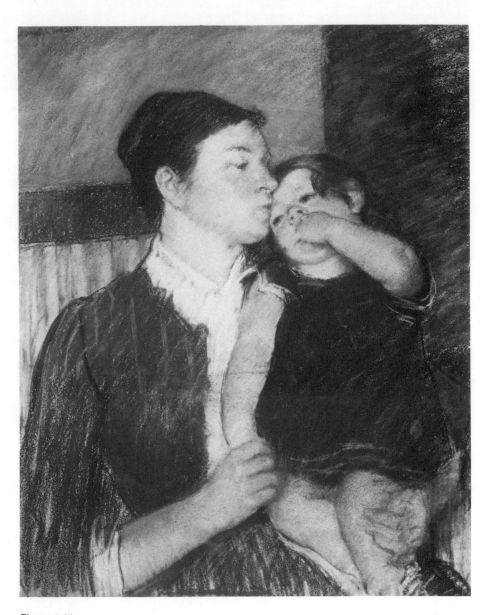

Figure 1.16
MARY CASSATT
Mother and Child
Courtesy The Art Institute of Chicago

PASTELS IN ENGLAND

In the late 1740s, the news reached England that the fashionable Parisians were having their portraits done in pastel rather than in oil. This news along with the growing fame of LaTour, convinced many portrait painters to try the new medium.

If their success is to be measured in pure numbers, the English clearly equaled their French counterparts, for the British fashion of having one's portrait painted was unmatched elsewhere.

This custom is apparent to anyone who has walked the endless rooms in British museums where the sheer number of powdered wigs alone tires the eye.

COTES

The most prolific of these portrait artists was Francis Cotes (1726–1770). His teacher, George Knapton, had introduced the child prodigy to pastels, and within a short time the student surpassed his teacher. He held numerous posts, being appointed Surveyor and Keeper of the King's Pictures in 1765. Besides his various positions for

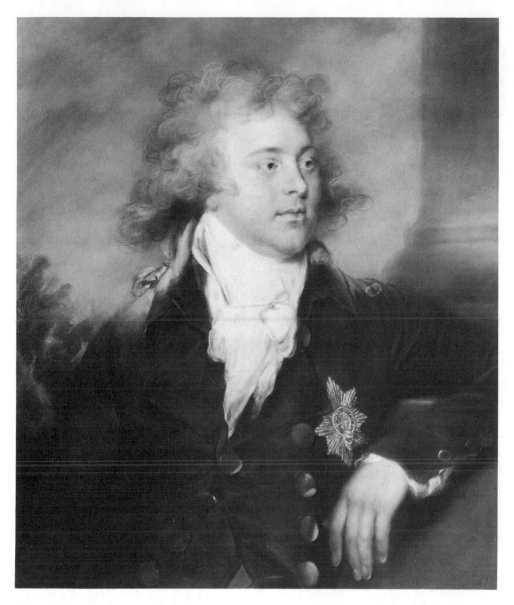

Figure 1.17
JOHN RUSSELL
Portrait of George IV
Courtesy Fogg Art Museum, Harvard University (bequest of Grenville L. Winthrop)

George III and his innumerable portraits, Cotes still managed to make his own pastels and to take on students.

RUSSELL

Cotes' most famous student was John Russell (1745–1806), who also showed great promise as a child. He became accomplished at an early age and was made an associate member of the Royal Academy at the age of twenty-seven.

Russell had great admiration for his teacher, and his praise helped to establish Cotes as the Father of English pastel, a position that many feel he could share. Russell was a gifted draftsman and also very fashionable. His "Portrait of George IV" (Figure 1.17) clearly demonstrates his skills: the skill of handling and the skill of flattering.

Russell wrote the first complete book on pastels, entitled *Elements of Painting with Crayons*, in 1772.

Other English pastelists of note are Daniel Gardner, a contemporary of Russell, and Sir Edwin Landseer (1802–1873). Landseer was the highly popular painter of animal genre, and his dogs with human expressions were shown throughout Europe.

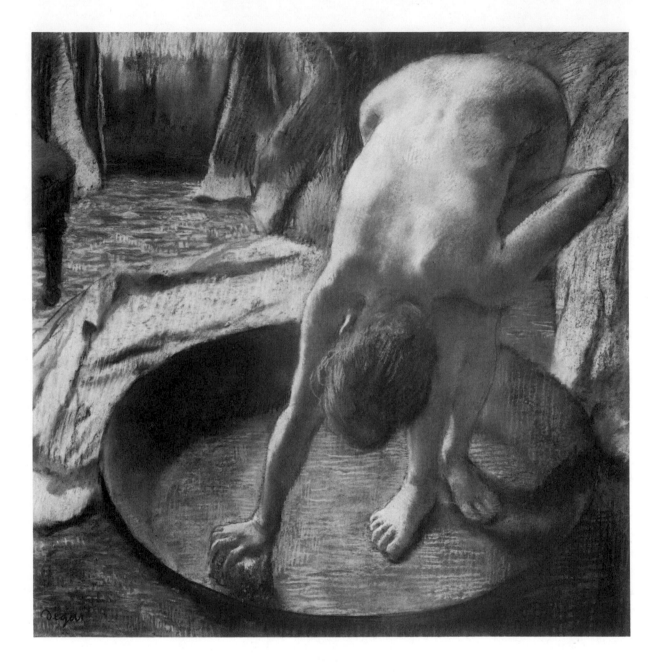

PASTELS ARE PURE PIGMENTS OF COLOR that are ground by milling machines into a very fine powder. These pigments are then mixed with a medium, usually gum tragacanth or a similar resin, that serves as a binding ingredient. The amount of binder also controls the degree of strength of the mixture. Harder pastels have more binder, or paste. The more paste that is added, however, the less pigment that can be added, causing a loss of brilliance. Therefore, most pastelists use a combination of pastels, relying chiefly on soft ones for their brilliance of hue and semihard and hard ones for details and finer

touches. Harder pastels also are more durable than soft pastels, which crumble easily, having less binder in them. As you can see, it is impossible to have both brilliance and toughness in the same stick.

Pastels are associated with chalk because a filler, such as pipe clay, is also added to the mixture of binder and pigment. It is this filler that gives us the infinite shades of pastels. In years past, up to one thousand different shades were manufactured. Today, less than half that number are to be found. Many shades were eliminated because their tints were so close to other tints of

The elements of pastel

the same color. The filler also helps to give the pastel better covering power, or opacity. Many watercolor, oil, and even acrylic colors do not cover well when used in pure strength. You may have noticed that green earth is a very weak pigment. A whole tube can literally disappear on your canvas, but with an addition of white, black or any stronger color, the opacity of green earth will improve greatly. The clay in pastels serves a similar function.

After the different ingredients for pastels are mixed together, the conglomerate is then wetted down and forced under pressure through ma-

chines that are cylindrical in shape. The sticks that come out are then cut, shaped, and dried in trays.

The strength of each color produced is controlled by the amount of chalk. The lightest shades have the most chalk, and since it is cheaper than pigment, these sticks are sometimes cheaper when purchased separately.

Black is added to some sticks of each color so that a full range of shades within a given hue is obtainable. There are other effects of adding black (and white) to pigments, some of which we will discuss in the section on color.

One further note. The pigments used to

make pastels are the same ones used in making oil- and watercolor-based paints. It is the process involved in creating each medium that makes them distinct from each other.

SEMIHARD AND HARD PASTELS

Semihard pastels are often used to accent areas or to define edges. They are also good for initial drawings, allowing for more detail and control. Like the softer pastels, these come in sets of twenty-four, forty-five, sixty, and so on. The leading manufacturers are Conté, Talens, van Gogh, and Pastellos.

Hard pastels have an edge more like pencils. They come in roughly three-inch sticks, which are not cylindrical but rectangular. The best are Nupastel, Grumbacher Golden, Palette, and Prisma pastel. Beware of student-brand semihard and hard pastels. They come in a variety of brilliant colors, some of which are fluorescent in nature. I assume they are fugitive (impermanent), as are most fluorescent pigments, so try and avoid them.

OIL PASTELS

In relation to soft pastels, oil pastels are a new product. They have a certain quality to be sure, but one should not confuse their characteristics with those discussed in this book. In fact, these oil-based sticks are pastels in name only, and many artists do not consider them to have any value at all. Personally, I have had some luck with them working in an open, free context, but they are not easily controlled and do not seem to be well suited for the subtle aspects of fine arts. The colors they produce are luminous, sometimes brilliant, but they lack the versatility of their closest neighbors, oil paints. When used with an agent (turpentine) they react as oils, except they do not mix as freely. My conclusion is that you would be better off working with oils, if that is the effect you are looking for.

Moreover, oil pastels are not compatible with chalk pastels, unless you accept the fact that they repel each other. So if a rule applies, use oil pastels as oil pastels only, and do not mix them with other media. Many of the same techniques used in the application of soft pastels will apply to oil pastels, but the final results will not bear resemblance to them.

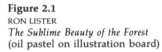

Figure 2.1
RON LISTER
The Sublime Beauty of the Forest
(oil pastel on illustration board)

WHAT TO BUY

Although several hundred shades are available to them, most pastelists use somewhere between one and two hundred sticks. If that sounds like a lot, it is, for in pastels it is best to do as little mixing as possible. We have seen that Degas was an exception to this rule, as he layered his pastels on quite heavily. But for most of us, it is best to choose as close a color and tone to the one desired as possible from among those shades readily available to us. You will see that this is one of the great advantages pastels have over other color media, and it is partly responsible for the freshness we associate with them.

In contrast to the variety of shades that experienced pastelists use, the student should start with a set of pastels of a considerably lesser number. Without wanting to limit it to an exact quantity, I do believe that a complement of fifty or more will suffice for a beginner's set. You may wish to use only a dozen sticks on any given subject at first, but you can have a better choice of which dozen to use if you have a larger set.

Brands

Most artists start out by purchasing a boxed set of pastels from one of the larger manufacturers. Considering that several companies sell specialized as well as general assortments, this is a safe method to start with. For instance, if you know that you only want to paint portraits or landscapes, separate sets can be obtained that are assembled for that very purpose.

In this country, Grumbacher and Rembrandt sell the greatest number of pastels. Their sets come in full sticks, about three inches long, or half sticks, thus doubling the quantity per box. Both of these brands are of good quality, but they do have different characteristics. Other well-respected manufacturers are George Rowney in England and Le France and Contí in France. It may be difficult to obtain English and French materials, but most of these products are well worth the effort.

Boxed assortments start in numbers of only ten or twelve and proceed upward: twenty-four, forty-five, forty-eight, sixty, ninety, and so on. Since there is no world standard for systems of numbering pastels, each company uses a different

Figure 2.2

Full set of soft pastels by Grumbacher.
Courtesy of M. Grumbacher Inc.

Figure 2.3
Courtesy of M. Grumbacher Inc.

GOLDEN PALETTE® PASTEL SET

44/48

method. However, Grumbacher and Rembrandt use similar numbering systems. Rembrandts, which are made by Talens in Holland, use a decibel numbering system to identify each shade. For instance, in a set of ninety, permanent green light comes in five shades, or tints. The darkest is numbered $+++618,3,C$, and the lightest $++618,9,A$. The pluses indicate the degree of light fastness, three pluses being the highest. The number 618 refers to the actual hue, in this case, permanent green light. The number after the color number refers to the various amounts of black or white that have been added to the mixture. A five indicates a pure or unmixed hue. The letters indicate price range, A being the lowest bracket.

Tint Charts

Whether your set uses numbers or letters, it is important that you keep a chart of the various tints. If your set does not include one, I recommend that you make your own. You may even find it necessary to make two charts, one on a white stock and another on a neutral gray background. The effects of background tints vary a great deal, besides which most pastelists work over a neutral tint the majority of the time.

In summation, I suggest that a minumum of fifty pastels is a reasonable start for the beginner. Please do not start with ten or twelve. You will want to add to your collection in time, but hold off until you see what colors are specifically needed.

MATERIALS

Choosing the right materials is not an easy matter. There are countless choices to be found and good advice at your local art supply store is not always forthcoming. Certainly to a large extent, prices dictate the choice we make, but remember all artists are dependent on the quality of their materials. Besides, many students in my classes have been sold inferior products at higher prices anyway. This chapter should help, but my advice is always to buy the best materials you can afford.

For many reasons, paper is the most commonly used support for pastel painting. Newsprint paper pads are often used for beginning drawing classes. They do have a slight texture and

work well for quick charcoal sketches; however, they have no value at all for pastels and should not be used.

Charcoal and Pastel Papers

Because pastels are sticks of dry pigments, they are inflexible when applied to a surface. It is the tooth of the surface that must hold the pigments. If there is too little texture, the pigments will fall off. With too much texture, it will be difficult to cover the surface, making it hard to paint areas of full-strength color. If you try, you could use a whole box of soft pastels on one rough surface, most of which would end up as powder on the floor. Charcoal papers have a medium-grained texture that accepts pastels very well. Most are machine made now, but at some time you should try a handmade paper. The uneven surface will produce effects that should be experienced.

In America, the Strathmore Company makes 100 percent rag charcoal paper as well as a full range of other stocks, which include drawing papers, mounted papers, and an excellent assortment of illustration board. The quality of their papers is excellent. Charcoal papers come in white and a variety of colors (about fifteen). All papers sold are 64-pound weight and can be purchased in single sheets or in pads. The pads also come in full white or assorted colors, which includes white. Since most pastels are drawn on toned backgrounds, the assorted pads are probably the best choice. The sets normally include a couple of sheets of black, and the rest are middle-toned values ranging in temperature from cool to the warmer neutrals. Pad sizes run 9 by 12 inches, 12 by 18 inches, and 19 by 24 inches. Remember, working on a small scale is difficult, especially with soft pastels, so I would stick to the larger pads and single sheets.

Other American manufacturers of note are Grumbacher of New York and Weber of Philadelphia. The best known European pastel papers are the French Canson Ingres and a heavier stock, Canson Mi-Teintes. From Sweden comes the Swedish Ingre, called Tumba. There is also Fabriano Ingre, sold in 90-gram and 160-gram weights. These papers are all named after the famous French painter of the nineteenth century, Jean Ingres. True Ingres papers are handmade, so read the label.

Canson-Montgolfier has been making paper

Figure 2.4
Selection of Strathmore papers.
Courtesy of The Strathmore Paper Company

since the mid-sixteenth century. In 1782, two years after the birth of Ingre, they sent up the world's first hot-air balloon, which was made of their paper, naturally. Canson Ingres papers are 100 percent rag, with even parallel watermarks. They used to come in a range of over thirty shades, but presently about twenty are available. Canson makes a very strong, durable paper; their Mi-Teintes papers are heavy enough for use with watercolor or gouache. These papers are sometimes preferred because they do not have to be mounted like the lighter papers when used with an agent. Note: Pastel papers are without doubt the most preferable surfaces on which to work. I recommend trying them at some time, despite their higher cost.

Tinted Papers

As stated, paper stocks are often tinted for pastel use. Many artists tint their own surfaces, but most purchase from dealers. The variety to be found is quite good in the middle-range colors such as neutral blues, grays, and browns. It is more difficult to purchase a similar range of darker tones, but again I suggest that it be attempted. A dark brown or gray stock can allow some very dramatic effects, and they are well suited of course for interior still lifes and evening or twilight scenes.

CHOOSING A TINT

One of the first questions normally asked is, "How do I choose a background tone?" In a general sense, you can start by choosing a tone that is in sympathy with your subject. Since shadows are usually neutral, it is often useful to pick a background in harmony with the shadows of your subject. Also, there are two types of color in any subject. One is the range of actual hues or specific colors to be found in the subject. The other is an overall saturation or basic color unity. For instance, summer landscapes are usually saturated with the blues of the summer atmosphere,

23

whereas winter scenes are normally cool gray in character. In a similar manner, mornings are saturated with blues, whereas evenings become warm with reds. Evening reds change very fast, as many outdoor painters know, and just before sunset this overall infusion of color peaks and turns toward violet, gray, and finally black. Figures have shadows that can be blue gray or even gray green, and the flesh tones of pastels applied over such colors makes a remarkable impression of reality. Perhaps the best way to see overall saturation of color is to look quickly at the total subject while squinting the eye so as to obliterate details.

The technical advantages of using tinted surfaces cannot be understated. Many oil painters would find it helpful, in a similar fashion, if they were to first tint their canvas. The unity of a painting would thus be greatly enhanced in its developing stages. At the same time, it would be easier to make an accurate analysis of color over a neutral backdrop than a white one.

MAKING YOUR OWN TINT

The first step is to dampen your paper on both sides. Remove excess water, and then lay the paper over a large drawing board. Tape down all four sides with a packaging tape or its equivalent; tape that is two and one half or three inches wide works well. Be sure to overlap both the paper and the board by at least an inch. Then leave the paper to dry; it will stretch out naturally. Next, apply a thin coat of wash of the desired tint and then let it dry again. The wash can be done with watercolor, gouache, acrylic, or even casein. It is not recommended that bright colors be used as backdrop tones. This is not merely a matter of taste since bright, garish colors will destroy any natural color sensibility you are trying to achieve.

Mounting Papers

You may wish to mount the paper after you have tinted it. To do so, place the paper face down on a clean surface (you may want to secure the edges temporarily). Next, apply a polycell paste, library paste, or similar adhesive. Rubber cement is not satisfactory because it will yellow with age and eventually seep through the paper. Even double-sticking or dry-mounting rubber cement does not yield a permanent bond. After applying the adhesive, mount the board surface over the paper and rub it down. I always let the paper overlap the board a little and trim it later. Finally, turn over

the entire surface and place a light sheet of paper (like tracing paper) over the paper side and rub it out from the center with a squeegee or template. This step will take care of air bubbles. Even if you use polycell paste, be careful not to use too much gouache or watercolor over the paper. Remember, it is still only paper.

BUYING MOUNTED PAPERS

There are a variety of mounted papers that can be purchased; however, most are smoothly textured and will not work well for pastels unless they are roughened up with sandpaper. The textured papers work better and also save a lot of time. Crescent Board Company makes a fairly large variety of mounted Strathmore charcoal papers. These are of good quality, although their main disadvantage is that they provide a fairly hard surface upon which to work. Some pastelists prefer to work over paper that has been softened with more paper placed behind the cover sheet. The main advantage to this process is that mounted boards will accept many layers of pastel without damage.

Watercolor Papers

Not all papers are inexpensive; good watercolor papers, which can be costly, are quite good for pastel with mixed media. Here, the pastels are applied on the paper over a watercolor or gouache drawing. The effects are most pleasing when the undercoat drawing is fairly opaque in nature. Transparent drawings or washes weaken the effects of pastel.

Like other papers, watercolor paper is either machine made or hand pressed. Good handmade papers are normally imported. Watercolor paper is sold by both weight (90 pounds, 140 pounds, 300 pounds) and the roughness of its surface. The heavyweights do not always have to be mounted, which is an advantage. Handmade watercolor papers have an unconventionally textured surface, which may have some surprising effects. Actually, this is a good characteristic, so do not be misled.

Parchment

Parchment or parchment-type papers are useful if the surface is roughened up a bit as I suggested with smooth textured boards.

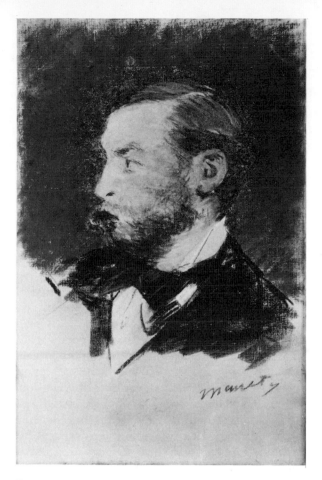

Figure 2.5
EDOUARD MANET
Study of a Blond Man (pastel on canvas, 21'' x 13')
Courtesy Fogg Art Museum, Harvard University
(bequest of Annie S. Loburn).

This is one of several portraits Manet made of George Moore. Note the granular effect caused by the roughness of the canvas's surface.

Canvas Supports

Prepared canvas is easily obtainable and is suitable for pastels; however, there are certain advantages to preparing your own. The sizing or ground coat provides the actual surface on which to paint, so it is beneficial to have control over it. Sizing is usually a lacquer or paint with an extra amount of toothy pigments, such as pumice, added. Be sure that your sizing does not include animal glue, for it will cause mildew. When applying the size, try using a brush one time and a pallette knife another. Also try to vary your strokes and experiment with different textures. Then, if desired, the ground can be sanded down and a second coat can be added.

On stretched canvas supports, a bump or vibration may cause substantial damage, so be sure to back it before you start to work. Actually, I prefer to mount canvas instead. The surface may be a little harder, but it will not be so vulnerable to disruption.

Other Supports

As we have seen, any surface with a slightly grainy texture will accept pastel. In the past, vellum was used, but I do not find this to be one of the better choices. Wood, on the other hand, has some beautiful qualities to it. One has only to look at the prints of Gauguin or Munch, the great

Figure 2.6
RON LISTER
Narcissus (pastel on gray charcoal paper)

Norwegian, to see the effects that wood offers. These artists did not merely use the wood as a surface but also integrated its natural grain with the medium. They chose this method in order to lend a very natural quality to their works. This same incorporation of medium and support in pastels produces a similar quality. I believe that plywood is most often used, but of course there are many other woods that will do.

PRESERVATION: FIXING, MATTING, AND FRAMING

Fixatives

Fixatives are useful, despite some arguments against them. As we will see, the only true and lasting method of protecting a finished pastel is framing it under glass, but since most of us cannot always afford to do this, other options must be exercised. Fixatives will help if used properly and only as sparingly as necessary. If you are

going to mat and frame a picture, then it is probably not necessary to fix it upon completion. Of course, you have to use your own discretion. If the pastel is a very heavy impasto, then you may have to fix it.

When spraying any fixative, workable, or finish, several light coats will always serve better than one heavy coat. A heavy spraying will blow particles off the surface. It will also dampen the particles, causing them to coagulate and thicken like distemper paint. In addition, the painting will darken and lose some of its brillance. All in all, the freshness of your work could be destroyed with heavy fixing.

METHODS

Fixatives are normally found in pressurized cans, although you can still use a mouth blower or bulb-squeezed atomizer. Regardless of what you use, always hold the spray far enough away from the work so that only a fine mist reaches the surface. I always spray away from the painting for a second before turning it directly onto its surface. Sometimes, drops of fix will have accumulated, so

Figure 2.7
RON LISTER
February at the Arnold Arboretum (watercolor and pastel on illustration board)

The broad effects were created with watercolors. The details and some subtle color changes were added with pastels.

it is better to waste a little of it than to have these drops fall in the middle of your painting. Generally, a steady back and forth, up and down application is suggested. I do not think its direction is overly important, as long as the application is steady and even. If you hold the spray off the page by at least twelve inches and use a fluid motion, all should be well.

Most sprays are a weak nonyellowing resin immersed in an alcohol solution. The pressurized cans normally contain lacquer instead of alcohol, and in spite of the fact that it smells bad, it has the advantage of letting you know how much fixative you are using and if your area is well ventilated. Most can sprays are extremely toxic. Inhaling any of it must be avoided or you will find yourself in a fine fix, if you will pardon the expression.

Fixes can be either workable or nonworkable. The nonworkable varieties include mat, semigloss, and gloss finishes. Normally, I use a light workable mixture after spraying, touch up the highlights, and let it be. Again, this method is only used on surfaces that have a buildup of pastel. For alternatives, we can always look to Degas. He used layers and layers of pastel to build, almost construct, some of his paintings. Therefore, he used a lot of fixing between layers. There has been a great deal of interest from students in the different techniques Degas used. His layered, impasto method is the most famous, and at the time (1880), it was also quite revolutionary. Remember though, Degas often returned to sketches and quicker, more direct pastels whenever the subject dictated.

MAKING YOUR OWN FIXATIVES

There are countless ways to produce your own fixatives. Some methods date back to LaTour and are still effective. A well-known recipe calls for one-half ounce of casein mixed with five ounces of water. Let it sit for several hours; then add a few drops of ammonia and slowly stir in a half-pint of pure alcohol. This amount should then be doubled with water, strained, and left to stand. The solution works well, but you may have to warm it up a little before applying it.

Mats

Matting a pastel is one of the best ways to protect its surface. I suggest that you mat any work you can whether under glass, acetate, or whatever. I mat all my own works, so I have experimented with a number of materials. Rag board will last the longest. Many commerical mats will either fade, yellow, or worse, literally disintegrate after years of exposure to the elements. The thickness of a mat determines if the pastel will be sufficiently protected by the glass or acetate. The width of the mat should be three and one-half or four inches at least. It may be slightly wider at the base, but generally, an even width is most attractive. Any width smaller than three and one-half inches tends to make the work look cheap or flimsy. Small pastels sometimes need wider mats to enhance their attractiveness.

Another purpose of a mat is to lead the eye to the painting; it is not intended to serve as part of the work itself. Manufacturers have produced a dizzying variety of colors and materials. Many are glaring, bright, and obtrusive and should not be used. I use off-white or gray almost without exception, seldom using even other neutral tones. Whatever the case, stick to subdued colors when picking a mat and be wary of fancy materials that will only add expense to your project.

Frames

There is a greater variety of frames to choose from than is probably necessary. In a frame store, small corner sections are often hung on the wall. These may number in the dozens, and in such small samples (usually six inches or so), it is difficult to picture what the whole frame will look like. A fancy frame is apt to appear much more powerful when the finished work comes back from the shop. Try to think about this fact when choosing a frame. Nice frames add a great deal to a piece, but, as with mats, try to avoid those that will compete with your work.

At home, I have a simple miter box for cutting wood at angles and a glass cutter. With a few minor accessories, you can frame your work for half the cost of a frame shop. It really is not difficult and is actually fun to do.

I have two words of warning about framing: stay clear of nonglare glass and avoid humidity. Nonglare glass, as with nonreflective photographs, will destroy much of the detail and brilliance of a work. Regular glass is much better. Besides, a framed pastel should not be hung in a direct line of sunlight, which will damage the

painting in time. As for humidity, it is hard to avoid if you live in certain parts of the country. However, you can seal the back of the painting and keep it from touching the wall with a small piece of cork or similar material, which will cut down the moisture content. Before sealing the back of a pastel, add an extra piece of cardboard or backing material to further protect against bumps and normal handling.

Other Materials

Standard equipment is used for pastel painting. Indoors, a stand-up easel, stool, taboret, or table are the large items needed. Two chairs will suffice if you do not have an easel. Of course, table space for accessory materials and shelf space for finished work are helpful, too. Although this is elementary, it is very important to have a proper setup. A good system enables you to concentrate more on your work and, whatever else it takes, art requires a great deal of concentration.

Standard pastel equipment consists of absorbent cotton for blending, kneaded eraser for removing small amounts of pigment, hog hair or bristle brush for clearing away larger areas of pigment, single-edge razor blade to roughen up the surface or remove particles, paper towels and tissues, a drawing board for backing, tortillons (paper stumps) for blending, charcoal sticks, pastel pencils, ink, watercolors, gouache, pencils,

Figure 2.8
Materials used with soft pastels.

tape, tacks, brushes, trays for storage and for catching loose pigments, and sandpaper for adding or subtracting texture to a surface. Optional are pieces of corrugated cardboard to keep the pastel sticks from rolling around and a variety of other media, such as acrylics, tempera, or casein, to use in conjunction with the pastels.

If you are working outdoors, a portable easel or French carry easel helps a great deal. I have a nice one that I obtained through a Russian friend. It was shipped directly from Moscow and cost fifty dollars, including spare parts. In Russia, they also make a good portable umbrella used expressly for painting. It is black on the inside, so as not to reflect color and light, and white on the outside for precisely the opposite reason. I have searched here, but have found nothing comparable to it.

One other item I use is a small aluminum folding chair of the type sold for viewing golf or baseball. Mine was purchased at Sears Roebuck for five dollars. There are similar wooden ones, but the aluminum weighs less and can be carried more comfortably.

BASIC TECHNIQUES

Application

Application of any color medium relies not only on the actual placement of pigment but also the mental coordination responsible for it. Often, too much emphasis is placed on the physical aspects without due attention to the thought processes behind them. In traditional pastel painting, there should be a fairly exact routine to one's method. I have observed at least four phases: The first is what we actually see or perceive. Second, there is what we wish to see for the purpose at hand. Third, we need to synthesize the first two observations in order to coordinate the mind and hand. As a last step, we should always analyze what we have put down against what we started out to put down.

The key to this method is in the second step, the one that involves what we want to see. To the person just entering the art world, there is always a transition from the traditional ways of viewing the world to one that involves seeing things with a new purpose in mind. For example, a door may be viewed for years solely for its functional use of

entering and leaving a room. But if one is to incorporate this door into a painting, suddenly an entirely new set of information is required. The dimensions, colors, designs, form, shadow, and proportion all become important. This is a product of the process I call *what we want to see.* In it, we must determine what we need to know in relation to the function at hand. There are all the normal considerations as well, that is, which colors, values, and so on the media can actually reproduce and the amount of time there is to accomplish the goal. Moreover, there are the options of the artist to delete or add to the subject matter or to modify what has been seen for aesthetic purposes.

Because each subject—each person, tree, or flower—is inherently different, it is logical to allow for this difference in our planning and execution, which is why we must experiment with more than one method of application. It is also important to keep this whole mental-physical process on a conscious level, so that we know why things happen when they do. One of the funniest situations in teaching arises from what I call *sophomoritis,* wherein students will look the teacher square in the eye and explain that the final outcome of their efforts reflects exactly their original intention.

Line and Texture

It is important to point out that pastels leave little room for major correction; therefore, drawing is very important. In order to acquaint yourself with some basic drawing methods, I have devised some simple experiments. First, take several sheets of stock charcoal paper, cloth, watercolor paper, and so on, and tear them in strips three or four inches wide. Overlap and secure them (you may wish to label each strip). Next take the pastel stick firmly in hand and draw a few linear strokes, repeating each stroke at the same angle and pressure on each of the different strips. For example, start with straight lines, horizontal and vertical; then try angular, curved, zigzag, and wandering strokes. Try different lengths, from broad, heavy strokes to short, tiny ones. Next, try to vary the pressure and angle of a stroke a bit to produce variations in it.

Mass and Tone

You will see that by crossing lines (overlapping), mass or volume can be obtained. In fact, crosshatching is one of the major devices used to produce mass areas. Try cross-hatching the same

Figure 2.9
Effects of pastel on different surfaces.

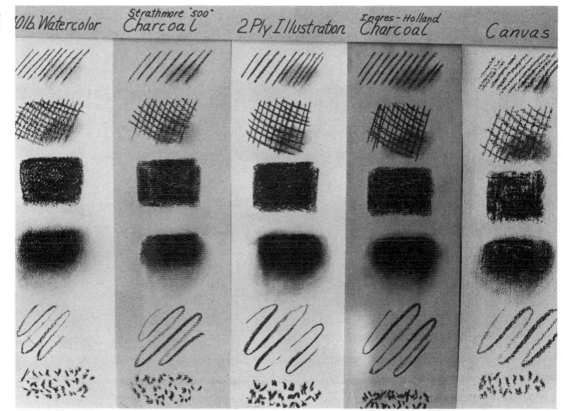

color stick to produce a solid area. Try right angles and then more obtuse and acute angles. Next, smudge the surface area a little in order to fill in the lines and produce a true solid, although the color will soften a little from the blending. We will further discuss rubbing, but for now, try just a little of it.

You will next see how easy it is to arrive at color modulation by overlapping different colors. Try it now without rubbing, keeping in mind that strokes are often the heart of a painting and should be visible. After first leaving in the strokes, try to rub a little the next time, letting the area vignette (fade off). Last, try this experiment with several colors in juxtaposition, light to dark and dark to light with and without rubbing. You will soon discover that after a certain amount, the tooth of the surface will lose its ability to accept more pastel. At this point, it is hard to continue without fixing the surface. You will see that in pastels, for this reason, it is best to build up the color slowly at first, until a basic feel has been established. With experience, you will learn how much surface is left, and this knowledge will enable you to move along at a faster pace. There are no shortcuts here. It takes time to understand the subtleties of manipulation. At least pastels are not as difficult to mix as oils or to balance pigment with water as watercolors.

Broad Strokes

One of the greatest problems in teaching is getting students to break up the sticks of a new pastel set. It should not be a difficult task if done properly; each stick should be broken off at least a quarter or a third of the way up from the end. If you try and save by breaking off just the edge, you will probably be left holding small crumbs, especially with soft pastels. The harder the stroking, using the side of the stick, the heavier the tonal buildup. If you are overlapping tints, a certain degree of surface tooth must be left open so that the second layer will hold. Build up a mass area slowly at first, saving the grain of the support for further manipulation.

Rubbing

Once you have tried the different strokes, advancement will come rapidly. Bringing out the subtle characteristics of each hue and of each ground support will take a little longer, but the basic methods are there. As for rubbing, use your senses. Each object you draw has its own texture. Some are smooth and deserve to be handled as such. Yet most objects in nature are not smooth, and the illusions used to simulate such rougher surfaces must fit in accordingly.

Remember, strokes identify an artist to a degree. Technically, it is advisable to know that too much rubbing causes a loss of surface tooth and a loss of brilliance as well. In fact, a well-rubbed pastel often looks quite dead from a distance. Remember, you are close to the painting, being only a foot or so away. The further back from it you stand, the more blended the colors and textures look to the eye.

The pointillist painters at the turn of the century and the impressionists before them used this optical phenomenon as a basis for most of their works. The impressionists (Monet, Sisley, Pizzarro, and Renoir) made their strokes of color appear to blend when seen from a distance, whereas the pointillists (Seurat and Signac) did not really use strokes. Instead, they applied pure hues in small dots, so that many dots of pure yellow and blue, for instance, became green when viewed from a few feet away. Their technique ensures that pastels will often look more unified the farther away you get from them. Therefore, all painting media demand that you stand back often, and rubbing will lose its importance naturally. Rubbing can be beneficial at times, though it is my feeling that it is best to minimize its use. Pastels are messy for beginners, and with a lot of blending, colors on the surface (as well as on the hands and face) can become muddy or dirty. There is a similar problem in oil painting, where too much mixing on the pallette creates a similar muddy range of colors.

Large Strokes

All schools of painting condemn small picky strokes. The pointillist days have been over for many decades. Larger strokes are good for your confidence as well as your work. They help to keep things lose, which is a good quality to have. Do not try to force the pastel too much. Being very tight is an accomplishment of sorts, but if a painting is to have life, it must have room to breathe.

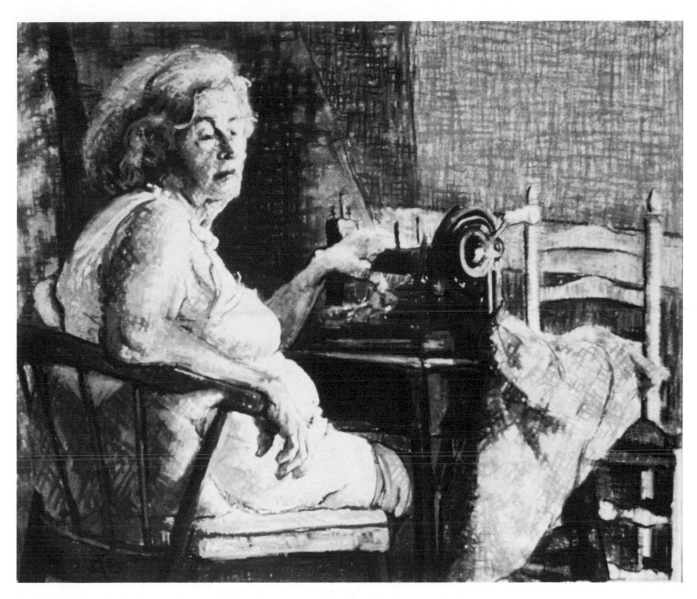

Figure 2.10
LUCILLE T. STILLMAN, P.S.A.
Old Singer #2

Summation

Linear strokes can produce most of the effects necessary in pastels. By cross-hatching and overlapping, they can also give tone and volume to a work. By the same methods, color modulation (manipulation of hue, tone, value) can be accomplished. Cézanne, the acknowledged father of modern art, rarely used lines for definition. Instead, he modulated colors in many ways to achieve a natural appearance. His lines are often formed where two colors meet. Without using linear strokes, modulation can also be acheived with broad strokes or by rubbing, vignetting, or overlapping.

Here again are the basic methods of applying pastels:

1. with the edge or tip of the stick (linear strokes, singular and multiple)

2. with the side or a broken piece (area or mass)

3. stipple effect (dots)

4. rubbing (blending with hand, paper stump, and so on)

5. different amounts of pressure (either linear strokes or area strokes)

6. combinations of the above

31

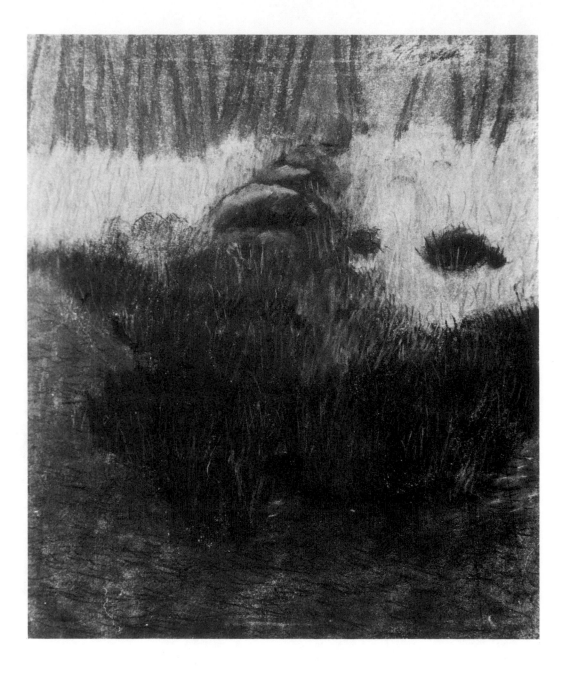

PASTELS ARE ONE OF THE FEW MEDIA available in which one can draw and paint at the same time. It was this very aspect that first captured the interest of Degas. But it is worth remembering that Degas was above all a draftsman par excellence. Good drawing is required in pastels and there are no shortcuts that I know of.

It is often difficult to keep the fundamental aspects of good drawing on a conscious level. Beginning students are frequently overwhelmed by details and technical problems, spending large amounts of time and effort on only one area. Advanced students sometimes take the basic elements too lightly, preferring to concentrate on more specific tasks. It is natural to set up more difficult problems to solve, but one should not neglect overall conformity. Artistic energy at any level (beginning or advanced) should be measured out as evenly as possible. Any pastel is only as good as its weakest part.

GENERAL SUGGESTIONS

In pastels, as in most media, it is helpful to step back occasionally and analyze the overall design.

CHAPTER THREE

Drawing with pastels

It is not necessary to slow down but rather to make adjustments constantly. Because each alteration is likely to affect previous ones, do not save them up to change later.

Pursue problems that are realistically achievable, and spend the necessary time on development to save time and frustration. For this reason I have tried to organize this book into logical progression of problem solving.

The choice of a reasonable size in which to work is also an important consideration. Drawing classes often utilize large surfaces, which are intended to keep students from becoming too tight in execution. This is a good idea when drawing

with charcoal or in one color, but filling up an entire 19-by-24 inch surface with color requires considerably more time than does a black and white sketch. On the other hand, when working with soft pastels, you ought to remember that they are not well suited for tight rendering. Keeping both aspects in mind, I suggest that you select a fairly large size but concentrate on the central portions of the composition. This technique works especially well when one is using middle-toned papers.

For years, I have been fascinated with the study of the old Chinese masters. Reading what Su Shih and Li Lung-Mieu of the Sung Period

Figure 3.1
RON LISTER
Franklinia (pastel on sanded pastel paper)

Figure 3.2
PAUL CEZANNE
Fruit and a Jug (oil on canvas)
Courtesy Museum of Fine Arts, Boston

Cezanne defined forms with subtle modulations of color, value, and intensity.

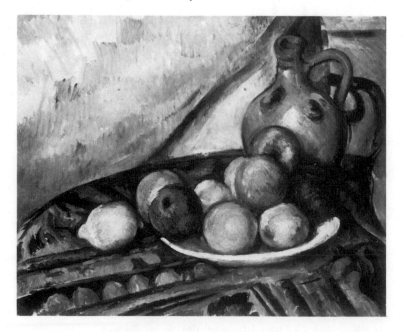

(roughly 1,000 years ago) had to say about drawing is like reading poetry. Their approach of *art as life* has been of great value to me in my own artistic pursuits. I feel this material fits in well with my discussion here about overall balance and conformity. You do not have to have a doctorate in art history to appreciate these old masters. The best collection I have read yet was edited and written by Osvald Siren, *The Chinese on the Art of Painting* (New York: Schocken Books, 1963).

LINE

Lines are used to separate forms, define objects, and in general create illusions that describe what we see. Pastels are ideally suited for these tasks. They can be shaven to a sharp point, used bluntly, or broken up and applied broadly.

There are several basic types of line: Contour lines follow the outlined shape of objects and planes within objects; gesture lines quickly follow movement within forms; mechanical or construction lines reduce forms to their basic structure.

Contour Lines

Contour lines are by far the most commonly used and misused lines of all. Because they are easily detectable, they often become the sole means of expression. The danger is two-fold: First, students tend to start a figure drawing with the head and then proceed to follow the outline of the figure, section by section, in a continual manner—usually at the expense of proper proportion, angles, and gesture. Second, when contour lines are used, other types of serviceable lines remain neglected.

Visual Study: The Still-life Paintings of Cézanne

There are many ways to produce lines other than with a direct stroke. Actually, there are no direct lines to be found in nature. Realizing this fact, Cézanne (1839–1906) chose to create his lines by butting edges together. In works such as "Fruit and a Jug" (Figure 3.2) lines are expressed where colors and forms join together.

TEXTURE

Pastels are a beautiful medium for realizing texture, partly because the pastelist begins work on a toothed surface and must work in order to create a smooth appearance. In oils, watercolors, or acrylics, the painter also starts out with a textured surface, but the difference lies in the application of the medium. In wet media, the brush is flexible and will fill in the tooth of the canvas or paper. In pastel, the stick is hard and will not compromise with the surface.

There are two elementary ways to utilize texture in pastel: first, by letting the grain of the ground support remain an integral part of the drawing; second, by building up a texture with pigments. This buildup can be achieved by overlapping broad areas of color, by cross-hatching strokes, or with a combination of both.

Textural Study: "Rocks at Platte Cove" by Albert Handell

Albert Handell is a prominent member of the Pastel Society of America. He was born in Brooklyn, New York, and studied at the famous Arts Students League in New York and at La Grande Chavmière in Paris. He has had many one-man exhibitions and has won numerous awards. He currently runs the "Albert Handell School of Pastel Painting" in Woodstock, New York.

In "Rocks at Platte Cove" (Figure 3.3) Handell started out by choosing a sanded pastel paper because of its lovely tooth. The different textures were achieved by applying individual methods to each area of concern.

The entire work was laid out on location, but the bright colors and values were held back on the first visit. The background area above the rocks was left in a particularly raw condition. Back at the studio, the upper area was washed in with a heavily diluted mixture of water and casein paints. Permanent green, raw umber, and purple were freely mixed and applied with a brush. On the following day, Handell went back to the original site, making sure to return at the same hour of the day. After carefully studying the patterns of light and shadow, he completed the foreground by rolling the sides of the pastel stick over the surface to produce a rough texture.

In the central portions the rocks were drawn more tightly. This technique helps to give added contrast to the overall texture while giving the natural appearance that the rocks are further away from the viewer. A variety of angular strokes and slight tonal modifications gives the picture a subtle and unified appearance.

The background area was then drawn lightly over, leaving some wash tones showing through. The effect was left purposefully simple and sub-

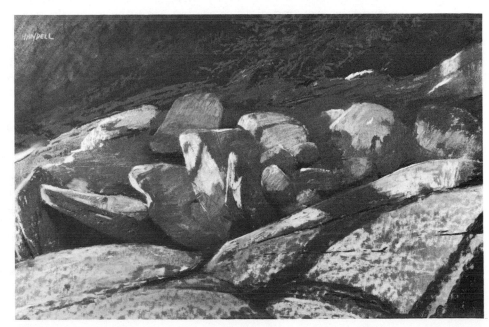

Figure 3.3
ALBERT HANDELL, P.S.A.
Rocks at Platte Cove

dued, which prevents this less important area from competing with the central plane of interest.

Although this pastel took three days to complete, the patterns of light and the rock forms were never muddled or confused. Each spacial plane imitates a natural impression. The foreground is rough and bold and was kept simple. The viewer's eye is led naturally to the more compelling central area. Similarly, the backdrop does not interfere with the other portions of the design, but it is not without interest either.

Textural Exercise

Take several pieces of tracing paper and a stick of pastel (brown or black). Place the tracing papers on a variety of surfaces and make rubbings. This exercise will help to identify a wide variety of surface textures, expecially those that appear essentially flat to the eye.

Textures, like forms, are hard to remember. A reference file of this sort is helpful to have around.

FORM

All shapes found in nature can be visually reduced or simplified. By such reduction, proper relationships can be more easily discerned, and proportion, size, and distance are less apt to be misrepresented.

The most common geometric shapes are circular (sphere, cylinder, and cone) and angular (square and rectangle). By referring to these basic elements, the pastelist can compromise the complexity of nature.

Visual Exercise

Form refers not only to objective shapes but also to abstract shape as defined by color. To better appreciate color as form, visit a contemporary museum of art and study the various color forms found in twentieth-century abstract painting. The works of Hans Hoffman, Franz Kline, Adolf Gottlieb, Philip Guston, and Mark Rothko are excellent examples. In these paintings, colors are seen to occupy their own spacial plane.

VALUE

Value refers to the contrast of light and dark. It will be discussed further in the section on color, but for now let's consider it as it relates to drawing. Various shades or tonal changes help to determine three-dimensional shapes. Shadows are most easily seen in simple geometric forms. It is said that when Plato witnessed a lunar eclipse some 2,400 years ago, he speculated that the earth was round. (The curved shadows of the earth that fell across the moon's surface indicated to him that only a spherical body could produce such an effect.) There are infinite numbers of shades between white and black. Yet the eye can discern and categorize only a small number of them. A useful value chart for the pastelist need only consist of ten or twelve parts. In a scale with ten parts, one indicates white, five indicates gray, and ten constitutes black. This limited system is normally adequate for most drawing.

Value Study: "Winter Landscape" by Americo DiFranza

Americo DiFranza is a native of Boston, Massachusetts, and a graduate of the Massachusetts College of Art. He received further training at the Arts Students League and The National Academy, both in New York. An original founder of the highly successful DiFranza-Williamson Graphic and Advertising Arts Studio, he has since retired to devote his time to painting. DiFranza exhibits his works through competitive shows and has won many prestigious awards. He is currently on the Board of Control for both the Pastel Society of America and the Arts Students League, where he frequently teaches as well.

"Winter Landscape" was painted on Snuffing Papier, a fine grade of sandpaper from Germany. He painted it directly from nature while looking out the west window of his home.

In viewing "Winter Landscape," we are first captured by the strong contrast of values. Color here is subordinate to drawing and is used chiefly to accentuate the wintery feeling of the subject. The central grouping of trees is most effective. Their relative size, deep values, and detail indicate closeness. Note that the bases of the trees blend while at the same time becoming slightly less de-

Figure 3.4
AMERICO DIFRANZA, P.S.A.
Winter Sky

fined. This device lets the viewer's eye follow the vertical lines of the subject, and it is not distracted by the foreground.

The background trees in the left corner are less defined and softer in handling, a device called *aerial perspective* (see the section on space). Although the overall value contrast in this pastel is very striking, there are many subtle uses of value as well. The soft modulation of shades gives the trees their cylindrical appearance and helps to create a sense of placement. Subtle changes of general tones indicate whether a particular branch is coming toward the viewer or receding into the background.

Careful attention has also been given to the sky. The horizon line, naturally the lightest portion of the composition, appears low in the picture plane because it was drawn while looking down

from a studio window. But it also adds strength to the composition. By remaining so low, there is more sky and thus more value contrast to the upper portions.

Finally, the foreground areas are deepest in total value, giving the design needed weight at its base. The result is a graceful and moving pastel which remains solid in composition.

SPACE

Space refers to both the illusion of three-dimensional space within a design and the two-dimensional space of the surface area itself. The most

Figure 3.5
Linear perspective is evident in this picture
of a covered bridge.
Photo by Ron Lister

Figure 3.6
Aerial perspective. A Scene in Bavaria.
Photo by Ron Lister

common device used to denote depth of field is *linear perspective.* In this method objects diminish in size as they recede from the viewer, and parallel lines can be followed until they converge at a *vanishing point.* Another method is *aerial perspective.* Here, colors as well as forms become less defined with distance. This illusion is caused by the number of small particles that float around in the atmosphere. The farther away an object is, the more particles there will be in the viewer's path; and since each particle either blocks light or reflects it, the object becomes less clear. This is the reason why the sun appears to turn red at sundown. As the sun nears the earth's horizon, we are viewing it through more and more of our own atmosphere. Again, the billions of particles in our atmosphere (pollution included) reflect and diffuse the sun's light and give us those beautiful sunsets.

In traditional painting, both aerial and linear perspective were usually used. In the 1870s, the European art market was greatly enhanced by the large importation of Eastern block prints. Many of the Impressionists, including Degas and Cassatt, were immediately taken by their use of two-dimensional space. In Japanese woodcuts, depth was defined only by overlapping. Objects remained clear and large at any distance. In Degas's "Dancers Au Foyer" (Figure 3.7), two-dimensional space takes precedence over three-dimensional space. Large areas are left open and flat. Negative space becomes more important, and the figures are drawn equally clear. The two figures in the left corner are somewhat smaller than those in the foreground, but there is no linear perspective anywhere to be found.

Today we can freely interpret space as we like. We can choose to draw perspective or not. We can even flatten space and use perspective in the same painting, but combining two- and three-dimensional space is tricky. It creates an awkward appearance that is difficult to control. Consistency is the key. Whatever your approach to this problem, try to remain consistent throughout.

Figure 3.7
EDGAR DEGAS
Danseuses au Foyer
Courtesy Museum of Fine Arts, Boston (gift of Arthur Weisenberger)

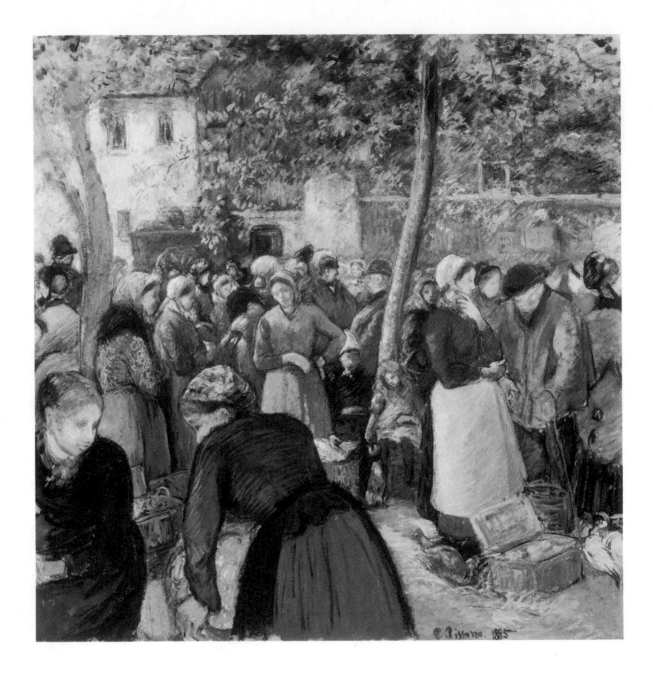

THE FOUR BASIC PROPERTIES OF COLOR that apply to painting are hue (actual color: red, yellow, blue, and so on), intensity (the brightness or luminosity of a hue), value (the degree of lightness or darkness), and temperature (the range between warm and cool). All colors share varying degrees of these same four properties, each having a different effect upon us. Some effects are psychological associations such as seeing red when angry, or feeling blue when lonely. Some effects are physical as well as psychological. For instance, warm colors appear to be closer to the eye than cool ones. This appearance is caused by an actual

physical occurrence in the eye. As light rays (which are actually waves of radiation) enter through the pupil they are directed to the rear of the eye and focused near the retina (back wall). I use the term near because only light waves of a certain length (yellow) actually focus directly on the back wall. Other waves like orange or red focus slightly behind the wall, and cooler colors like blue and green focus just in front of it. We need not be concerned with why or how this happens, but only with its effects. In this case, the information that our brain receives is somewhat confusing. The end result is that certain colors

CHAPTER FOUR

Color in pastels

cannot be interpreted simultaneously by the brain. So, warm colors actually do appear closer to us while cooler ones appear more distant. The point of this rather lengthy example is to illustrate that the properties of colors interact with our eyes in some very complex ways. Colors interact with each other in complex ways as well. I might add that a study of color does not have to be dull or exceedingly demanding. Since color is a primary tool in visual art, I hope that you will go beyond what is discussed here and make a more complete study of color. There are several fine books available that are neither difficult to understand

nor tedious to complete. One very good book is the *Art of Color* by Johannes Itten, first published in this country by Van Nostrand Reinhold Company in 1961.

HUE

Hue refers to light waves of varying lengths which our eyes perceive as different colors. Red and yellow are hues. When they are mixed together,

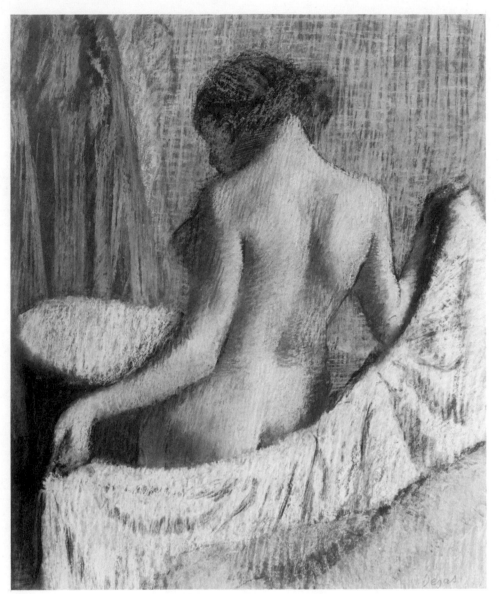

Figure 4.1
EDGAR DEGAS
After the Bath (pastel on brown
cardboard, 28″ x 22⅝″)
Courtesy Fogg Art Museum, Harvard
University (gift of Mrs. J. Montgomery
Sears)

they produce a third hue, orange. Whenever two
different hues are combined, a third hue will re-
sult. As artists we must understand what third hue
will be produced *before* the first two are combined.
Imagine the expense and time lost without this
understanding. Simple combinations such as red
and yellow producing orange are easy enough to
see. But what about more complex mixtures that
involve more than two hues? To better under-
stand and control such effects, artists, scientists
and even philosophers have long been interested
in organizing and categorizing these effects into a
reliable system that can be referred to with con-
fidence. One early system was devised by the
German philosopher and writer, Johann Wolf-
gang von Goethe (1749–1832). His color triangle,
Figure 4.2, is still reliable today. In this scheme,
the primary hues (red, yellow, and blue) occupy

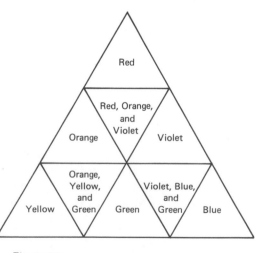

Figure 4.2

Color triangle devised by Johann Wolfgang von
Goethe showing primary, secondary, and tertiary
color scheme.

the corners of the triangle. Any combination of two *primaries* produces a *secondary* color such as orange, green, or violet. Likewise, any secondary hue can be mixed with a primary hue to produce what is called a *tertiary* color. These include yellow-green, blue-green, red-orange, and so on. Thus, a full range of visable colors can be created from combinations of the three primaries.

Note: The more complex hues such as brown simply call for the mixing of more than two hues.

Goethe's triangle is a very simple system. More complicated ones have been developed in the past hundred years. Yet this early system contains a great deal of insight into color. For example, when the triangle is viewed in full color it is obvious that the strongest hues are the three primaries. The secondary hues are less powerful, and the tertiary hues are weaker still. Thus, any mixing of colors will dilute the strength of the initial color group.

Many artists keep either a color triangle or the more popular color wheel (a similar system based on a circular motif) nearby as a reminder of the inherent structure that forms the basis for using colors properly.

INTENSITY

Each hue has only one level at which it is fully saturated with pigment. In pastels this level corresponds to that stick of any hue to which no amounts of black or white have been added. Remember that combining any colors (in this case, black and white are seen as colors) will dilute the strength of the original hue. A large set of pastels may include as many as seven nuances of a given hue, but only one of these sticks contains no additive of black or white. Rembrandt pastel sets marks this maximum strength stick with the number five added on to the hue number. (See Chapter Two.) As a rule then, the purest, most intense hue is one that has no additives and is instead fully saturated with pigment. Fully saturated hues tend to be the most *active* colors, and less intense colors are less active. This means that the most brilliant color combinations will produce the most striking or forceful effects. This puts the primary hues (red, blue, and yellow) at the top of the list (provided they are viewed at full intensity). Remember, however, that an abundance of brilliantly saturated colors will soon tire the eye. Less intense colors and neutral ones are essential elements in a pleasing pastel. The importance of less saturated hues, along with gray, can not be stressed enough. Besides giving our eyes a needed rest, they give us the necessary contrast we need to promote and accent stronger colors. For example, if we wish to paint a shiny gold object we will not find a pastel that matches such brilliance directly. However, by using what colors we do have in contrast to softer less intense colors, we can indirectly achieve the desired effect. In this manner, light ochre tones can take on the appearance of gold when surrounded by much darker, more neutralized tones.

Figure 4.3
RON LISTER
Study of Clouds

VALUE

Value refers to the contrast between light and dark as discussed in the previous chapter. When seen at full strength each hue has only one corresponding value. Yellow is the lightest hue, whereas violet is the darkest. Each color can be made lighter or darker by adding white or black. However, the most pleasing effects are those produced when color values are altered by other colors, not by black or white.

There are many effects that are made possible by the use of value contrasts. Light colors can take on even lighter appearances when contrasted against successively darker backgrounds. Dark colors can likewise be made to appear darker when contrasted against lighter colors. Learning to associate the different hues with their relative values and learning how to take advantage of value contrasts should be a primary concern.

Figure 4.4
BERTA R. GOLAHNY
Susan

This pastel is made up of many variations of hue temperature.

TEMPERATURE

The last of the four fundamental properties of color refers to the contrast between warm and cool. The proper use of color temperatures creates perhaps the most pleasing of all effects. "Les Canotiers," by Renoir (Plate 3) provides a wonderful example. The warmth of the flesh tones contrasted against the cool hues of the surrounding atmosphere provide a very pleasing effect.

At first, identifying color by temperature may not come easily, partly because color temperatures can only be evaluated in relation to each other. The color yellow-green will appear cool when surrounded by areas of warmer hues such as yellow or orange. However, the same yellow-green appears considerably warmer when contrasted with a cooler color such as blue. If subtle shifts of temperature are hard to identify, try to

Figure 4.5
RON LISTER
Spring on Commonwealth Avenue, Boston (pastel on sanded pastel paper, 19" x 24')

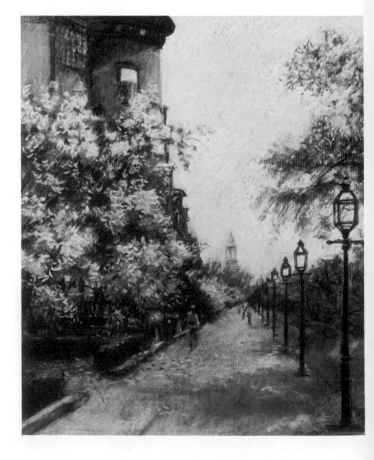

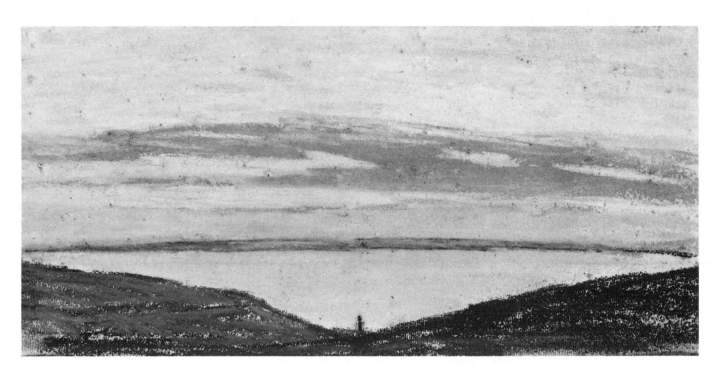

Figure 4.6
CLAUDE MONET
Etude de Soleil
Courtesy Museum of Fine Arts, Boston

recognize broader contrasts which are more easily noticed. In time, even minute fluctuations will be easy to detect.

PASTEL COLORS

The range of pastel colors is quite large, and owning a set of one hundred sticks is in some ways similar to owning as many tubes of oil paint or watercolor. Because wet mediums do not come in such a wide variety they must be mixed more often to produce the finer shades available in pastels. Most mixing of wet mediums is done on a separate pallette, not on the painting surface. Mixing is best done directly on the drawing surface where an immediate analysis can be made. This gives pastels a clear advantage when learning about color.

In most other comparisons, pastel colors are equal to or better than other mediums. Pastels undergo no major chemical changes, either when applied or during aging. If pastels are delicate to handle, they are also very permanent if cared for

properly. Pastel colors will appear fresh years into the future.

SUMMATION

With a basic understanding of color you can go far with pastels. Always try to keep in mind the four properties discussed here: hue, intensity, value, and temperature. It is advisable to start analyzing your own colors as soon as possible. Keep a color wheel nearby and memorize it. This will not take long and will help enormously. When a color has been applied, ask the basic question: How does my color compare in the four fundamental areas? If you notice that your color is not warm enough or light enough, try adding the simplest ingredient you can think of. After just a few trial and error sessions the answers will become more clear. So, for now, do not be afraid to darken a color with a little black. In time a more exact color can be adapted to achieve better ends. What is important is that you can start to rely on your own judgement and resources now.

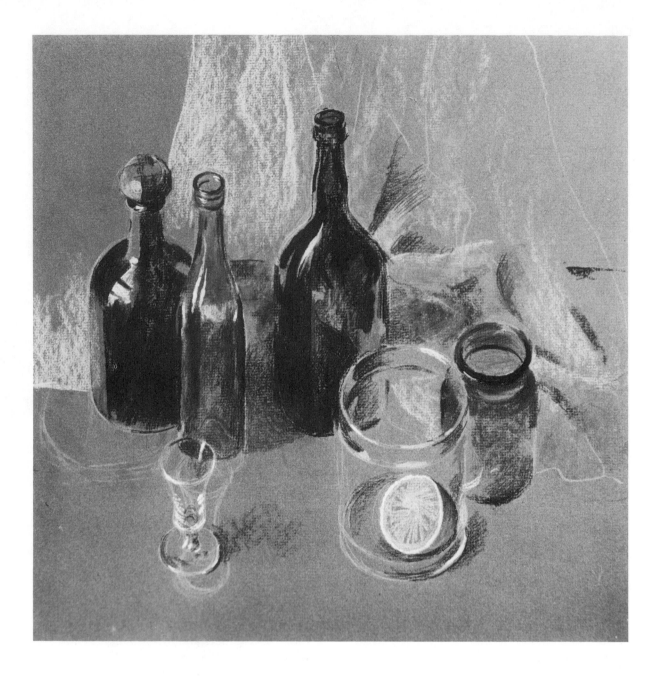

T HE PRIMARY CONCERN of a beginning exercise should be to concentrate on color and to explore the potential range of each pastel set, and still life painting is a natural starting point. In the first demonstration, I have made as many suggestions as possible. These are given to help in any way they can and are not intended as dogmatic rules that must be followed.

LIGHTING

Working from a still life offers numerous advantages, one of which is added control over direction and maintenance of a light source.

Indoors, light normally comes from one of three major sources: natural daylight, incandescent light or fluorescent light. Of the three, daylight varies the most and is the hardest to maintain. In comparison with artificial light, it is cooler, tending to diffuse particles in the air, making contrasts less dramatic. Edges, tones, and hues are softer than those obtained by artificial light. If natural effects are sought, daylight is the most reasonable choice.

Artificial Light

The greatest advantage in using artificial light is the relative ease of controlling it. Natural light

CHAPTER FIVE

Still life

conditions change steadily as the overall saturation constantly rises or falls, especially early or late in the day. Artificial sources can be controlled evenly for as long as necessary and can be reproduced whenever needed. Among the different types of artificial light, fluorescent light creates the most natural effect. Fluorescent lamps contain long cylindrical tubes which are either warm or cool in temperature. The cool tubes provide a subtle light, but I often use both warm and cool tubes together to create a more natural effect.

Incandescent light, such as normal household light bulbs, provides the least natural appearance. The light is overly warm and harsh in contrast with other types. Painting at night solely with incandescent light is not recommended. Results of viewing the pastel the following day in natural light can range from shock to devastation.

Weigh the advantages and disadvantages for yourself. At some time, give each one a try—your conclusions may be different.

Sunlight

It is a misconception that bright sunlight will enhance color. In fact, intense light of any kind, natural or artificial, will only lighten the subject. The brilliance will be diluted, not increased, especially if one is painting outdoors. Indoors, objects such

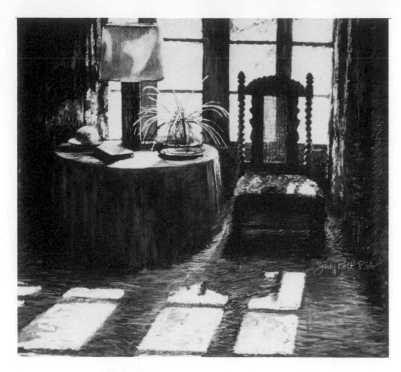

Figure 5.1
JUDY PELT, P.S.A.
Winter's Kindness

overall values and colors to make up the difference is a problem I sometimes try to work around. This problem applies most often to large-scale works that include florals. Floral subjects, when studied separately, are a different matter. Light that penetrates leaves and petals can, in such cases, add to a painting.

When dealing with indirect natural light, remember that over a period of hours, it is likely that the total amount of light flooding the studio will vary. Working until dusk to complete a pastel is often a mistake. Adjustments will mount, as energies fade and values appear darker by degrees, and a return to full saturation of light the following day can be disappointing.

as windows and screens normally cut down the overall saturation to a sufficient level.

SETTING UP

Direct Versus Indirect Light

I find that direct light indoors is suitable for most still lifes, with the possible exception of some florals. The translucent nature of petals can make direct light difficult to balance. The adjustment of

Once a source and direction of light has been decided, tables and easel can be set up. Try to situate yourself as close to the subject as possible, without being so near that you cannot encompass the entire still life within your vision. Body position should be at a slight angle to the subject, so the neck is not strained from the constant looking back and forth. If you must turn your head completely to view the still life and the drawing surface, you are essentially painting from memory.

Figure 5.2
RON LISTER
Study of Bananas

Figure 5.3
ANATOLY DVERIN
Bottles and Glass

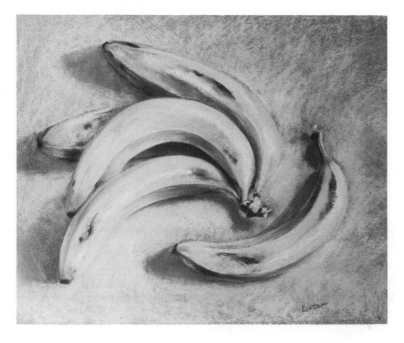

Check the drawing surface to see if it is receiving a compatible amount of light. The drawing support should not be in direct sunlight nor in a heavily shadowed corner either. Also see that your body does not cast a shadow on the surface. Proper positioning of the arm will solve any potential problem of that sort. Try to become comfortable holding the pastel stick away from the body, with the arm extended approximately three quarters of the way. This position will help you to view the whole process better. Do not draw with your face to the surface. It is impossible to see correct color relationships from such close proximity.

There is no rule that governs whether sitting or standing is the better position. I have known artists who are comfortable standing at an easel for eight hours a day. Most often, what will determine your position is the relative position of the still life. I prefer to sit when I can, but if I begin to tighten up, I will alter my position.

Viewpoint

Wherever your eyes are in relation to the subject is your viewpoint. This is an important consideration that is often neglected. A change in the level of vision can increase or decrease the linear perspective, amount and angle of light, and even the relative size of the composition. Take time to

Figure 5.4
RON LISTER
Bread and Peaches (detail)

choose the optimal viewpoint. Walk around and analyze different positions until you find the one that seems appropriate.

The previous comments are suggestions that will help out in the long run. Basically, I am hoping that you will prepare yourselves well before beginning a pastel. These preparations should not take a great deal of time if they are handled in a routine manner.

DEMONSTRATION 1: "Pears" by Ron Lister

The demonstrations in this book try to follow a logical progression of problem solving. By starting with a limited exercise, it is possible to concentrate on color, and drawing and lighting difficulties should be minimal. It is not easy to estimate the degree of effort required to paint even the simplest of forms in color. At first, any subject more complicated would probably require two sittings to finish. A study such as this should take approximately one to two hours to complete.

PLACEMENT

The pears were subjected to a variety of positions to determine the best arrangement. After the layout and light direction were chosen, I set out my materials in a routine manner. I did not want to risk breaking my concentration by having to search for a missing article once I became absorbed in the painting.

CHOICE OF PAPER

I chose charcoal paper partly because I would expect the beginning student to choose the same. A charcoal paper with a middle value also closely resembled the shadows involved in the design. The edges were taped to a larger sheet of paper in order to soften the surface. Placing one sheet of an assorted charcoal pad on top of the rest of the pad will accomplish the same thing. Next, the papers were secured to a drawing board, and I made sure that all the edges were taped down firmly. It is not necessary to tape all around the surface unless you are using watercolors and watercolor paper.

If you are working on a heavily textured surface, a piece of cardboard can be placed un-

derneath to catch all the falling particles of pastel. Some artists collect these small pieces and press new sticks out of them.

SIZE

The pears were drawn approximately twice their normal size, allowing room to manipulate the pastel and creating the illusion that the viewer is close to the subject. Generally this is a good idea. Leaving large amounts of negative space around a simple composition creates a detached and distant feeling. A third reason for working in a large size is that it helps to keep the manipulation of the drawing loose. Tight renderings do not necessarily connote total control. A compromise in this area will assure that the pastel appears more naturalistic.

Step One

The initial drawing can be done with any number of instruments: soft or hard pastels, pastel pencils, or charcoal. For this study, a soft brown pastel was used. More complex compositions are best drawn with a harder stick. Whenever you are unsure of how to draw the subject, a pastel with a color and value close to those of the papers can be used. Then, mistaken lines will not be so noticeable.

PROPORTION

For those who have little or no formal background in drawing, it is helpful to invent some method for determining basic proportion and shape. One way is to consider each object in its simplest geometrical form, that is, cube, cylinder, square. Proportions can be measured by simple mathematics. Normally, holding up one's fingers and counting spaces works well. "Eyeballing" or drawing freehand becomes easier with practice. It is not easy to do, and the tendency should be avoided. Again, any simple device will probably prove more accurate. The aim of measuring space is to determine where a line is going to end before starting to draw it. Emphasis is best put on the imitation of the essential characteristics of the line while rendering it.

SHADOWS

The next step was to draw the basic shadows by pressing down on the stroke to indicate deep shades and by easing up on the stroke to indicate softer tones. Dark colors such as brown, gray, and

Figure 5.5
RON LISTER
Pears (step one)

even black are best suited for this step. Later, more specific coloration can be chosen. If you are using black, restraint is helpful: A little bit goes a long way. When the shadows are drawn, a sort of *blueprint* of the design is created, keeping areas from later being confused. These tones must be done first because in any pastel painted in daylight, they help to indicate where the shadows are when the painting was started. Even two hours will see a great deal of shift in the shadowed areas, so indicating shadows simultaneously at the beginning is a must.

Step Two

DARK TO LIGHT

The next step was to pick a middle-valued hue that was relatively easy to identify. One pure hue helps to start the whole process of choosing proper colors and values. The color was applied firmly to establish a scale of brilliance as well.

Although I suggest placement of a middle-

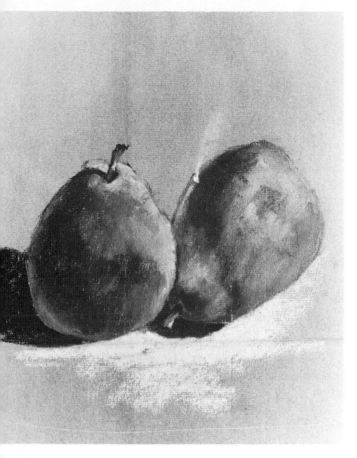

Figure 5.6
RON LISTER
Pears (step two)

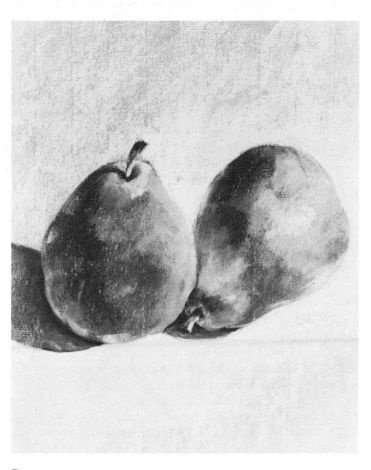

Figure 5.7
RON LISTER
Pears (step three)

toned hue, as a general rule it is best to work from dark toward light. It takes more effort and pigment to deepen a color than to lighten one. Thus once the middle range has been identified, it is possible to rework the shadowed areas. After a few attempts it will become evident how far the color can be pushed. Identification of proper hues will become second nature, including the more difficult shadowed tones.

BUILDING AND MIXING COLORS

It is natural to want to work carefully and to apply the pastel in thin coats at first. Try to compromise this feeling with the attitude that this is only a color study. Pushing down on the strokes will not only help the color experiment but also give an idea of how much pigment the surface will hold. Most people find that paper surfaces will take more color than they expected.

Whenever possible, apply the right color without mixing. Some mixing may be necessary, but the best method is still the most direct one. Do not rub or smudge the surface unless absolutely

necessary. If the surface texture looks unpleasing, you are too close to it. In this case step back and look again. There are few cases in which a lot of rubbing is helpful.

When it becomes apparent which colors are to be used, separate them from the others. If you are using only a few sticks, they can be held in one hand. A piece of foam or corrugated cardboard also works, and it will keep the pastels from rolling as well.

At this time, I added shadows outside the pears and sketched in the foreground. Both were drawn boldly, even overstated, so that a complete range of values could be established. From here on, I worked from the shadowed areas toward the lightest tones.

Step Three

Shadows and colors were fully extended so that textures could be applied over preexisting colors. Basic relationships were not changed, and over-

stated shadows would be softened back when the final value scale was finished.

With the overall effect established, I refined or altered edges and colors and further developed background tones. I chose to lighten this area considerably to give added contrast and weight to the pears.

In the closing moments the shadows were softened back, and details such as the stems were touched up. It is easy to overstate stems in any fruit design, much the same as painting bright blue eyes in a figure. Analyze the importance of such things and try to keep them in their proper places.

Remember that outlined areas will not always be viewed in sharp contrast. Some edges, such as where the pears overlap or where the shadows of the background meet those of the pear, will blend together.

Curved forms often reflect light around the edges. If you hold your open hand toward a light, your fingers will appear lighter around the edges, as if outlined. This effect can be seen on the back side curve of both pears.

Finally, the highlighted reflections were brought to full intensity, and a little of the color from the pears was "dressed" into the background—just enough to help unify the color feeling.

FIXING

I gave the pastel a light coat of workable fixative and then retouched the lightest highlights. I did not spray again. (See cover for finish.)

DEMONSTRATION 2:
"Bottle Stillife"
by Anatoly Dverin

Anatoly Dverin was born in Dnepropetrovsk, a large industrial city along the Dnieper River in the Central Ukraine. He received over eleven years of formal training, including a B.A. degree from the Commercial and Industrial Arts Institute in Leningrad and an M.A. degree from the Kharkov Institute of Fine Arts. At the time he chose to leave the Soviet Union, Dverin was the chief artist of a Commercial Enterprise Studio of more than two hundred artists. Today he works as a freelance artist in Boston, frequently exhibiting on his own.

Step One

One of the most striking aspects of Dverin's art, is his ability to utilize the individual characteristics of each medium. When drawing with pastels, he invariably makes good use of the background support, textural possibilities, and unique subtleties of pastel color.

First, he chose six glass objects from a large array of shapes and forms. Each bottle or jar was carefully selected to represent the best range of size, color, and proportion. The two large bottles are brown, the thin bottle and jar are green, and the two glasses are clear.

Next, a large piece of warm, gray Crescent board, measuring twenty by twenty inches was selected. The composition was first drawn with a slight angle or viewpoint. However, this was abandoned, and a more aerial view was established.

The final arrangement is a masterful composition. The two large, brown bottles were placed in the rear. The largest one formed the apex of a

Figure 5.8
ANATOLY DVERIN
Bottle Stillife (step one)

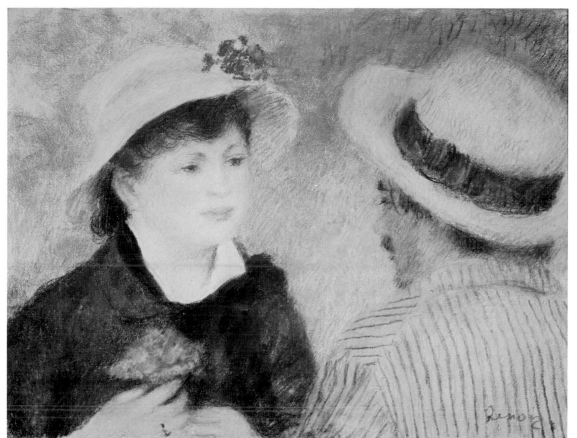

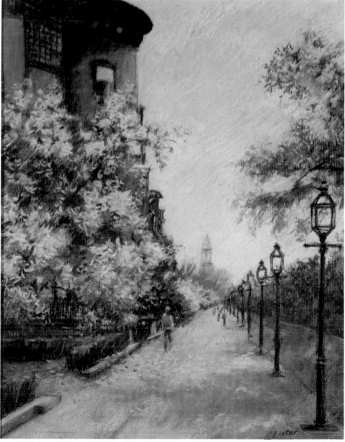

Plate 1
PIERRE AUGUSTE RENOIR
Les Canotiers (45 x 60 cm.)
Courtesy Museum of Fine Arts, Boston
(gift of Fuller Foundation)

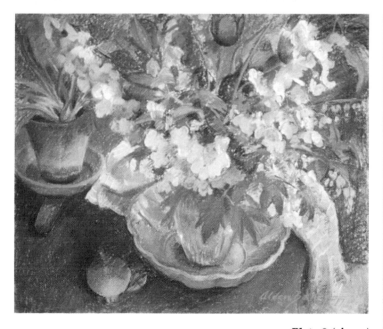

Plate 2 (above)
ALDEN BAKER, P.S.A.
Flowering Ash

Plate 3 (right)
RON LISTER
Spring on Commonwealth Avenue

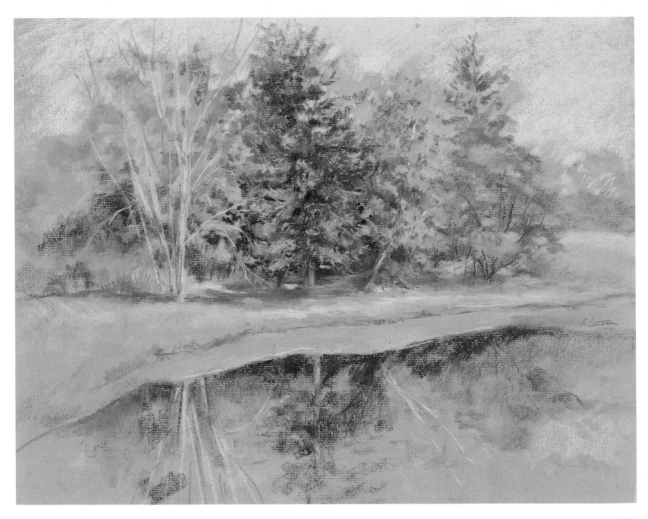

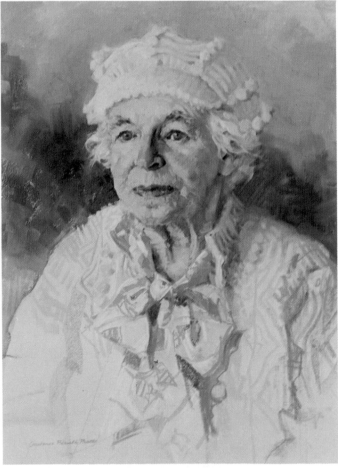

Plate 4 (top)
RON LISTER
Larz Anderson Park

Plate 5 (right)
CONSTANCE FLAVELL PRATT, P.S.A.
Mother

Plate 6 (bottom left)
ANATOLY DVERIN
Bottle Stillife

Plate 7 (left)
RON LISTER
Arnold Roses

Plate 8
ESTHER GELLER
Reclining Nude

Plate 9
MEI-KI KAM, P.S.A.
Mt. Watkins

Plate 10
RHODA YANOW, P.S.A.
Frank

pyramidal design. The green objects were placed in front, with the thin green bottle overlapping the large bottle at the left. In turn, the small liquor glass overlaps the thin green bottle, and so on. The result is a well-thought out arrangement that encompasses a pleasing variety of spatial locations. The viewer's eye is controlled in a circular rotation within the picture's frame. Each glass was given strict attention, yet none of the objects has been hidden nor were any of them separated physically from the others. This element creates a cohesive composition, further enhanced by the attention given to the negative areas as well. The objects were given sufficient room to rest in, and the spaces surrounding them are just large enough to relax the eye and not cramp the general motion of the design.

The initial drawing was accomplished with a series of contour lines, not by one individual contour, and the objects were not perfectly rendered. Dverin is certainly capable of complete linear and aerial perspective, but he chose to leave a little "breathing" space in the design.

Step Two

Immediately, Dverin set out to visualize the full range of color and value. The darkest values were painted in first. Next, the highlighted areas were indicated, not with a finished look in mind but to establish scale and dimension. Already by this point the general balance of the design had been laid out. The strokes are fresh, direct, and confident. Naturally, such an immediate approach must be tempered by an evaluation of what will happen next. The beginning student is not encouraged to work as fast as possible but to work as directly as possible.

Step Three

At this stage, the backdrop was loosely sketched in, reflections began to appear, and colors were built up in all areas simultaneously. Never was any one object given full attention or carried to completion. A continuous analysis is evident.

Figure 5.9
ANATOLY DVERIN
Bottle Stillife (step two)

Figure 5.10
ANATOLY DVERIN
Bottle Stillife (step three)

Figure 5.11
ANATOLY DVERIN
Bottle Stillife (step four)

Figure 5.12
ANATOLY DVERIN
Bottle Stillife (detail)

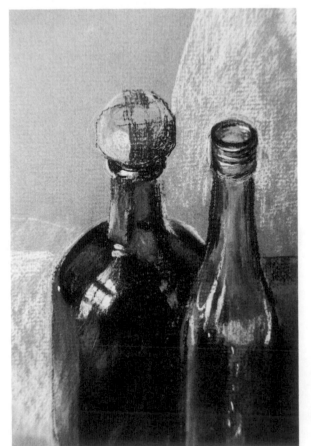

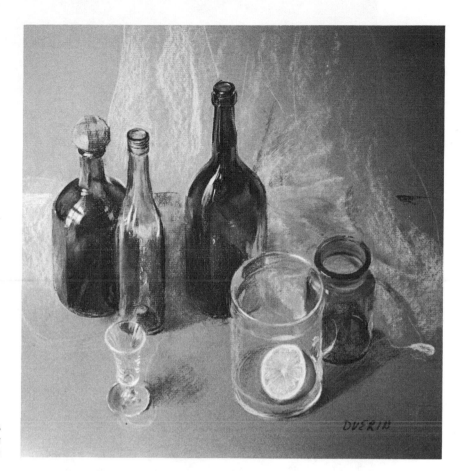

Figure 5.13
ANATOLY DVERIN
Bottle Stillife (step five)

With the addition of the lighted areas in the backdrop, the rest of the spatial plane is established, and the viewer's position is firmly set.

Step Four

As the pastel neared completion, shaded areas outside of the objects were added and details were finalized. In the blowup of the left-hand corner (Figure 5.12), we see the cap on the large brown bottle. Here, Dverin has taken full advantage of the surface texture and value. The cap looks essentially complete at a glance, yet a closer look reveals that it was left in sketch form. Wherever possible, Dverin has let the background surface remain an integral part of the design.

The backdrop was further developed in a similar manner, the Crescent board showing through in most places. By keeping the background and foreground in a minimal state, the viewer can concentrate on the central design without distraction.

Step Five

The final design was completed with the addition of small details. The reflection on the left corner bottle was finished to reveal the image of a window. Transparent color effects were drawn. A light sienna brown appears to glow within the brown bottles, and light green comes from the green jar as well. This reflection was carried outside the jar onto the cloth.

Final highlights and tonal adjustments were painted last, as some of these had to be added over preexisting colors.

Finally the pastel was matted with a four-inch border of the same gray Crescent board. The design was separated from the matting by a strip of white measuring one-half inch in diameter. This strip works quite well. The white locks in the design without overpowering it, and the large gray mat serves to rest the eye further and does not interfere with the composition.

In a final comment, this is a masterful pastel. The balance of attention given to each facet as well as to the overall design is remarkable.

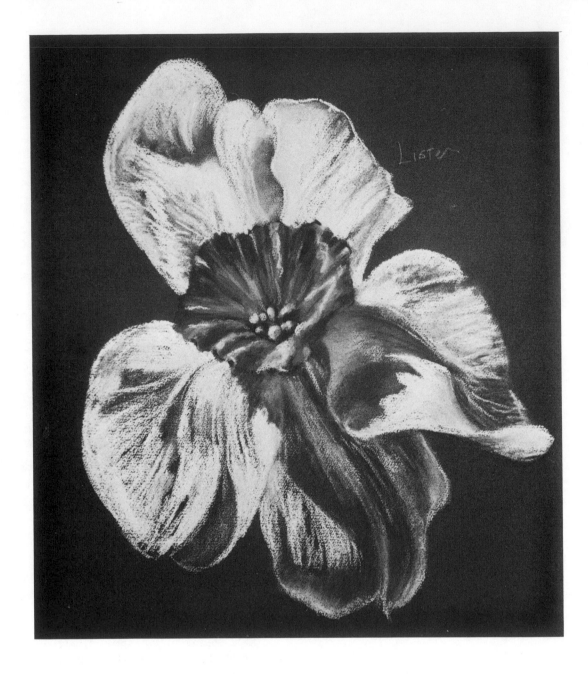

THE ARTISTIC IMAGE OF FLOWERS dates back nearly 6,000 years. The Island of Rhodes derived its name from roses that were portrayed on its coins in 4000 B.C. The Babylonians, Assyrians, Greeks, and Romans were fascinated by flowers as well. Throughout history, flowers of all kinds have had their day of glory. Perhaps the most influential peak was the tulip craze which struck Holland at the turn of the seventeenth century. This "tulipmania" was so widespread that by 1630, the economy of the Netherlands was almost totally dependent upon their sale. In 1637, a single tulip bulb was auctioned off for the equiv-

alent of $4,600. A carriage, gear, and two dapple-gray horses were even thrown in to sweeten the pot. However, that same year the bottom fell out of the tulip market and Holland was left on the brink of bankruptcy. It took years to recover.

The forty-year rise and fall of the tulip in Holland was well documented by the artists of the day. Not surprisingly, not all of them favored what was happening. Allegorical paintings showing monkeys trading tulips, or fools bargaining for them, were common.

The introduction of pastels in the eighteenth century led to new exploration of familiar sub-

CHAPTER SIX

Florals

jects, and pastels proved to be a medium well suited to floral art.

PASTEL COLOR

Capturing the brilliant coloration in flowers is often an eluding prize. Oils and watercolors each have definite drawbacks in this area. Oils tend to yellow with age, and watercolors lose intensity through dilution of the pigment with water. Pastel colors, however, can be applied directly and undergo no chemical changes with age.

The majority of pastel hues are not fugitive. An assortment of brilliantly hued sticks ranging from lemon yellow, cadmium yellow, yellow ochre, and orange through rose, cadmium red, vermillon, purple, and crimson covers the general spectrum of floral coloration. Each of these hues comes in varying strengths, and only the middle value in each range produces the maximum saturation of pigment.

The other color grouping needed are the greens. A partial list would include a light- to

dark-value range of permanent greens, chrome greens, olive greens, and blue greens. The normal assortment of browns siennas, umbers and ochres round out the general pallette. Naturally, there are blue flowers and countless other colors as well, but these lists will normally suffice. Remember, nice browns and grays may be obtained by mixing complementary colors. Red and green, for example, produce a very effective brown gray.

Soft pastels can handle the bulk of the work. Certainly the intense colors will have to be soft pastels, but adding a few semihard sticks or pencils is a good idea. They can be used for the delicate lines found in leaf veins or flower stems or the detailed work in the stamens (pollen organs) or pistils (reproductive organs). I also tend to use pastel pencils to start the initial drawing.

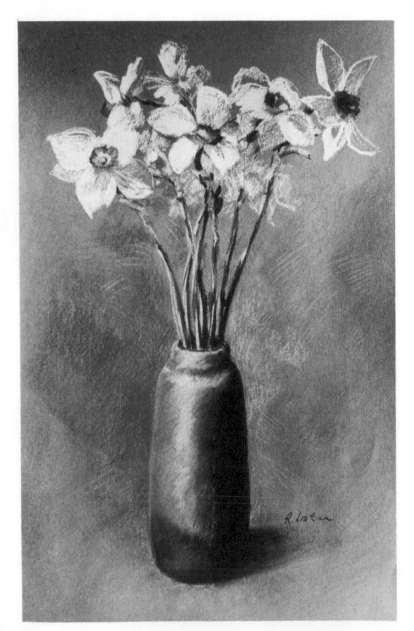

Figure 6.1
RON LISTER
The Old Vase with Narcissus

A fairly deep-toned charcoal paper proved well suited to represent the shadowed portions of the flower petals.

PAPERS

Most flowers have a delicate or smooth texture that accompanies the brilliance of color. Thus, a good grade of pastel paper will be more serviceable than charcoal paper.

I usually use a fine-grained sandpaper to sand off some of the texture of the surface. Pastel papers will still hold more pigment after sanding than charcoal papers will without sanding.

A circular or cross-hatching motion will produce an evenly sanded surface. Sometimes I leave the outer areas or foreground in a rough condition to add variety to the design.

TECHNIQUES

Basically, the same procedures apply to painting flowers as to still life, though more rubbing and blending may be required to simulate the smoothness of petals or the bleeding of colors.

Even though many flowers last for weeks, they are likely to show changes, and some may fade or die from one night to the next. Thus, it is best to work on the most transient elements first. Portions of the background, a vase or basket, can be left for later. Overall color relationships should still be established, but it is not necessary to complete the entire element. One word of caution: Bright portions of the flowers may be sketched in to capture the light or to avoid other changes, but care must then be taken to keep those colors clean. Often working on shadowed areas or on the background can cause these clean light portions to become grayed or dirtied.

MIXING MEDIA

Flowers are so numerous in variety of size, shape, and color that continued work stretches the imag-

ination beyond the normal scope of the medium. At times, it seems apparent that new techniques should be tried. Watercolors and gouache lose some brilliancy through dilution with water, but they still have a freedom of handling that pastels cannot duplicate. Wash tones can provide a quick, rhythmic, impression in minutes, and pastels can then be used to intensify and freshen the color. In "The Poppy Garden" (Figure 6.2) by Mary Hurliman Armstrong, watercolor was used extensively. Values were established, accents given, and the basic design was completed. In the later stages, pastels were added effectively. For another example of this approach, see "The Aspen Ride," also by Armstrong (Figure 7.3).

LEARNING ABOUT FLOWERS

Pastel florals can be treated successfully in a number of different ways. They can be rendered in an analytical or illustrative fashion, or they can serve to stimulate the imagination. The more complex the composition, the more difficult it is to remain purely analytical. A large assortment of flowers offers such a tremendous variety of elements that they must normally be simplified and personalized in order to achieve a degree of success. For this use, pastels are excellent. The medium is so quick that sketching and painting become one, and large arrangements or outdoor scenes can be done with flair and imagination. This does not in any way detract from the fun you can have by taking a single flower, such as in "Poet's Narcissus" (Figure 6.3), and rendering it several times its normal size. The closer you look, the more you can find. There is a fascinating universe to discover within any size or scope.

It is natural to want to express feelings through design, but I suggest you exercise some restraint at first. The more you understand flowers, the clearer your feelings about them become. The imagination is continually expanded and then fueled by such intimacy.

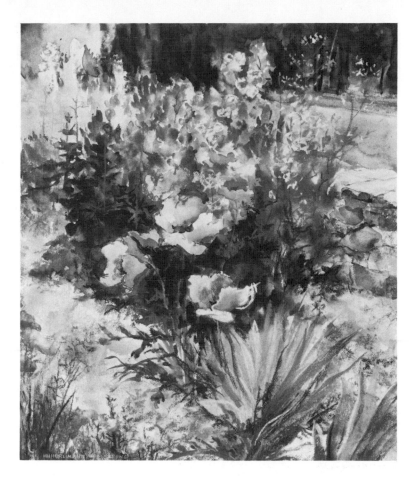

Figure 6.2
M. H. HURLIMAN ARMSTRONG, P.S.A.
The Poppy Garden (watercolor and pastel)

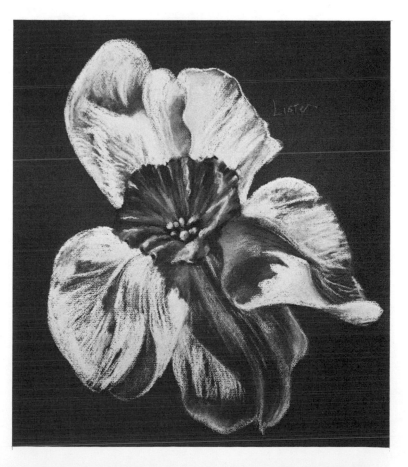

Figure 6.3
RON LISTER
Poet's Narcissus

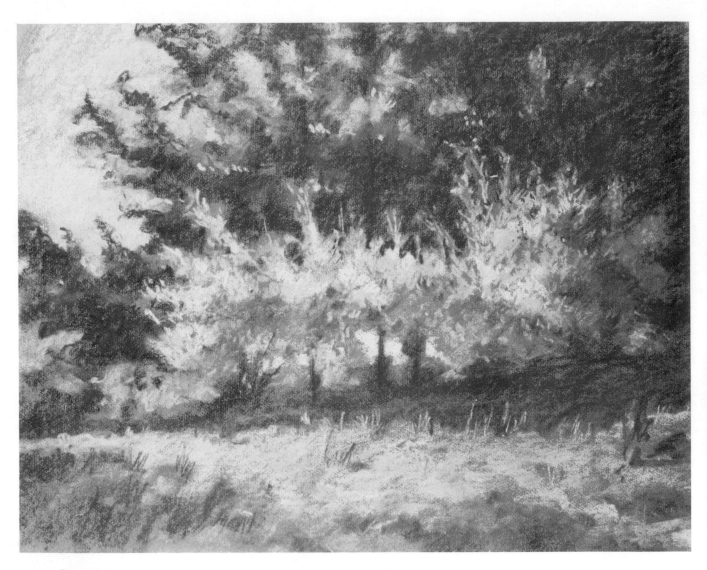

Figure 6.4
RON LISTER
Forsythia

Outdoors

BLOSSOMS

Certain trees and shrubs blossom only once a year. The magnolia tree, which is one of the prettiest of all, blooms early in April and may last less than two weeks. The bright yellow flowers of the forsythia bush likewise bloom and die very early.

I feel that April and May are the best months of the year to go outdoors and sketch. The weather is cool and the sky is a clear, cold blue. The clouds are billowy and white, and the bugs are not yet abundant (not a small consideration).

Dogwood trees blossom shortly after magnolias, and they bring a wide variety of shapes and colors to the scene. There are white, gray, and pink dogwood blossoms, and the species called Summer Star lasts as long as July.

To me, the most beautiful of all blossoms is the franklinia (Figure 6.5), or Ben Franklin's tree. Brought from Georgia to Philadelphia in 1777, it blooms in the late summer or fall. The white chalice measures only three or four inches in diameter, but it holds a mass of orange gold stamens and makes an eloquent visual statement. Franklinia trees cannot be found in the wilds, not even in Georgia. Instead, they must be cultivated in gardens and parks.

PARKS

Since I moved to Boston several years ago I have attempted to visit all the local parks and ref-

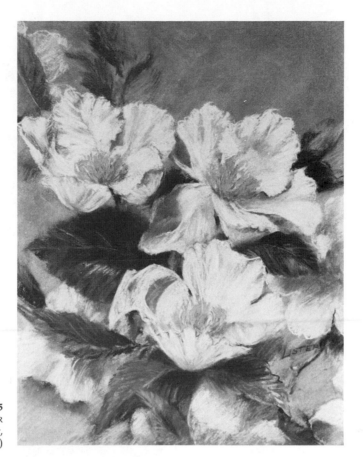

Figure 6.5
RON LISTER
Franklinia (pastel on sanded pastel paper, 14″ x 17″)

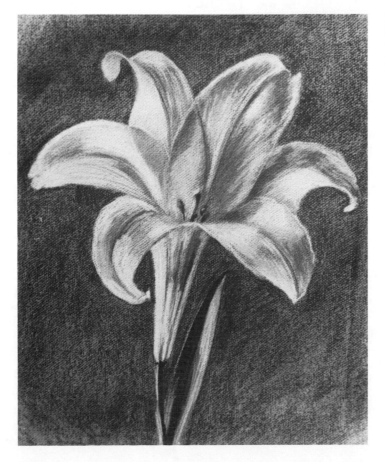

Figure 6.6
RON LISTER
Lily (pastel on unsanded pastel paper)

Note the rough grain of the paper and its integration into the design.

uges in the area. I live within walking distance of the famous Arnold Arboretum, which is owned and operated by Harvard University. Here, trees shrubs, and flowers have been brought from all over the world. They are first adapted to the local climate at the Case Estates in Weston, Massachusetts, before being transplanted to Jamaica Plain.

Besides the Arnold Arboretum, there are several other good places to sketch. The Garden in the Woods in Framingham, Massachusetts, has over 4,000 species of wildflowers on a forty-eight-acre wooded area. Most major urban areas have good parks, and many have public gardens as well. It is worth taking the time to explore them. If time is a problem, then a camera will help. Remember that no matter how good your imagination is, it is nearly impossible to dream up anywhere near the numbers of forms and color combinations that already exist. Do not take my word for it. Sit down sometime with plenty of paper and a soft pencil and try to draw as many trees or wildflowers you can think of without using a reference.

CALENDAR OF EVENTS

Here is a simplified list of floral events for most northern temperate zones:

- April: forsythia, early cherry, daphne, honeysuckle, peach, magnolia
- May: cherry, crabapple, pear, currant, azalea, dogwood, silverbell, lilac, thorn apple
- June: late lilac, wisteria, hydrangea, rhododendron, rose, amorpha
- July: linden, tamarisk
- August: aralia, shrubby althea
- September: franklinia
- October: fruit

GARDEN FLOWERS

There are a great many garden flowers. The Amaryllidaceae family contains several of the most popular ornamental plants. The most cultivated is the narcissus, a vast genus that includes daffodils, which are easy to grow. The most widely grown of all bulbs, they come in a wide variety of colors and shapes. They will grow almost anywhere and are frequently seen in the wilds.

There are too many garden varieties to discuss, but worth noting is the Liliaceae family,

which contains over 3,700 species alone. The most common variety of the Lilaceae family is the lily, which is among the oldest cultivated plants in the world. They were grown by Egyptians and Cretans and appear on art objects dating back to 2000 B.C. They are among the most symbolic forms found in art and have long been associated with purity. The madonna lily was favored by the monks of the Middle Ages, and its religious context remains intact to the present day.

Roses are perhaps the only flowers to have been interpreted more often than the lily. Moreover, they have symbolic meaning, such as love and war. They even became the emblem of Britain following the War of the Roses in 1461.

Thus, flowers are not something to be admired only. They also have far-reaching connotations.

WILDFLOWERS

The vast majority of wildflowers are too small to be well suited for pastels, at least on an individual level. But fields of them have inspired many artists. In "Poppies in a Garden" (Figure 6.7) by the American, John Appleton Brown (1814–1902), we see one of the most popular of all wildflowers. The landscape in this pastel is free from realistic convention. It has a feeling of uncontrolled interaction, yet somehow there is an underlying harmony that presents a natural appearance.

"Dandelions" by J. F. Millet deals with one of the least popular subjects in floral art. Millet must have found something here he wanted to record. Perhaps he felt that ugliness is in the eyes of the beholder.

Indoors

Painting indoors offers advantages similar to those discussed in the last chapter. Lighting and other physical conditions can normally be better controlled.

HOUSEPLANTS

There are abundant houseplants suitable for use. One of my favorites is the African violet, which originated in Tanzania. They are easy to grow, and if treated properly, they will bloom for months on end. The different varieties include

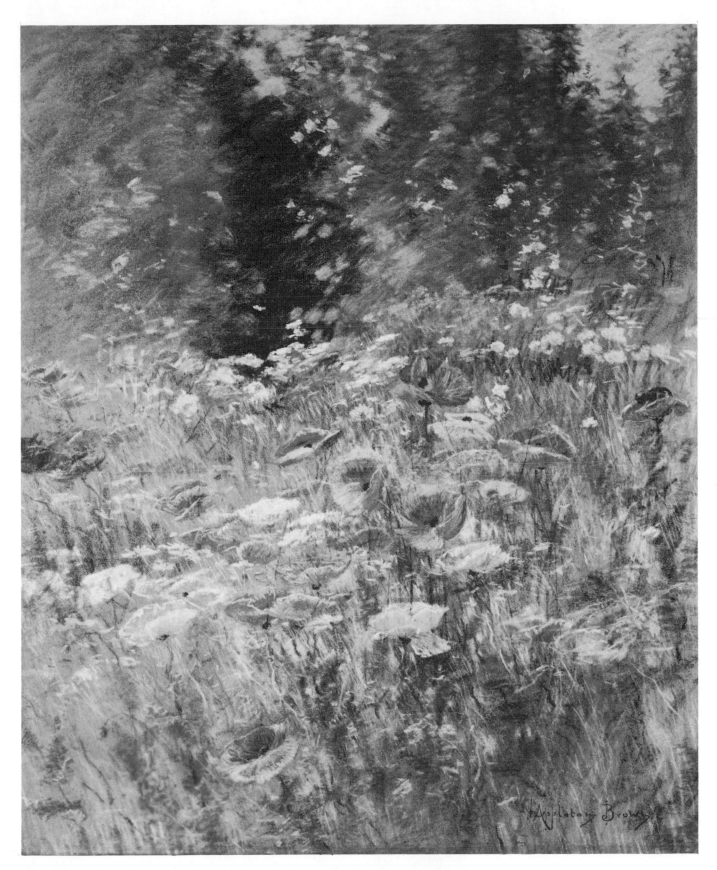

Figure 6.7
JOHN APPLETON BROWN (American, 1814–1902)
Poppies in a Garden
Courtesy Isabella Stewart Gardner Museum, Boston

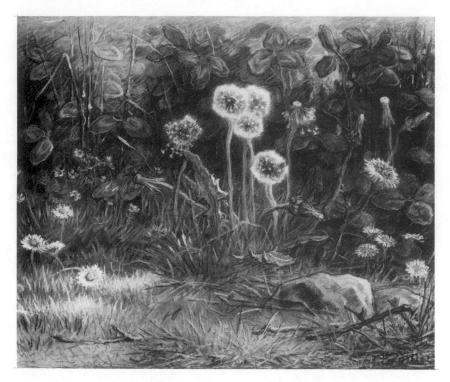

flowers that are pink, white, mauve, and purple. There are also bicolored flowers.

In Figure 6.9 I chose a dark blue-gray pastel paper on which to paint some bicolored African violets. The flowers are purple and white, so the dark background helps to add depth and contrast to the design. I had a good bit of fun with this setup. I simplified the flowers quite a lot and tried to extend the contrast of light and dark that was already created by the morning light.

CUT FLOWERS

Cut flowers can be separated into groups, each in a different vase or pot, or they can be arranged as an assortment within a single container. Redon's "Vase of Flowers" (Figure 6.10) shows a

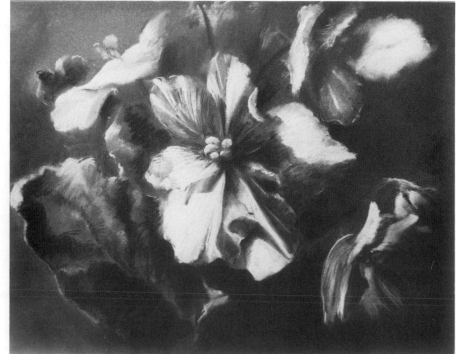

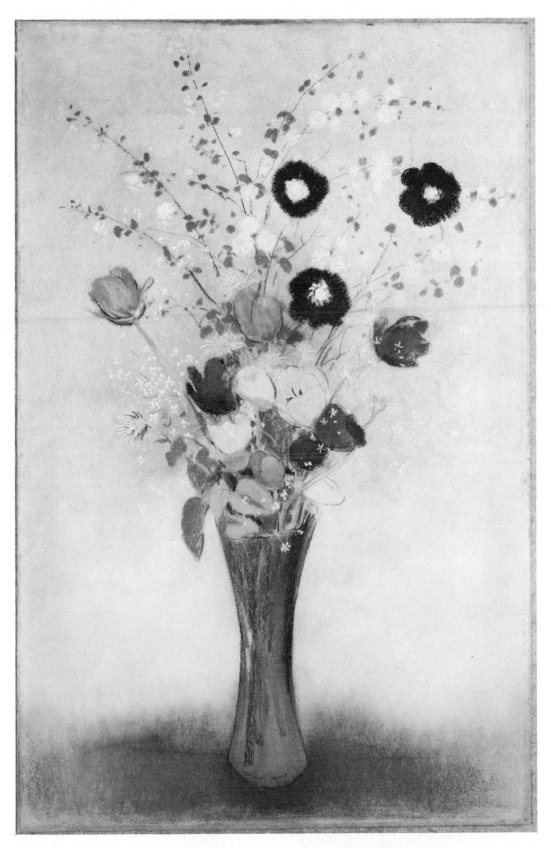

Figure 6.10
ODILON REDON
Vase of Flowers (36⅛'' x 23⅞'')
Courtesy Cleveland Museum of Art (Leonard C. Hanna, Jr. Collection)

delicate linear design that has been drawn over a subtle backdrop. The size of the support is large—over three feet in height, allowing for a graceful flow within the design surface. Nothing looks worse than a cramped bouquet with a disproportionate use of space. Redon grouped the

tulips together to give weight to the center. The rest of the floral then fans out in a fluid motion. The heart of this composition lies in the placement of the individual elements. The flowers were not arranged symmetrically but were balanced by position and color. In fact, symmetry in floral de-

Figure 6.11
ALDEN BAKER, P.S.A.
Flowers in Design

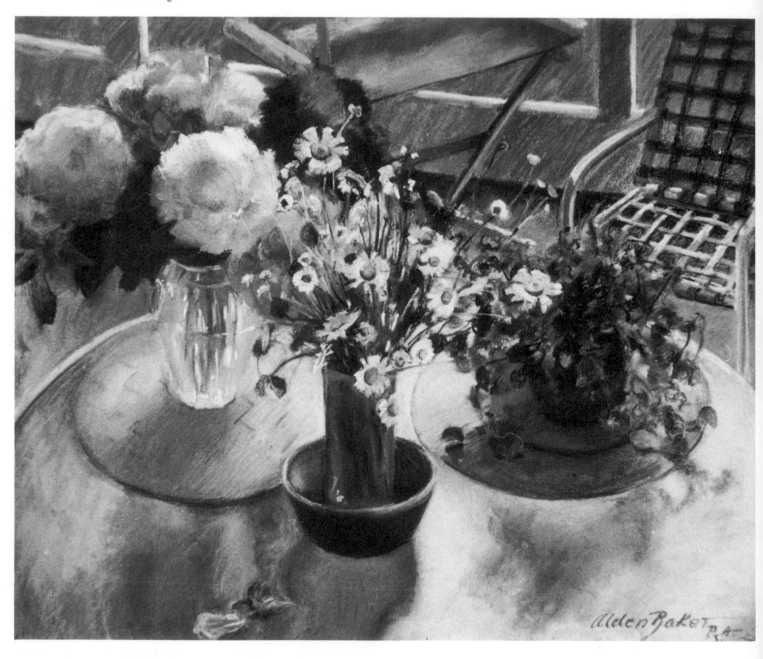

signs is often deadly, and time should be taken to compose each element carefully.

Of special interest in "Vase of Flowers" is the simplicity of the application. Redon presents a two-dimensional spatial plane on which only basic flower forms are pictured. No attempt was made to analyze or record detail. Instead, the love of shape and color served to inspire the artist into making a direct and easily accessible statement.

COMPOSITION

It is safe to assume that the majority of single vase designs are likely to be vertical compositions and that groups of flowers may often be horizontal. Here are two such compositions: "Flowers in Design" (Figure 6.11) and "Flowering Ash" (Plate 2). These are both well-organized arrangements by Alden Baker. The viewpoint in each case has been established well above table level. In this manner, the curve of the table is a compositional device, used to control the viewer's eye movement.

Any curve, straight line, or form that leads the viewer's eye away from the design will cause problems. The viewer's eye is controlled by several other devices besides the table. The mums in the left corner form a curve leading into the design, and the direction of the chair on the right side also does the same.

There is a refreshing division of space in both of these compositions, and Alden's use of color in "Flowering Ash" is refreshing as well. The color is handsomely subjective in nature. The cold blue tablecloth adds weight and depth. White flowering ash divide the design in a diagonal, and the red tulips further compliment the blue from below. Both the curves and the diagonals serve to form the structure of this interesting composition.

DEMONSTRATION 3: "Arnold Roses" by Ron Lister (Plate 7)

Generally, roses are among the more difficult flowers to render, especially the modern hybrid varieties that we usually see. I prefer the older rose and the wild rose because of their unstructured appearance.

The Arnold rose was developed in 1889 at the Arnold Arboretum. It is a shrub rose that blooms in midsummer. The chalice is formed from many loosely formed petals, with yellow-gold stamen in the center. One beautiful aspect of this rose is the off-white halo that surrounds the stamen.

Step One

I chose to work horizontally and to use a diagonal ascension of flowers and leaves as the main compositional device (Figure 6.12). I sometimes feel that nature's organization cannnot be matched, that almost any viewpoint or cropping method would yield a satisfactory composition.

I decided to use a full sheet (26 by 20 inches) of pastel paper. A warm gray was chosen because it matched some of the shadowed areas in value and tone. The surface was sanded and brushed, and a white pastel pencil was used to draw the initial layout. I started with the rose just to the left of the center and tried to establish a size that would allow for the inclusion of about a dozen flowers. The general pattern of the roses was first put down and leaves were then sketched in. With a rough contour drawing to go by, I then filled in the deepest tones. These were roughly sketched in to indicate the overall relationship of values. Raw umbers, burnt umbers, mars violet, and a dab of black were used. The lower middle area was designated to be the darkest value, and the upper portions to be the lightest. Some values were also indicated in the leaves and petals. The same colors were used.

Step Two

Olive greens, chrome greens, and permanent greens (middle and dark values) were then used to sketch in the shadowed parts of the leaves (Figure 6.13). Lighter-toned sticks of the same greens were used to indicate roughly the full range of the leaf coloration. The colors were sketched in over the preexisting browns.

Simultaneously, I began to use the reds, first madder lake deep, carmine, and permanent red deep. The cup centers where the stamen form had to be left untouched. In certain places a mixture of dark crimson and gray was put down to denote

Figure 6.12
RON LISTER
Arnold Roses (step one)

Figure 6.13
RON LISTER
Arnold Roses (step two)

Figure 6.14
RON LISTER
Arnold Roses (step three)

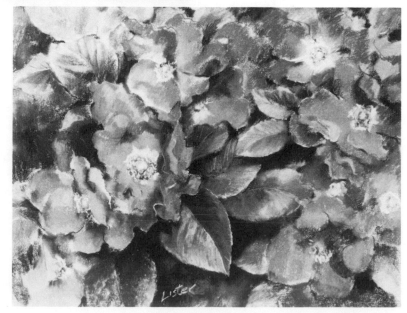

where the light could not filter through the stamens.

The design was expanded in all directions. Flowers, leaves, and background were worked on together. The center areas were refined the most. I wanted to present a two-dimensional plane that would fill the entire surface, but I did not want to treat all areas equally. Thus, I left the outlining portions in a slightly unfinished state.

Some of the highlights were then added and shadows deepened, which became the final measure of overall coloration and value. Most of my effort to this point had been given to overall unity. Now I began to concentrate more on temperature contrasts and subtle hue variations.

Step Three

The final stages (Figure 6.14) included lightening the top portions of leaves with yellow ochres and soft greens. The background was also lightened with burnt sienna light and yellow ochre. The leaves were given full detail, and reds and browns were "dragged" into them.

The stamens were drawn in, using yellow, ochre, and orange. The petals were accented with permanent red light and deep rose in some of the lighter areas. Colder reds and a touch of violet were added to a few of the deep shadows.

The details of leaf veins, stamens, and the yellow white halos were added. Finally, deep crimsons and reds were mixed in with some of the background colors to indicate the existance of more flowers beneath the surface. Likewise, deep greens were added.

No attempt was made in this pastel to capture all the detail of the forms. Liberties were taken from the start. Several roses were excluded or simplified, and all the details were subordinated to keep the overall feeling. My goal was to bring out the design elements inherent in what I saw (see Plate 7).

SUMMATION

Painting good florals is a somewhat trying experience but well worth the effort. One of the major difficulties encountered is balancing detail with strength. By this I mean that it can be difficult keeping stems, stamens, leaf veins, and so forth in their proper perspective. Often, stems become too heavy, stamens too bright or too large, and leaf veins too noticeable. These tendencies can be curtailed with a concentrated effort. As with all subjects, standing back frequently and viewing the pastel as a single unit is a major step toward success.

SUGGESTED VIEWING

Here is a partial listing of some of the most admired floral artists:

Albrecht Dürer (1471–1528) was born in Nuremberg, Germany, and worked primarily in watercolor. He was a keen observer of all life forms. He painted flowers, animals, even insects, with penetrating accuracy. Today, his style is considered illustrative, but his approach was so intense his personality still shows through.

Jan Brueghel was born in Brussels in 1568. He lived most of his life in Antwerp but traveled back and forth to Brussels to copy flowers in the archduke's gardens. His paintings are typical of the northern countries of the time. The flowers are silhouetted against dark backdrops and are very lush. Compositionally, the details may be naturalistic, but the design and effects explode toward the viewer in a more expressionistic manner.

Henri Fantin-LaTour (1836–1904) came from Grenoble, France. He was a friend of the Impressionists but worked in his own plodding way. He liked to record likenesses and did not incorporate any of the younger generation's ideas into his paintings. He used dark backgrounds rather than dark over light, which is what the Impressionists were implementing. Nonetheless, his flowers are still very beautiful to look at. He was popular with the bourgeois society of his day, but today his work is largely overlooked, partly because of the nature of the rest of his works—portraits and allegorical themes. These are by any standard incredibly dull and uncreative. But, ah those roses. . . .

Odilon Redon (1840–1916) needs no further comment except to say that almost all his floral subjects were handled with pastels and easily represent the most creative effort in this area.

THERE ARE FEW THINGS I enjoy more than painting outdoors, but it took a while to develop this feeling. At first, it was difficult to make the adjustment from the studio to the open air. Wind, rain, heat, and insects are variables that have to be dealt with outdoors, which can be frustrating even to the experienced artist. However, the scales are more than balanced by the many positive factors involved, one being the close communion with nature.

I especially enjoy the birds and animals, who gradually accept my presence and resume their business without a fuss. This isn't just an aesthetic appreciation; it is also an objective one.

When the animals are relaxed, they can be observed in their natural state. In this way, knowledge, appreciation, and respect for nature can mature together.

The most important thing to remember is that you should not be intimidated by your first attempts at working outdoors. There is a wealth of visual information that simply cannot be dealt with on a grand scale. Even choosing a subject may be difficult at first. Settling for an impression rather than trying to faithfully record nature as it is brings more satisfaction. Unfortunately, I know several artists who work only in their studios because of a bad first experience outdoors. They

CHAPTER SEVEN

Working outdoors

never got over the initial problems they encountered, problems that can be overcome in time, without much difficulty if two things are used—good practice methods and good equipment.

EQUIPMENT

Preparing to sketch outdoors is in many ways similar to preparing for a camping trip or a long hike. It is important to bring everything that is absolutely necessary and to leave the things that are not. It takes energy to transport yourself and the

equipment, and it takes even more energy to set it up. So it is best to conserve as much of that energy as possible for the actual sketching. I have gone out on some muggy summer mornings only to find that by the time I was ready to begin, I was totally exhausted. Since then, I have learned to bring only what I need and to have a good idea of where and what I want to sketch.

Easels

The most important item is a good easel. A good outdoor easel is usually different from a good in-

Figure 7.1
RON LISTER
Ruins in Northern Spain (pastel and watercolor on illustration board)

door easel, and usually one type does not suffice for both. For outdoors, a light easel that folds up and can be carried with relative ease is absolutely necessary. In Chapter Two, I mentioned that I use a Russian-made easel similar to one called an Anderson, Gloucester, or French Carry Easel. This type has a wooden box that folds to include pastels and paints. These carry easels have folding aluminum or wooden legs, and they function much like a camera tripod. They also have metal clamps or attachments to secure a pad or canvas. The greatest advantage in this design is the distribution of weight. The box formation has a low center of gravity, and the legs are pointed so that they can be firmly planted in the ground.

Cheap aluminum easels that do not include a built-in box are not well suited for outdoors. Although they are light and can be transported easily, they do not stand up well against the wind.

Accessories

Because I usually prefer to sit, I bring a small aluminum folding chair (Figure 7.2) with me. I try to fit the other items in one large canvas bag: paper towels, a throw-away garbage bag, a thermos, and a camera if needed. Anything smaller, like pencils, paint, or tape, can fit into the carry box along with the pastels.

I wear a straw hat when I paint, not only to cut down the scope of vision but also to keep the sun out. In the summer, I often stuff the inner rim with folded paper towels to absorb sweat. There is usually sufficient shade in New England, but if you live in the Southwest or West, you may need to bring a portable umbrella similar to the one discussed in Chapter Two. Remember, it is important to keep the paper's surface out of direct sunlight while you are working.

Figure 7.2
Russian carry easel.

Palette

YELLOW

A good range of yellows is necessary because it helps to limit the amount of white used to lighten other colors. Of course, there are many direct uses for yellows as well. Cadmium yellow or yellow light are the purest hues and closest to primary yellow. Lemon yellow is cooler and lighter and complements yellow light nicely. Naples yellow is an *off*-yellow, and yellow ochre light and gold ochre light are good yellow browns.

RED

Reds are sometimes a problem in that the brightest of them often appear too dark or lack a desired temperature. Permanent red light is a fairly pure hue, closer to an orange than a red. Permanent red deep is close to a primary red. For cooler reds, madder lake deep, allzarin crimson, rose deep, and red violet offer a strong variety. For reddish brown tones, burnt sienna or venetian reds are good.

BLUE

Ultramarine blue middle is closest to a primary blue. It can be mixed well with both warmer- or cooler-toned sticks. Phthalo blues and blue greens are good cool blues, and blue violet and violet make up the warmer tones.

The family of blues are generally the best colors for mixing with white, gray, or black. They retain more of their original character than most other hues.

BROWN

Again, burnt siennas provide good warm tones. Raw sienna is less saturated and the umbers, raw and burnt, are very different. They are low in intensity and are not overly handsome when used alone. However, they are good for mixing, reacting almost as gray does.

Of the lighter browns, gold ochre deep is a richly toned color and can be used alone or in mixing.

This list represents an assortment of ready-made browns. Mixing your own browns will be necessary at times. Richer tones can be mixed by using more saturated sticks, such as ochres and siennas. Also, a mixture of the three primary hues, or a combination of complementary colors, will yield brown or gray brown. I prefer to mix my own browns whenever possible.

BLACK, WHITE, AND GRAY

Limit the use of all achromatic sticks. Black has a very strong influence on all colors, and a little will go a long way. Pure black is seldom found in nature, so mixing your own warm or cool gray blacks is helpful.

White is deadly. It is often used to excess, and it dulls and changes most hues dramatically for the worse. It is also a problem when pastels are photographically reproduced.

Grays are needed in most pastels, but they are seldom totally natural. Try to avoid using those neutral grays straight from the box. Most of nature's grays are either warm or cool, taking on the tone of surrounding hues.

I hope that by this time you have already experimented with black, white, and gray with a variety of different colors. Seeing what happens to each hue is better than any description I can give.

GREEN

Greens are secondary hues arrived at by mixing blues and yellows. There are good pure greens to choose from as well. Permanent green light and deep, phthalo greens, chrome greens, and olive greens comprise a nice range in temperature. However, some olive colors and chrome greens lack intensity because of the amount of chalk they contain. One solution is to mix a pure green, such as permanent green light, with a warmer, richer hue, such as ochre or yellow orange. This mixture will give you the desired temperature without sacrificing brilliance.

OBSERVING NATURE

Selecting a subject is a task that becomes easier with experience. On first occasions, too much time and effort are often used searching for a special view. Ideal visions are seldom found. In fact, landscape artists are apt to make more compositional adjustments than painters of any other subject that comes to mind, especially when confronting a heavily wooded area or open countryside. Sometimes, objects must be simplified, reshaped, or deleted. Seldom does one view offer all that is needed in precisely desired amounts. For a comparison between vision and impression, I have included a photograph of the view used as a demonstration in this chapter (see Figure 7.12).

Viewfinders

To help limit the scope of vision, a viewfinder can be used. These were more popular in the past than at present, but they are helpful and should be at least considered. To make your own, cut approximately a four-by-six inch rectangle out of a larger sheet of gray or brown cardboard. Hold the larger piece a foot or so in front of you and view only the scene that is cropped inside the cut-out rectangle. This is a simple device to block out extraneous information.

Viewing the Subject

Before discussing specific treatment of subjects, here are a few general comments.

Try to approach all subjects as simply as possible. Do not become involved in trying to simulate subtle variations or minute details. Instead, look for basic shapes, values, and colors. When viewing trees, do not think about individual leaves. Concentrate on the general aspects of the form. Where does light reflect? Where do shadows group? What is the general color tone and temperature?

If you have trouble seeing this way, try squinting, which helps to blend elements together.

Values

Recognizing correct values outdoors is more difficult than in the studio. First attempts are likely to

Figure 7.3
M. H. HURLIMAN ARMSTRONG, P.S.A.
Aspen Ride (watercolor and pastel)
The pastel here has been used primarily to accent colors and to give added detail. Note the different textural effects between the media.

lack overall contrast, and specific elements tend to be overdramatized. Tree trunks and branches are often given too much importance.

Being outside adds considerable depth to the vision. In order to simplify, values must be categorized by some method. Try to pick out the most significant spatial planes by applying aerial perspective. Combine general distances together as well as overall groupings of elements. This device will help localize the general colors, tones, and values.

General Colors

Proper color comes only with proper observation, which means letting the eye overrule the mind. Thinking that trees are green and water is blue and clouds are white is a real setback. Water is clear and has no color; trees are infinite in color and tone; and clouds reflect surrounding sky coloration. Each element is so individual that common mental associations are insufficient. A reasonable compromise between the wealth of individual characteristics viewed and a generalized mental attitude must be reached.

The key to understanding and dealing with outdoor color is a return to the basics. Ask yourself if this color needs to be lighter or darker, warmer or cooler, more or less intense. The best part of this process is that once you have memorized the basic color contrasts discussed in Chapter Four, you will not have to ask anyone but yourself for the answer.

Spatial Considerations

Establishing an optimum viewpoint is essential to any good composition. The most obvious "don't" involved is dividing the space into equal halves. Any other division is more interesting. Cutting the space into thirds works very well, either two-thirds land and one-third sky, or two-thirds sky and one-third land.

This same proportion works well for vertical and horizontal elements alike. It used to be called the *golden cut* and was a popular formula in landscape painting at the turn of the century. In "The Peek-A-Moose Falls" (Figure 7.4) by Albert Handell, the falling water separates the design into such a division.

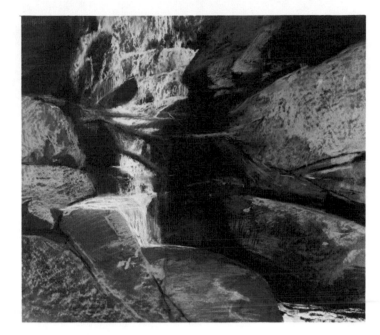

Figure 7.4
ALBERT HANDELL, P.S.A.
Peek-A-Moose Falls (pastel on sanded pastel board, 24" x 24")

Other than the *golden cut*, the basic law of composition is still to keep the viewer's eye interested within the picture's frame. In landscape painting, rivers, streams, paths, snow packs, rocks, trees, roads, and so on should normally lead into the heart of the composition. But remember that the shortest route is seldom the best for a design. A stream that winds gracefully into the design is more interesting than one that cuts through like an expressway. In this way, nature's own course is generally adequate, and minimal construction is needed. Do not be afraid to exercise your power as an artist either. If the natural curves found do not look natural, change them.

CENTER OF INTEREST

It used to be that every painting had to have a center of interest, a focal point where the heart of the subject would take command over the design. Other areas were often subdued to accommodate this singular task, and it was definitely the acceptable method.

In today's art, variation from the old principles is considered only a misdemeanor. There have been great paintings since the time of Cézanne that have strayed in this area, but it is also true that many compositions have failed for this very same reason. Take each pastel as it comes. If the view needs interest, develop some, but do not add things for the sake of adding them.

75

Let the scene remain natural in appearance and not look contrived.

BALANCE

I have never been convinced that elements should be arbitrarily added to a composition for the sake of balance or for interest. There are too many other ways to set the scales right. Adding an object may be the easiest way to balance a composition, but there are many solutions to consider. By studying the basic color contrasts discussed in Chapter Four, you can discover several valid ways of achieving similar effects.

A small spot of intense color can offset much larger areas of less saturated color. Likewise, a small area full of detail and interest can be balanced by a larger area or areas of less complexity.

The formal interplay of visual elements can range from the obvious to the highly complex and subtle. Cézanne devoted decades of work to seeking out a method of structuring his compositions that would transcend the visual plane; often this involved setting highly complex elements in a delicate balance.

We do not have to be concerned with such goals, but it is good to know there is a variety of choices available. Take advantage of them when you can. Try to avoid being predictable.

Time of Day

Morning is perhaps the most popular time for sketching outdoors. It is probably best to wait

Figure 7.5
RON LISTER
5 O'Clock Shadow (pastel on charcoal paper, 13″ x 17″)

until the sun is well up before you begin. Early morning is similar to late evening, when the sun's rays saturate the atmosphere and changes occur rapidly.

I also enjoy working in the late afternoon. In "5 O'Clock Shadow" (Figure 7.5) I was struck by the diagonal shadow line that fell across the trees. The brilliant fall colors added an extra dimension to the picture by extending the range of contrasts.

Working in the middle hours of the day is fine if shadows are not essential to the design. Try to utilize shadows as a compositional device wherever possible. The basic rule is to let the shadows fall into the design, not outward, leading the eye out of the composition.

I have cautioned against painting very early or very late in the day because of time restrictions, but Monet discovered a good way to handle this situation. He simply brought two or three canvases with him each time and worked on each canvas for only a short period of time.

He would return the next day at the same hour and continue with the paintings in the same order. His series of studies involving haystacks or the façade of Rouen Cathedral are the most famous examples of this method. He also applied this style to painting a branch of the Seine which ran near his home at Giverny and to the little wooden bridge and lily pond in back of his house.

Seasons

FALL

There is considerable variety in the seasonal changes throughout the country. Some areas have four noticeable seasons, whereas others are less dramatic. I recently met a person who impressed me with her awareness of seasonal variations near her home in Key West, Florida, where the shift of time is most subtle.

New England is quite different. Here, fall colorations are appreciated the most. Yet each fall brings a variety of conditions all its own. In "5 O'Clock Shadow" the colors are brilliant because of the good weather we had that year. The following fall was not so beautiful. We had a lot of rain and the foliage never reached expected peak colorations. Thus, my painting, "Larz Anderson Park" (Plate 4), lacks the same intensity of hue.

A recurring problem in rendering fall foliage is the tendency to overstate the intensity of hue.

All landscapes involve shadows and need gray or neutral hues. Try to look for these grays in all landscapes.

SPRING

Spring is my favorite season, but as much as I love the clear air and fresh coloration, there are two minor drawbacks worth mentioning. The first is the wind, which may interfere with the delicate nature of pastels, and the second is the cloud cover. Driven by the wind, spring clouds are often numerous and large and they can alter the light every five minutes.

SUMMER

Summer offers long daylight hours, little rain, and full foliage. It also offers heat, humidity, smog, and insects. When you are painting, especially at dusk, insects can be a real problem. On some evenings a can of insect repellent can be more valuable than a can of fixative.

My only reservation about summer is the haze that filters through the atmosphere. This haze is sometimes caused by different atmospheric conditions, but more likely it results from air pollution. The blue or gray haze can smother out detail and color and create a false sense of depth.

WINTER

Pastels may alter your thoughts about going outdoors in winter. Unlike watercolors and oils, they do not need to be mixed or diluted, so you do not have to worry about freezing pigments.

Some artists use thin gloves with the finger tips cut off to keep warm. Little hand warmers used to be popular, but I think this is a bit dangerous. One option I have tried is working from within my car. With pastels, it is relatively easy to do. I tried it a few times with my oils but wound up painting part of my dashboard.

"Snow Scene with a Barn" by the Norwegian, Fritz-Johan Fredrik Thaulow (1847–1906) is a beautiful impression of winter. The wisps of snow blowing around offer a special visual effect. Detail and color are somewhat lost, but this loss is compensated for with strong value contrasts. The light snow against the darker wooden structures creates a dramatic tension that has been fully appreciated. The positive and negative areas are well balanced, and the overall design is simple, allowing these forces to work without interference.

Figure 7.6
FRITZ-JOHAN FREDRIK THAULOW
Snow Scene with a Barn (19⅜″ x 27″)
Courtesy Museum of Fine Arts, Boston (gift of Misses Aimee and Rosamund Lamb)

Specific Subjects

TREES

There are two major groupings of trees: deciduous, those that defoliate during winter, and evergreens, which do not. Within each group are countless species and an infinite variety of forms and color, a variety far too complex to record sufficiently in the mind. Sketching is the most adequate way of learning about trees, and winter offers the best time to do it.

In winter, because deciduous trees have lost their leaves, their skeletal structure can be observed. Evergreens are also more visible because there is less obstruction from defoliated trees.

Figure 7.7 shows two quick sketches of a white dogwood drawn only one week apart. The first pastel reveals much of the tree's structure, with only a few mature blossoms. The second sketch shows the same tree at peak strength, just a few days later. Figure 7.8 was sketched at approximately the same time as the second white dogwood. This tree is quite different in form and general feeling from the white dogwood. Its use in a design would have a markedly different effect.

Figure 7.7
RON LISTER
Two Studies of a White Dogwood Tree

These sketches were made approximately one week apart.

Figure 7.8
RON LISTER
Pink Dogwood

DEMONSTRATION 4:
"Larz Anderson Park"
by Ron Lister

This demonstration is in five parts, with a photograph of the actual scene included for comparison (Figure 7.12). The approximate time needed to complete the work was just over two hours.

Step One

A full sheet of warm gray charcoal paper was chosen for this impression, and a very simple linear sketch was first made. The water line was drawn approximately one-third of the way up from the bottom. Most of the other two-thirds were left for the trees. It was planned not to include the sky.

Step Two

The darkest values were sketched in along with some of the lighter greens (Figure 7.9). A small sample of the full color range was put down to serve as a scale for the overall development of the picture.

The time of day was late morning, so shadows did not play a very important role. I felt that the rolling bank and the reflections would give enough help to the composition.

Figure 7.9
RON LISTER
Larz Anderson Park (step two)

Figure 7.10
RON LISTER
Larz Anderson Park (step three)

Step Three

The entire surface was then worked on simultaneously, with quick, short strokes (Figure 7.10). This was not a particularly good fall, so my choice of pastels was more limited than in previous years. The greens consisted of permanent green light and dark, chrome greens, and olive greens. Yellow ochre, permanent red light, and light yellow were used, as were siennas, umbers, and permanent red deep. The sky was kept simple, with only phthalo blue light and cobalt blue light and a little white mixed in. No black or neutral grays were used.

A major change between steps two and three was the addition of a deeper spatial plane on the right side of the design. This change helped open up the view and gave it more interest.

The left side was then filled in, eliminating the tree skeleton that was first indicated in step one. This elimination was made so that the background foliage could be attended to without having to work around the foreground tree. Likewise, I wished to work the trees back into the design freely over the existing backdrop without breaking up the strokes.

Step Four

More details were added (Figure 7.11). The reflections in the water appear, and the trees on the left reappear. The sky was developed to encompass the tree line, and an evergreen was added in the right-hand portion for contrast with the yellow tree in front. There actually was a small evergreen in the vicinity; I simply enlarged it and

79

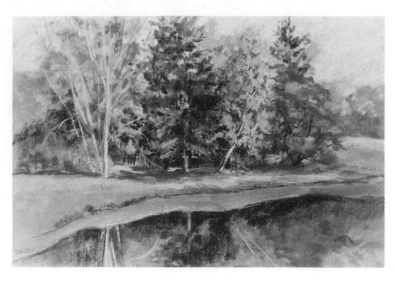

Figure 7.11
RON LISTER
Larz Anderson Park (step four)

Figure 7.12
Photograph of Larz Anderson Park by Ron Lister

gave it more importance. Branches, tree trunks, and leaves were given slightly more prominence as well.

Step Five

The final step shows the completion of the sketch. The foreground trees were highlighted and detailed, but little attempt was made to refine the picture. A realistic representation was not sought, only an impression.

After the pastel was finished, a photograph of the actual landscape was taken, showing how many liberties were taken with the actual view. First, I narrowed down my field of vision considerably, incorporating less sky and water. I also left out much of the detail reflected in the water. The large central tree was reduced, whereas the little evergreen was enlarged. There is still a variety in the tree line, but I tried to give a more unified appearance by bringing the different sizes closer together.

The barren trees can be seen only in the extreme far left of the photograph. They were moved considerably to fit in.

These are some of the basic alterations—moves that were deemed necessary to the overall feeling I was seeking.

Figure 7.13
ALBERT HANDELL, P.S.A.
Yankee-Town Pond (18″ x 24″)

WATER

Clear water is totally transparent. It reflects whatever coloration is near. Water with a dark floor will appear black, whereas water with a light sandy floor will naturally appear lighter.

I often like to paint by the Muddy River in Boston, which is truly deserving of its name. The colors vary from gray to brown or to greenish brown. The stream is not wide, and trees block most of the direct light. As a result, blue is reflected only in a few places. This particular coloration forces me to use my eyes more and to allow for a refreshing difference in the palette.

Do not confuse reflections with shadows. If a yellow orange tree is reflected by water, its image will be yellow orange. Only the degree of intensity is slightly lessened. When the water has a dark floor, even the intensity of the reflected color isn't lessened, which creates a true mirrorlike effect.

Probably the hardest water effects to imitate are the ripples caused by wind and currents. When a ripple is created, the water's surface becomes three-dimensional and reflects light accordingly. One side may reflect what is positioned nearby, whereas the other side of the crest may reflect the sky or another direction. Often the result is a pattern of light and dark.

These patterns would not be so difficult to observe except that they are caused by forces in motion and are thus moving with them. The best way to learn more is to make quick sketches, waiting for patterns to be repeated.

ROCKS

Rocks are as individualistic as most other natural elements. They come in all shapes and forms, not generally oval or pebble shaped, and some are worn from wind and water. Actually, these do resemble pebbles, but most are sharp edged or jagged and have an opposite character.

If the rocks are a vital element of a design, then close attention to particular features is necessary. In "Peek-A-Moose Falls" (Figure 7.4), Albert Handell has given the rock formations a broad variety of strokes and textures because of their essential role in the composition.

CLOUDS AND SKY

Cumulus clouds are the most abundant forms in the sky and the most three-dimensional of the cloud forms. Because of their low altitude, they reflect many color tones. Cumulus clouds move by rather quickly and often must be finished from memory. Clouds change their shapes rapidly as well, so concentration on general features is recommended.

Figure 7.14
RON LISTER
Storm Clouds (pastel on mounted pastel paper, 19″ x 24″)

Making quick sketches of cloud formations is helpful. Photographs can be used, but they tend to flatten the field of depth and destroy the perspective of the actual scene.

The first thing we normally learn about painting sky is that it gets lighter closer to the horizon and the sun's light. Care should be given to picking the correct color tone and value. Incorrect values can flatten a design. As for tones, there is a great deal of difference between the cold blues of the Northeastern states and the warm blues of the West and Southwest. Likewise, there are major differences between winter coloration and spring and summer coloration. Try and differentiate the temperature and intensity of the sky tones in each pastel and utilize what you see to give a more specialized impression.

Note the Western sky tones used in "Mt. Watkins" (Plate 9) by Mei-ki Kam. This picture was begun with a thin wash of acrylic on a masonite board. Then, soft and semihard pastels were used over the wash. It definitely reflects Western colors.

Although the sky looks essentially flat in character, try not to treat it as such. Rubbing the pastel in until a smooth surface is created is not helpful. Try to handle the sky in a similar manner as that used in the rest of the picture. Look for the unity of all natural elements.

If the sky gives you trouble, look at its treatment in some of Monet's, Sisley's, or Pissarro's paintings.

CHOOSING STRUCTURES FOR SUBJECTS

Using architecture in a design is a fairly common practice, but one that I often feel is not thought out enough. The major consideration is whether or not there is something personal to express in rendering the subject. Some particular structures present a special problem in this area. In Ohio, I was taught that barns were great to look at but difficult to personalize. Because of their familiarity and popularity they were taboo subjects, not to be painted. I have discovered a similar situation involving sailing vessels. There is an overabundance of them in New England, and with that in mind, I have resisted painting any such ships.

On the objective side, sailing vessels, barns,

or for that matter, any subject, can be justified under certain conditions. If your motive is purely artistic or if you have a particular insight, then no doubt you can transcend this problem.

Buildings

Linear perspective plays a large role in drawing buildings, as incorrect drafting will present major spatial problems. Adapting a "safe" viewpoint or vantage point may be helpful at first.

Values and shadows are also essential aspects to consider. In "Venice at Noon" (Figure 7.15) Americo DiFranza has fully utilized both elements.

This composition presents an intimate view of one of the many small canals of Venice. It is unpretentious as a pastel, and yet to me it has all the eloquence of the more familiar grand views of the Piazza di San Marco.

The bridge is set only slightly off-center, which ordinarily would not be an interesting division of space. However, DiFranza has masterfully overcome this problem with a clever use of shadows, light, and color. The building on the far left is almost in full shadow and represents one separate spatial plane. The next building in from the left is almost completely out of view, but it has the lightest value in the design, giving it an important role in the overall composition. The central grouping includes more color with a more intricate division of space and serves well to attract the eye. The buildings to the right of the center are in full light, in marked contrast to those on the left.

If we divide up the space in this picture, we have at least four major divisions, each of which offers a variety in color, value, or form. The result is that when viewed in its entirety, the composition is neither static, nor uninteresting.

Finally, note the good use of all the linear angles in the composition. Not only does the perspective of the buildings lead into the design but so do the shadows in the upper left and the shadows reflected in the canal.

Houses

Houses, in composition, are normally limited in size and importance, but they need not be. "House in St. Cloud" by Alden Baker singles out

Figure 7.15
AMERICO DIFRANZA, P.S.A.
Venice at Noon

Figure 7.16
ALDEN BAKER, P.S.A.
House in St. Cloud

one older type of farmhouse as the subject. Linear perspective, division of shadows, and a dramatic use of light and dark contrast are all combined effectively. The strokes are quick and clean, leaving fresh impressions.

EXERCISE

Imagine how different "House in St. Cloud" would appear if it had been drawn at a different time of the day. To learn more about using shadows to your advantage, take a limited number of pastels and sketch a fairly interesting house or building early in the day. Give special attention to the shadows and overall values. Once or twice, later that same day, return to the same spot and repeat the sketch. Each time, the shadows caused by the complexity of the structure will probably reveal a different effect, which will probably give the sketch a different feeling or impression.

USING MEMORY AND IMAGINATION

This book often stresses painting what you see. At numerous times, I have pointed out the advantages of careful observation. In time, some of the knowledge learned from observation will become stored away in the memory and can then be recalled when needed. I am always afraid that students will skip the first leg of this artistic journey and move on too quickly. I am convinced that most great artists who worked from memory and imagination were well trained as students to observe and record. James Whistler took notes, made sketches, and even asked for impressions from others before he returned to his studio to work. Albert P. Ryder, one of America's greatest marine painters, worked entirely from memory. He had a friend who was a sea captain, and on trips to Europe, Ryder would accompany him. He was not in the least interested in European art or artists, but instead he would stand on deck each night and observe the sky, clouds, and sea. His small seascapes made from these memories are among the most inspiring paintings I have ever seen.

Degas, too, painted from memory extensively, often paying his models to keep moving constantly while he observed and made mental notes.

Certain visions are products of impression and expression at the same time. "Sinai Summit" by Berta Golanny (Figure 12.12) is a subjective landscape inspired by a trip to the holy land. The impression is one that combines what is seen with what is felt.

Figure 7.17
JEAN-FRANÇOIS MILLET
Farm Yard in Winter
Courtesy Museum of Fine Arts, Boston (Shaw Collection)

SUGGESTED VIEWING

John Constable (1776–1837) was a famous landscape painter and contemporary of Turner. Although his large oils such as the "Hay Wain" represent some of England's most celebrated paintings, his smaller, less formal sketches impress me equally as much, especially his wash studies of clouds and sky.

Jean-François Millet was often content to paint or draw subjects that others were normally uninterested in. "Farmyard in Winter" (Figure 7.17) pays close attention to a commonplace scene.

Also one should see the works of the seventeenth- and eighteenth-century Dutch and Flemish landscape painters such as Jacob Van Ruisdael (1628–1682) or Jan Vermeer (1632–1675), whose "View of Delft" is one of the most remarkable paintings in all art history. Holland is a land built from what was once the sea, and it has extremely flat terrain. Because there was always so much sky, Dutch painters became very responsive to its changing faces and much can be learned from their studies.

THROUGHOUT HISTORY, the figure has remained the most challenging subject in art. By the time pastels were introduced in the eighteenth century, Watteau, Boucher, and the other great Rococco painters were already in the habit of using colored chalks for figure studies. Mostly, these were preliminary tonal sketches for larger oil paintings, and chalks had proven to be well suited to the task.

With the invention of pastels it appeared likely that they would replace chalks and enlarge the process to include more color. Except for a few exceptions, this was not the case. Only in portraiture were pastels immediately adopted as a medium for *finished* works. Sometimes, the portraits were large enough to include the full figure, but only for ornamental reasons and not for the love of the form. In fact, very few nudes were painted at the time.

The first serious nude studies began a century later with the pastels of Degas, and to a lesser extent, Cassatt.

Degas's chief aim was to explore the body in motion, which was also his purpose when he stud-

CHAPTER EIGHT

The nude

ied ballet dancers and race horses. He emphasized muscular activity, choosing not to present the usual nude fashionably draped in fat. His models were often sketched while bathing or drying, and his viewpoint was innovative, even shocking, for the times.

In "Le Tub" painted in 1886, Degas has taken an unconventional viewpoint, in this case, looking down on a bather, who is bending over. A wonderful play of light dances through the entire picture: through the drapery, the tub, and the floor, as well as the figure. This type of setting was distasteful to the art connoisseurs and to the public as well. Particularly irritating was Degas's habit of minimizing facial features, or in this case, leaving them out completely.

Mary Cassatt's approach was more conventional. Her subjects were infants and mothers, and her compositions were sentimental enough to be popular. Yet Cassatt was a thinking artist and many of her aims were lost to the public. She had a genuine interest in movement and chose to paint babies for the special problems they brought to this area. Like Degas, she became a master at

Figure 8.1
FRANÇOIS BOUCHER
Reclining Nude (chalk)
Courtesy Museum of Fine Arts, Boston

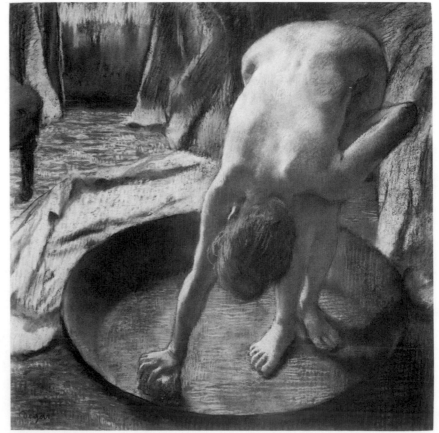

Figure 8.2
EDGAR DEGAS
Le Tub
Courtesy Hill-Stead Museum,
Farmington, Connecticut

using angular and curved forms together. "Baby's First Caress" (Figure 9.4) reveals her successful technique and also her ability to use straight strokes to depict curved forms. This is most noticeable in the legs of the baby.

PARTICULAR ADVANTAGES OF PASTELS

Pastels are a great medium for either sketching or painting the figure. A linear or tonal approach is equally possible, and the two styles can easily be combined. Because they are dry, pastels can be worked and reworked without the usual waiting period. The freshness of directly applied pigments often gives a spontaneous appearance that is rich in color and vivid in application.

This combination of capabilities—linear, tonal, full color or monochromatic, quickness, and spontaneity—are unsurpassed by other media.

SURFACES FOR SKETCHING

A study, sketch, or fully developed painting all rely heavily on the surface on which they are done. This idea has been discussed previously in Chapter Two, but the figure requires a second look.

For sketching, I suggest using a toned paper. A gray, green, or blue with a middle value is the most useful because these tones are normally found in the shadowed areas of the nude. So, instead of starting with a white background and establishing all the values from scratch, start with the middle range and work out in both directions. In a sketch, the background tone can often be left uncovered by pigment. This idea may be difficult to grasp at first, so do not be frustrated if you find that the areas you have worked over eventually match the background tone that was there in the first place. This is a trial-and-error process and the only way to avoid the unnecessary application of pigments is to recognize the situation before it occurs. I do not know of any shortcuts.

Strathmore and some other manufacturers

sell pads that consist entirely of one shade of gray or green, and there are at least two sound reasons for using them. The most important is to limit the background to one tone, making the trial-and-error process a little quicker. It is then unnecessary to test how each color will react with each different surface. In a way, each sketch becomes a continuation of the previous one.

The second consideration is purely economical. Good pastel papers cost two or three times as much as charcoal or sketching papers, and the advantages that pastel papers offer are not generally necessary for simple drawings. Besides, working on expensive surfaces just for sketching can be a little intimidating. Sketches are usually best when they are loose.

Figure 8.3
BERTA R. GOLANHY
Untitled Nude

SURFACES FOR MORE "PAINTERLY" PASTELS

Pastels built up with pigment can be put on most surfaces, charcoal and sketching papers included. The only disadvantage may be the amount of pigment that these thinner papers will hold, especially if there is reworking. Pastel papers are soft and heavy. They accept more pigment and also retain their initial character and freshness when reworked. Areas that need corrections will still appear texturally the same as before.

There is no reason why middle-toned surfaces are not equally as good for painterly pastels as they are for simple sketches. White surfaces are still the most difficult to work on regardless of artistic aim.

Boards, canvases, and other surfaces can be used as well. There are varieties especially made for pastels, but they may have more of a tooth than desired. It is best to reserve their use for special occasions, mixed media, perhaps.

VALUES

Many problems associated with first attempts at the nude concern contrast as much as color. More precisely, it is a lack of sufficient contrast that affects beginning works the most, and painting on a gray stock will not alleviate this problem. A full range of lights and darks must be observed and recorded in order for the figure too appear lifelike. Of course, this statement does not pertain to those who wish to work in a two-dimensional graphic style. The graphic approach is perfectly valid, but one must be certain to avoid combining three-di-

Figure 8.4
ALBERT HANDELL, P.S.A.
Portrait of Gayla (on pastel sanded board, 24″ x 30″)
The initial tones were blocked in with casein and were finished with pastel.

mensional aspects in the same pastel—which results in an awkward appearance that is neither pleasing nor convincing.

If contrasts remain a problem, try to sketch on an even darker surface. This will allow you to concentrate on more values in a single direction instead of having to work simultaneously in both directions.

COLORS

Determining the warmth or brightness of a particular hue is a relative question. Each element can be measured only in relation to other surrounding local elements. One skin tone may appear warm against a cool background, but the same tone may appear cool if placed over a background that is warmer.

Similarly, intensity and value must be measured by comparison also. It is up to the artist to set the levels of these contrasts. Generally, the more pigment that is used, the more dramatic the effect. Try not to be overly cautious at first. Artists who are new to the medium find it hard to let go and really press down on the stroke. Even though half-developed sketches may appear to be what you are looking for, try to experiment further.

The basic color palette for painting the figure need not be too extensive. A well-chosen assortment can effectively limit the number of sticks needed. It is wise to place a limit on this number, at least in the beginning. The human figure can contain and reflect countless color tones, but as I have maintained previously, it is best to start out slowly. Try to achieve most of the work by contrast of values, which along with a little mixing of pigments can achieve most desired results.

A basic list of colors would include the following:

- Yellows: lemon yellow, cadmium yellow, yellow ochre light, naples yellow
- Reds: cadmium red light, madder lake light, permanent red, yellow ochre deep, burnt sienna, rose
- Blues: cobalt blue, ultramarine blue middle
- Greens: olive green, permanent green, viridian
- Browns: raw umber, burnt umber, venetian red

- Others: blue gray, warm gray, dark gray, black and white

If you can afford to, it is recommended to have these colors in a variety of strengths or values, but if not, mixing with white and black will suffice. This method of mixing achromatic and chromatic pastels perhaps works better in figurative subjects than in others.

LIGHT

Making good use of available light can be very important. If contrasts are presenting a problem, multidirectional light can soften the effects.

Basically, there are three types of light to look for: highlights (which are directly reflected from the surface), halftones, and reflected light (which is seen only in shadowed or halftone areas). Whatever the source, try to account for the range and degree of the light that you see and simplify only when necessary.

POSING THE FIGURE

The human figure can be posed in a countless variety of ways, but for the purpose at hand, we can classify all the various positions into four fundamental actions (standing, sitting, reclining, and moving). Of all these, the standing pose allows for the easiest and most direct measurement of true proportions. The most important consideration is to avoid a stiff presentation. This can be accomplished by paying attention to the overall distribution of weight. It is more difficult to accent gesture lines when the figure's weight is evenly distributed on both legs. Shifting the weight toward one leg tends to create a more fluid and natural appearance.

The reclining position is not as easy to draw as it may appear. The body is seldom straight enough for easy measurement of proportions. Perhaps the best method for measuring both the reclining and seated figure is to divide the body into four or more equal sections and assign reference points.

The seated pose creates some interesting

Figure 8.5
ALBERT HANDELL, P.S.A.
Standing Male Nude (18" x 24")

effects. The figure can be placed in a variety of interesting positions, especially with the use of props. "The Red Ribbon," by Flora B. Giffuni (Figure 8.7), makes good use of such a device. The gesture of the figure has been exaggerated nicely by placing the weight of the upper body directly upon the prop. However, accenting the body's gestures can be difficult at times. This seems especially true when the model is seated in a chair. Take care to find the best angle for both the placement of the figure and for yourself, and to slightly exaggerate the angle of any visible gesture lines. This may help to keep the gesture active when the figure is reduced in size in your drawing.

For me, the action pose is the most interesting but the most difficult position to draw. However, the countless number of possible positions can be approached in three basic ways. First, the body can be drawn quickly with an animated gesture. Second, the action can be studied or sketched and later painted from memory, as Degas often did; and third, photographs can be used. Photographs are good for learning correct muscular and skeletal positions but generally lack any feeling for actual movement. A camera will simply freeze all action into a precise frame and will not accent any of the looseness necessary to imply movement.

Figure 8.6
ESTHER GELLER
Untitled Nude (pastel on middle-toned paper)

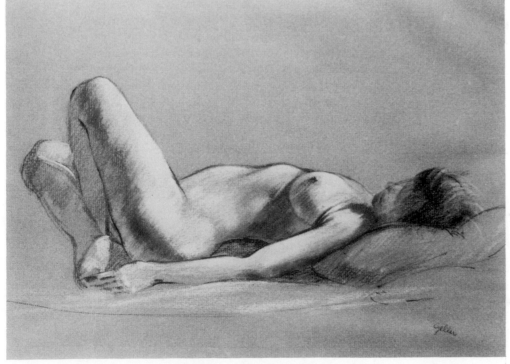

92

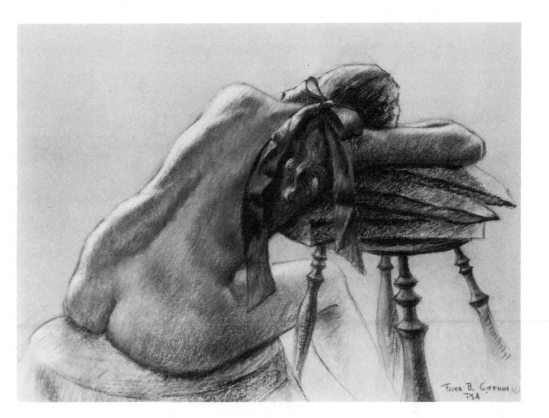

Figure 8.7
FLORA B. GIFFUNI, P.S.A.
The Red Ribbon (pastel on Canson
pastel paper, 18" x 24")

Note the importance the spinal
column plays in the gesture.

The body can also be captured in three basic positions: just before motion, in mid-action, and during follow through.

Figures caught in mid-motion are off-balance, or more precisely between balance. A moving figure with its weight evenly balanced is unconvincing. Some great painters of the past have had problems with this. David and some of the other Neoclassical painters in France, and Arnold Bocklin and a few of his German Romantic contemporaries, did not sense the necessity for placing the moving figure off-balance, and the results were varying degrees of consistency.

DEMONSTRATION 5: "Reclining Nude" by Esther Geller

There must be as many ways to approach the nude as there are individual artists. With pastels, each different technique brings with it results that are for the most part characteristically unique. This demonstration can best be described as a minimal tonal sketch or drawing. Many of Geller's pastels are more "painted" in style and rely on mass and tone almost exclusively. This one, however, has linear elements as well.

Geller is a devoted student of the figure. She works dilligently, filling up pad after pad of sketches. She prefers to use sketching paper rather than heavier pastel papers, and she normally draws on a middle-toned gray or green stock.

Geller is a firm believer in drawing from the live model. She uses quite a variety of pastels, many of which are homemade.

Step One

The first impression of the nude was drawn in lightly with two Othello pastel pencils (Figure 8.8). The darker line is burnt umber, and the lighter line is cadmium red light. The burnt umber was used primarily to indicate the body's form and gesture, and the red pencil was used to sketch in the material underneath.

Next, a stick of sandalwood, which is close to venetian red in character, was used to develop the shadows in the figure. In this first step, note that care was taken to leave the middle values of the figure untouched and that the application in the shadowed areas was also kept to a minimum. If these tones are applied too heavily, the visual transition between those areas with pigment and those without will appear unnatural, especially in the fringe of the pigment areas where the uncovered surface begins to assume visual priority.

93

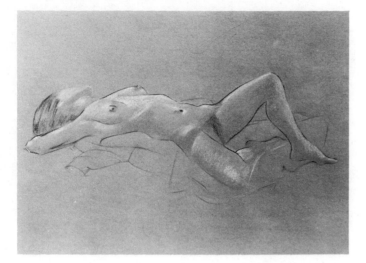

Figure 8.8
ESTHER GELLER
Reclining Nude (step one)

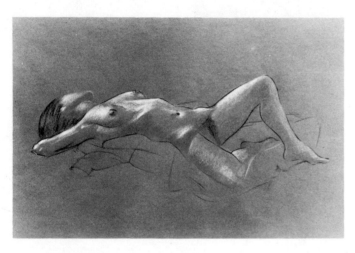

Figure 8.9
ESTHER GELLER
Reclining Nude (step two)

Figure 8.10
ESTHER GELLER
Reclining Nude (step three)

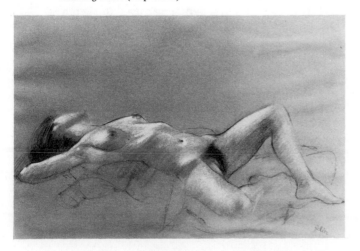

Step Two

As the drawing developed (Figure 8.9) the same sandalwood pastel was further used to indicate the basic rhythms and movements by using the sides of small broken pieces rolled over the surface.

Geller used a variety of different pigments, including soft and semihard pastel sticks and Conté chalk leads. At this point, she used a white chalk lead (made in Czechoslovakia) because it comes to a fine point. She then laid in the highlights with the white chalk lead.

Step Three

Next, the lightest and darkest portions were indicated (Figure 8.10 and Plate 8). The white chalk lead was softened by applying soft white pastel. This step was taken because of the harsh nature of the chalk leads.

Only in the final stages were other colors introduced. In this sketch, only pink, yellow ochre light, and burnt umber were used. With these three colors and the sandalwood previously applied, the middle range was built up. Note that even here, care was taken not to lay in too much pigment or to cover up the bare portions of the surface.

The contour of the figure was accented with a dark brown Conté chalk lead; lighter lines were also given more emphasis.

The pastel, left unsprayed, was then matted and put under glass.

This sketch was completed with a minimal amount of actual pigment, but it was given a great deal of forethought. The delicacy and freshness of such a drawing are not necessarily the result of quick sketching. Careful premeditation was essential with each stage, because once any part of the surface was covered with pigment, it could no longer be retrieved.

MALE AND FEMALE FORMS

The male skeletal structure is somewhat larger than that of the female, carries less fat, and is more muscularly developed.

Female forms tend to be more rounded and

less angular, and general features are softer and more delicate. Bones are smaller, especially the hands and feet, and the shoulders are more refined and the collarbone less pronounced. The neck is longer and less muscular as well. Also, the Adam's apple is less visible.

Perhaps the most noticeable difference between male and female is the hip. The female waist is considerably higher and the hip bones much wider, which affects the lower portions of the body. The male, with narrow hips and only a slight curve, appears to be more bowlegged.

RENDERING HANDS, WRISTS, AND FEET

The hand is a remarkable mechanism with amazing flexibility. The mobility of the thumb played a large role in human development. The hand and wrist are a complex ensemble of twenty-eight small bones. It is no wonder that artists' fear of them is so widespread. Some artists try to hide the hands in subtle ways or simplify them, whereas others study them repeatedly. Learning how the hand hangs freely and how it grips is a start in the right direction. But for now, remember that hands are only a small part of the figure and need not throw overall progress off-course.

Feet also tend to be a problem for artists, but at least they are not as difficult to render as hands. They contain nearly as many bones as the hands do but are not as mobile. The action is more a rotating or pivoting kind. There is no joint as versatile as the thumb, which helps to limit the number of positions.

Because blood flows downward toward the extremities, hands and feet have a deeper tone than do the other areas of the body. Veins and blood vessels lie nearer to the surface. There is little fat to shelter them, so they are more pronounced.

THE TORSO

The trunk is the bulk of the body. Most major organs are held within or just below the rib cage. Interestingly, the only structure that connects the ribs and upper body to the hip and lower body is the spinal column. When drawing the figure from behind, you can best observe gesture by viewing the line of the spinal cord (see Figure 8.11). From the front, the middle of the rib cage can be used for dividing the form and measuring gesture.

THE HEAD

Most figures begin with the head, which helps to establish size and proportion. The placement of the head should be well thought out because it will determine how well the surface area will be utilized. Try to visualize the full gesture from the neck down and see where the head can best be put.

I feel the most productive way to interpret the head is to consider only the general features:

Figure 8.11
ESTHER GELLER
Male Nude

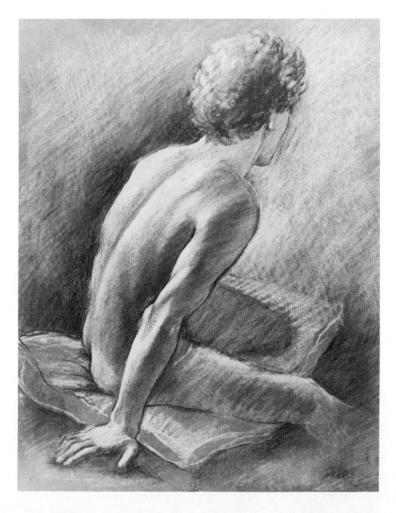

light and shadow, mass, and basic hue. A good figure drawing does not need a fully drawn head.

The best way mentally to approach drawing the head is to think of the entire cranium as one solid unit, the eye sockets being the only major deviation. The mandible or jaw is the only moving addition, and it hangs from just below the lower part of the ear.

How Important Is the Face?

My answer is, not very important. I think of the face as a mask that hangs from the cranium. Proper placement of the eye socket, nose, and mouth are fairly important, but specific features are not.

Figure 8.12
BERTA R. GOLAHNY
The Embrace

Golahny's pastels are done on large sheets of handmade papers from Israel. The sheets measure over three feet in length.

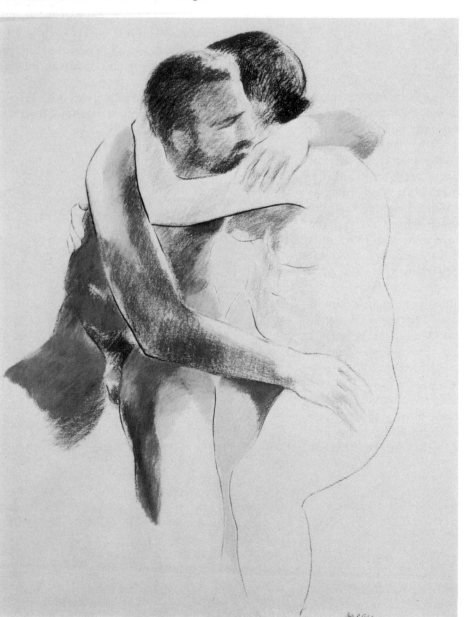

Careful attention to eyes, lips, teeth, and so on is usually ruinous to a pastel, especially soft pastels which are not well suited for such detail. Besides, closely depicting the face involves expressions, and that is a whole new dimension. The task at hand is hard enough, so try to keep these features out of the picture. If you cannot resist, remember that from twenty feet away or even less, eyes are not bright blue and lips are not bright red. More essential to the face are the shadows in the eye sockets and below the nose, lips, and chin. These shadows are more important than even local color.

ARMS AND LEGS

The role of arms and legs is to balance the figure. When rendering the body in a standing pose,

keep the legs under the figure with the proper weight distribution. When the seated position is used, look for the similar role that arms play in balance.

HAIR

Hair is fun to draw and it does give interest, but trying too hard can throw a pastel off-target. Look for the overall play of light and shadow. Keep those highlights where needed and do not become absorbed by the detail of individual hairs. If only hairs are drawn, the head will flatten out spatially. Value and hue contrast are essential in giving the head a three-dimensional appearance (more about this subject will be discussed in the next chapter).

Figure 8.13
ALBERT HANDELL, P.S.A.
Mary

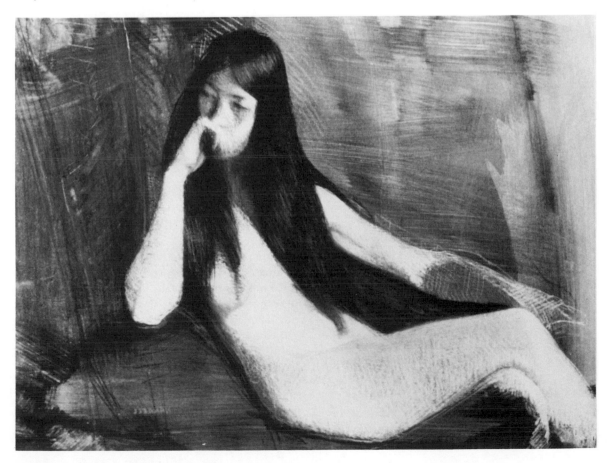

LITTLE HAS BEEN WRITTEN about painting the clothed figure, although there are special problems involved which deserve attention. Here is a simple method of approaching the subject.

FOLDS

Folds play an important role in the painting of clothing. Smaller creases or wrinkles are considerably less significant and can either be suggested with minimal effort or deleted all together, depending on the procedure.

First-hand observation is a good approach to the subject. Simple setups, which can be made on your own, will clarify the relationships among light, shadow, and colors. Sketches can be made of almost any article of clothing, from a crumpled towel to an overcoat thrown over a chair. But the best method is to draw clothing while it is actually being worn. Only this exercise will help you develop an understanding of how materials conform to the body. Look for those places on the body that support clothing; the shoulders and hips are

98

CHAPTER NINE

The clothed figure

the most prominent areas. From these support areas, clothing tends to hang freely or to follow the flow of natural curves.

Another way to study folds is to visit museums. Many artists have made studies of the clothed figure. Some of these are finished works and can be seen directly in a museum's permanent collection, but most are not "finished" and do not command prime viewing space. Museums just do not have the facilities to hang most studies or sketches, which are usually relegated to back rooms or to drawing and printing departments.

In truth, about the only disappointing event during my research for this book was the discovery of so many pastels (and some great ones) tucked away in obscure places. Seeing works by LaTour, Chardin, and even Degas in private rooms is both exhilarating and frustrating at the same time. Museums are generally polite about showing pastels to interested students, especially if you stress an academic concern.

The most often repeated mistake in painting folds is to get caught up in detail and to lose sight of the basic proportions. Too often each fold is considered independently of another. Also, the artist has a tendency to paint folds larger than life,

Figure 9.1
ABRAHAM BLOEMAERT (Dutch, 1564–1651)
Standing Figure (chalk)
Courtesy Museum of Fine Arts, Boston

In Bloemaert's sketch only the central folds have been rendered. Lesser creases have been deleted.

which causes an eventual shortage of space. Normally, large concessions to the actual vision are made in the late stages, in order to complete the picture. Remember that it is the major folds, properly proportioned, that indicate movement, gesture, and body support. Do not bother to draw less important wrinkles. They can be indicated at any time without close rendering.

In "Travelin' Man" by Rhoda Yanow (Figure 9.2), a solitary figure is boldly silhouetted against a light backdrop. Important folds are emphasized, wheras smaller ones are only suggested. Smaller creases were indicated by shortened strokes, small color and tonal modifications, and subtle contrasts in value. There is a real art to giving the impression of a fully observed form. In this pastel, a strong combination of both subjec-

tive impression and close observation helps to convey verisimilitude.

TEXTURES AND PATTERNS

Smooth textures reflect more direct light than do rough ones. The highlights on such a surface are therefore greater, which affects the overall contrast of values. For example, see "Portrait of Jean-Charles Garnier d'Isle," by LaTour (Figure 1.2).

Some rubbing and blending are usually required to depict very smooth surfaces, especially when the surface tone is not sympathetic to the color you wish to use. There are other instances when blending techniques are useful as well, for example, on commercial graphics or when one is trying to produce the effect of smooth hair or fur in animal sketches.

Patterns are fun to work with, but it should be remembered that they reflect light and fall into shadow no differently than any other surface.

Figure 9.2
RHODA YANOW, P.S.A.
Travelin' Man

Figure 9.3
RON LISTER
Nanu's Funeral (watercolor and pastel on watercolor paper)

A somber feeling has been maintained with the use of dark values and muted colors.

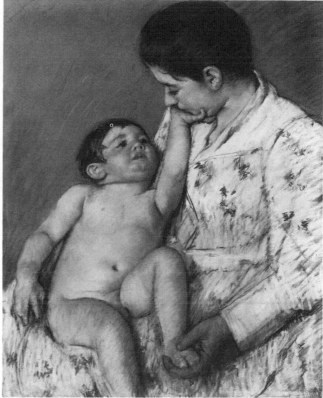

Figure 9.4
MARY CASSATT
First Caress (30″ x 24″)
From the collection of The New Britain Museum of American Art (Harriet Russell Stanley Fund)

Note the exceptionally loose but effective handling of the patterned clothing.

Patterns that are reproduced stroke for stroke in an even manner will tend to flatten out the spatial plane, and probably tire the eyes as well. Do not be afraid to take liberties in this area. A few well-chosen strokes can often suggest an entire pattern, and a suggestion is generally all that is required. This technique leaves room for the imagination and actually adds interest to the design.

"Baby's First Caress" (Figure 9.4) by Mary Cassatt is a fine example of a pattern being indicated rather than copied. Only in a few places is a repeated pattern well defined. Shadows obscure most of the pattern's color texture and overall detail.

Try to keep all patterns in their proper perspective by avoiding overmanipulation.

COLOR AND LIGHT

Not ony patterns but also local colors should not be overly dramatized. Artistic compromises must be made in order to maintain the proper ratio or balance. Even soft pastels cannot reproduce the exact effects of the most brilliantly saturated materials.

In addition, remember that even extremely bright materials fall into shadow, as do all materials. The use of gray is just as necessary here as in any other pastel.

SHADOWS

Shadows can help create drama, give definition, or lend structural support. In "The Seamstress" (Figure 9.5), by Rhoda Yanow, they play a decisive role by giving direction and weight to the design. Sharp contrasts between the seamstress and the dummy work as essential compositional devices by dividing the space in an interesting manner. By overlapping light and dark areas and by superimposing the dummy in front of the worker, the artist has defined further spatial depth.

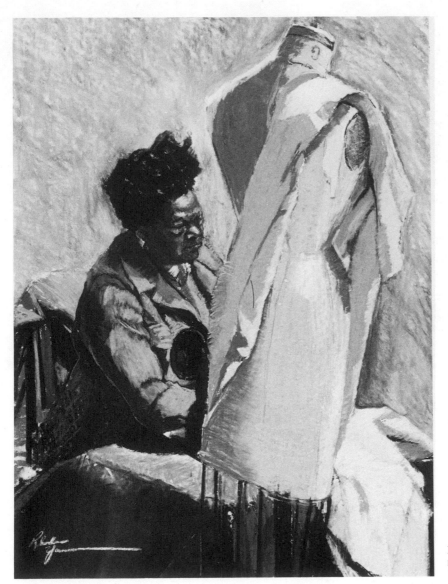

Figure 9.5
RHODA YANOW, P.S.A.
The Seamstress

I tend to think of shadows as grays with a little color or tone in them, not as colors that are grayed. Look at the shadows on your surface. If the first thing you see is a color, brown, blue, or any other, then you are probably using too much color. Remember that shadows should support lighted areas, not compete with them.

GROUP COMPOSITIONS

Painting several figures is naturally more complex than painting one, but with simplification it is not an impossible task.

Whenever two or more figures are put together, a certain interaction takes place. In the heavily expressive paintings of the Norwegian, Edvard Münch, figures are often totally alienated from one another. This too, is an interaction, though quite opposite in character from the typical loving ensembles found in a Renoir or Cassatt.

Different still is the way in which Degas handled such compositions. Sometimes he became absorbed in the feeling and aspirations of his ballet dancers, but often he was only interested in the action of the group as a whole. Note the fluctuation in feeling between "Dancers Resting," in which all gestures from head to toe accent the feelings of the two dancers, and "Danseuses Roses," which is a straightforward play of colors,

Figure 9.6
EDGAR DEGAS
Two Dancers
Courtesy Museum of Fine Arts, Boston (given by Mrs. Robert B. Osgood in memory of Horace D. Chapin)

This sketch is a typical example of Degas's loose manipulation of form and color. Here texture, pattern, line, color, and composition all share equal ground. The subjects are almost secondary.

Figure 9.7
EDGAR DEGAS
Dancers Resting (50 x 58.5 cm.)
Courtesy Museum of Fine Arts, Boston
(Juliana C. Edwards Collection)

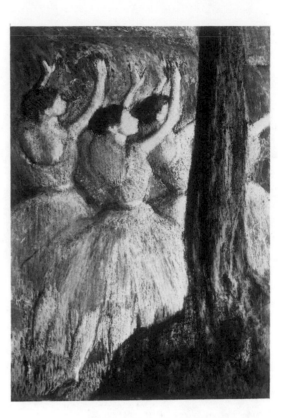

Figure 9.8 (right)
EDGAR DEGAS
Danseuses Roses (84 x 58 cm.)
Courtesy Museum of Fine Arts, Boston (Seth K. Sweetser Fund)

Figure 9.9 (below)
MAURICE PRENDERGAST
South Boston Pier I
Courtesy Museum of Fine Arts, Boston

forms and textures. The latter is devoid of feeling, the faces are empty, the space is flat, and there is no semblance of naturalism. This pastel, painted about 1900, points directly to the future.

In comparison to both Munch and Degas, "South Boston Pier I" (Figure 9.9) painted by Maurice Prendergast in 1895, is a combination of feelings which suggests the influence of both Munch and Degas. The woman in the foreground has a stark expression that seems to cry out with anxiety, much like Munch's subjects. Yet everybody else in the picture appears to be uninvolved.

Closer to Degas is the placement of all the dark figures against a lighter background. The figures have become one group and are contrasted against the negative space that surrounds them. There is a lot of empty space in this design, similar to Degas's "Dancers Resting." The space is also flat and most of the detail has been lost.

SUGGESTED VIEWING

For study of the nude or the group, Degas is always a good choice. For textured effects, I suggest looking at the early twentieth-century works of Pierre Bonnard (1867–1947), and Edouard Vuillard, (1868–1940), two members of the group known as the *Nabis* ("prophets" in Hebrew).

For use of patterns and decorative forms, try looking at Henri Matisse (1869–1954), the most famous of the group known as the *fauves* ("wild beasts" in French).

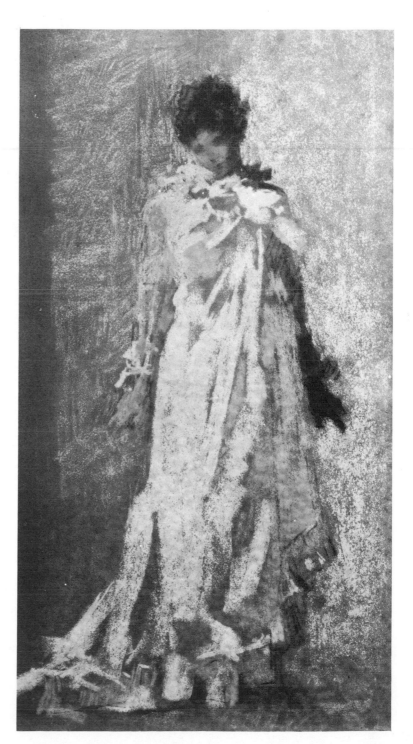

Figure 9.10
SARAH W. WHITMAN (American, 19th Century)
Draped Female Figure
Courtesy Museum of Fine Arts, Boston (bequest of the artist)

I HAVE TRIED in the previous chapters to advance a logical progression of problem solving that involves both observation and application. There are alternative methods of presenting this material, but I feel that a sensible focal point of any problematic progression would include this section on the portrait.

Painting the portrait requires all the skills one can accumulate. Good portraiture is judged not only by likeness and technical merit but by aesthetic quality as well. The last requires that an artist probe beyond mere semblance and good draftsmanship to some degree of insight and intuition. Beyond these prerequisites, the visual elements must be applied with confidence and vitality. An overworked pastel cannot survive. It must look fresh and spontaneous.

It is worth remembering why portraits are painted because this consideration will answer some of our questions about approaching the subject. In ancient times, portraits were commissioned when a person of notable fame or affluence died. The Egyptians, for example, often had countless portraits taken. All these works had a

CHAPTER TEN

The portrait

religious context and were intended to help the deceased in the next life. However, these religious overtones have changed, and today portraits usually serve to preserve a memory. In this light, it would appear that we are in direct competition with the photograph. Photographs do serve a similar function, which satisfies the needs of most people, but the painted portrait still holds a significantly higher position in society, for several reasons: Paintings are unique; they are subjective interpretations; they are larger than photographs. Thus, the painted portrait will probably remain the more personal method, and will therefore be more valued.

APPROACHING THE SUBJECT

As always, painting directly from life affords the best opportunity. However, this method requires the undivided attention of the sitter, which can be difficult to obtain.

graphs are used and one does not just copy the information without interpretation.

Other possibilities include painting from memory and from sketches, which I personally enjoy.

Remember, most portraits will be judged by people with no personal knowledge of the sitter.

POSING

When one is setting up a still life or floral arrangement, only the formal elements of composition need to be analyzed. When one is posing a sitter for a portrait, the process is considerably more complex. It becomes necessary to consider how the sitter's personal characteristics can best be described. Ideally, lighting, backdrop, props, and the pose itself should all reflect something of this character. The pose especially should be typical of

Figure 10.1
JEAN-BAPTISTE CHARDIN
Portrait of the Painter Bachelier (21⅝″ x 17⅝″)
Courtesy Fogg Art Museum, Harvard University (gift of Grenville L. Winthrop)

This portrait, dated 1773, illustrates Chardin's ability to simplify forms and to present a candid, unpretentious appearance.

One of the reasons pastels originally proved to be so successful as a portrait medium was the relatively short amount of time needed to paint them. The patrons of eighteenth-century France and England were not too fond of having to sit through four or five sessions to have their portraits done in oils. Pastels could be sketched in just one or two sittings.

Nevertheless, it is still often necessary to work from photographs instead of from life. This method is perfectly valid, providing good photo-

Figure 10.2
ALBERT HANDELL, P.S.A.
Portrait of Morin Sirine (pastel on sanded pastel paper, 18″ x 24″)

the movement and gesture of the person being studied. These gestures should be *played up* or accented. This skill becomes increasingly difficult the less one knows about the model, and it frequently calls for the use of other methods.

One method is to observe carefully the hair, dress, and general appearance of the sitter. A lot can be learned from such scrutiny, provided the person has not dressed and prepared expressly for the occasion.

Talking to the sitter is another approach. In fact, any way you can gain insight into someone's character is valid. Being able to penetrate the surface is a knack that a good portrait artist must obtain. It is a true test of one's powers of perception. Of course, it still remains for those perceptions to be portrayed visually. How else can such things be measured?

How Much to Include

Various elements other than the head can be utilized. Shoulders, arms, and hands are frequently included, and at times the entire figure seems called for. It all depends upon which features are essential in presenting the personality.

"The Great Coat" (Figure 10.3) by Rhoda Yanow uses aproximately half the entire surface area to accent the head. The angular contours and general shape of the coat are bold and simple, lending drama without interference.

How close to stand and how much to include are questions that must be answered one painting at a time. No single rule governs such decisions. Likewise, whether or not a background will be helpful is contingent upon an analysis of the desired effect of the picture as a whole.

The Head

The best angle and position of the head makes good use of the available light and space in order to present the sitter in a typical pose.

The head can be viewed straight on, at a three-quarter angle, or in complete profile. There are infinite variations to these poses as well. The most common view is the three-quarters angle, which reveals the most information about its subject. It conveys just how deep the head is set, and it also includes most of the facial features and

Figure 10.3
RHODA YANOW, P.S.A.
The Great Coat

skull structure. In contrast, the profile is less revealing but has certain advantages. Besides being the easiest position to draw, there are times when the profile is preferred.

The most famous examples are the portraits of Federigo da Montefeltro, the Duke of Urbino, painted by Pierro della Francesca in the mid-fifteenth century. The duke was Piero's most important patron, and like all patrons he liked to have his portrait painted. Unfortunately, the duke had lost part of his nose in battle, which left the artist with no choice but to present his benefactor in full profile.

Indirectly, this statement raises the question of how much an artist should flatter his or her

patron. James Whistler refused to do so, a large reason for his unpopularity. Goya even wound up in jail for presenting one less than beautiful member of the royal family with her face to the wall. It is true that most people like being flattered. Only a few appreciate honesty when it applies to them, and portrait painters have been known to make some concessions in this area. However, the decision is yours to make.

The Frontal View

This is the most difficult pose. It is hard to treat the symmetry of the face favorably without being totally symmetrical, and gestures are difficult to ac-

Figure 10.4
ALBERT HANDELL, P.S.A.
Portrait of Peter Martin (pastel on sanded pastel board, 16″ x 30″)

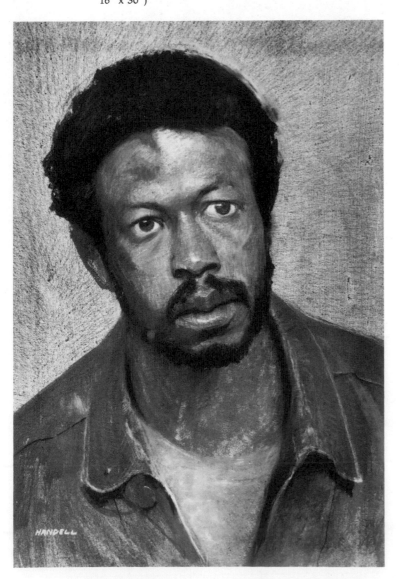

centuate. In "Portrait of Peter Martin" (Figure 10-4), Albert Handell has placed the head and shoulders of his model at an obvious angle to help reduce the static effect that often accompanies the frontal pose. The lighting is even and the strokes are basically broad. Background, hair, and most other features are simply stated. Note the massive handling of the hair and neck especially.

Lighting the frontal view is very important. Evenly distributed light, as seen in Figure 10.4, is not easy to paint. During first attempts, try to limit the direction of the light to one side or the other. Shadows can then be used to denote the form.

Viewpoint

Slight angles of viewpoint can be quite influential to general appearances. Remember that different psychological connotations are likely to be derived from different viewpoints. A chin held high can exude confidence, well being, even arrogance. A head held low can by the same measure reveal a state of contemplation, insecurity, or depression.

Do not attempt any radical viewpoints. Slight angles are enough to contend with. Anything more deviated will distort the features and make it difficult to maintain a likeness.

As a rule, the greater the angle, the more foreshortening is necessary and the less naturalistic the figure becomes. Radical viewpoints have a very dramatic effect and should be used accordingly.

Positioning

Portraits are usually painted while the model is seated. Naturally this position helps the sitter become relaxed so that he or she is able·to maintain the pose longer.

The head is always the first thing to draw, regardless of how much of the figure you intend to include. It should be placed as high in the picture plane as possible without cramping the space. The size of the head determines all proportions, so be sure to consider this question first and to draw the head as large as possible. There is no sense in wasting space in a portrait. A small head gives a distant, detached feeling that is seldom desirable in portraiture. Also, the consistency of soft pastels prohibits their use in very tight, small areas. If

semihard pastels are not being used, be sure to allow a little room to manipulate the pigment.

Try to limit the background unless it is an integral part of the design. It is a common mistake in beginning exercises to include props, such as chairs or stools. Any props used in a portrait should generally be kept simple. One that works well is a door or window frame behind the figure. Detail is not important. A simple silhouette will suffice to give extra contrast to the composition.

Accessories

Accessories include jewelry, handbags, and other nonessential clothing. Such ornamentation is not needed unless the sitter usually wears it.

Probably the most common accessories are hats or caps. People have always been identified with individual styles. Common sense again dictates the choice of their use. For instance, occupations can be illustrated with hats quite well. After all, what's a cowboy without a Stetson?

APPLICATIONS

The pastelist, as always, has the option of either sketching the portrait or painting it; and even though paintings start out in sketch form, it is still wise to have a particular goal in mind.

Painted pastels often start out with a loose application, and less premium is placed on any particular strokes. Sketches tend to start out slowly and develop slowly, and more care is taken during the initial stages.

Choosing the technique is up to the individual. I seem to prefer the sketch over the painting, at least in portraiture; but this preference in no way detracts from my pleasure in seeing painterly styles.

In my sketch of "Anatoly Dverin" (Figure 10.5), I used only three colors, all semihard pastels. Burnt umber was the primary color, with dark brown put in for extra contrast. White was used in a few areas to accent the gray in the hair and beard. Even with this limited palette, this sketch is fairly well developed. There is a considerable range of tonality, and the drawing relies on both texture and line. Compare this development with Anatoly's portrait (Figure 11.5) in the next

Figure 10.5
RON LISTER
Portrait of Anatoly Dverin

chapter. His sketch is more limited in both a textural and linear sense. Yet the impact is still there. The delicate balance of elements and the soft handling are well related internally. Still, the linear aspects dominate the softer tonal modulations. There is a clarity of form and detail that allows each stroke to serve the whole without interference. I point this out because in my estimation, a minimal sketch can be as difficult to execute as one that is considerably more developed.

One last note about the sketch form; minimal designs leave almost no room for corrections. Usually erasing or covering up mistakes are fatal. It is best to start over if any significant problems develop.

Combining Styles

This method is best described by using a pastel to illustrate. Again, I have chosen a design by Anatoly Dverin, "The Man with a Hat" (Figure 10.6).

111

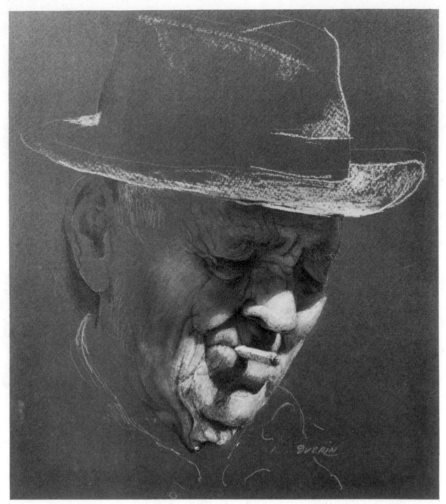

Figure 10.6
ANATOLY DVERIN
Man with a Hat

This pastel was made from an old photograph but has been transformed admirably into a sketch form. The difference here is that this sketch has some painterly elements as well. There is a build-up of pigment in the lighted portion of the face, giving the design an entirely different dimension. The effect is further strengthened by the severe limitation of pigment throughout the rest of the surface. It is obvious that light fell across the hat as well as the face, but Dverin has indicated it with only a slight textural application on the front rim. The medium of pastel has been faithfully served by this restriction of handling, another example that the most difficult portions of a pastel are those in which little or nothing has been done.

Painterly Techniques

There are several painterly styles represented in this chapter, perhaps none more so than "Portrait of a Poet" (Figure 10.7) by Americo DiFranza. Here, tone and mass were laid in with open, broad strokes. Textures were applied throughout, and very few lines are evident. A strong use of shadows divides the composition vertically, just off-center. However, those areas that lie within the shadows have been treated in the same way as those in full light. In fact, the entire surface has been styled by the same method of application. From corner to corner, texture, tone, and pigment abound.

Strokes

Strokes can be of equal importance to both the painterly portrait and the sketch. In "Portrait of a Poet" massive strokes were applied loosely. In "Mike" by Constance Pratt (Figure 10.8), the emphasis is on more visable linear strokes. Both

112

Figure 10.7
AMERICO DIFRANZA, P.S.A.
Portrait of a Poet

Figure 10.8
CONSTANCE FLAVELL PRATT, P.S.A.
Mike

pastels are still painterly in style, but the difference is quite noticeable. Of special interest in "Mike" is the use of straight strokes to denote rounded forms. (You may recall this was a favorite technique of Mary Cassatt.) These strokes are most visible in the face and hands. The clothing involves much the same stroke, but it is broader in appearance. Only in the background are curved strokes utilized.

Finally, note that the head remains virtually upright but that the left shoulder has been dropped down to create a graceful gesture. It also forms a perfect visual lead-in. In fact, both of the shoulders and the hand have been used as compositional directives.

Most portraits involve a combination of both linear strokes (straight or curved) and tonal strokes, which leaves the possibility of the crosshatch stroke. "The Sweater Girl" by Flora B. Giffuni (Figure 10.9) illustrates this style. The skin

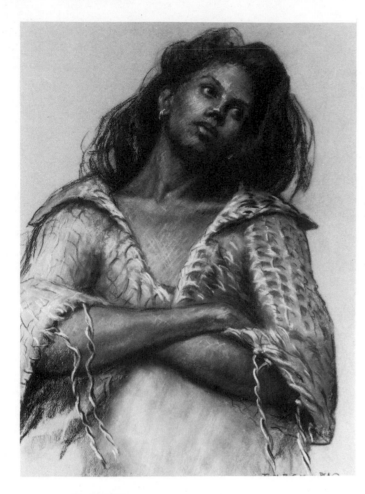

Figure 10.9
FLORA B. GIFFUNI, P.S.A.
The Sweater Girl

tones were laid in first with some blending, and crosshatch strokes were then applied on top. Different colors were used, the same as with any other technique. Note that the strokes were not applied harshly or with too much pressure. This technique allows them to give visual interest to the surface without overpowering the form itself. The method is not as common as the others, but it is obviously no less effective.

In summation, it is the consistency of the strokes, not the type of strokes, that assures proper continuity. Different styles can successfully be combined as long as you are careful and let logic dictate which areas are to be handled in a specific manner and to what extent.

SKIN TONES

When compared with other elements, skin tones are fairly subdued in coloration. They are seldom

bright or intense. Dark skin tends to reflect the largest range of values and hues. Lighter skin offers an assortment of subtle variations.

To think of skin tones by associations of race is to ignore the reality that all people are individually unique. Generalizations are responsible for stereotyping of this sort. Caucasians do not have white skin. Light skin is the only category I find acceptable. I would roughly classify pale skin (off-white), fair skin (flesh pink), sallow skin (yellowish), olive skin (greenish), and ivory skin (grayish). Pale skin is sometimes associated with red hair, and olive skin is often found with dark brown or black hair. But variations to these generalizations certainly exist. Each person must therefore be looked at individually and without preconceptions.

Dark skin includes a much wider scope of hue, value, and temperature, including so many variations that no simple categorization will work. Black skin as such does not really exist. Therefore, try to mix most color combinations without its use. Avoid also relying on too many warm browns. Use cooler tones with them whenever possible. Dark skin is commonly rendered too dark, too warm, and too flat. Look carefully for subtle modifications in tone and temperature and avoid overstating values.

There are many ways to dramatize skin without saturating the tones with intense color. In Americo DiFranza's portrait of "George Shulman" (Figure 13.8), a strong color sense has been produced by the juxtaposition of intense sky with the brilliant whites of the clouds and the sweater. The skin tones have been contrasted against these white areas, not against the blue of the sky. In this way, brilliant color does not compete directly with the skin tones but offers contrast instead.

Skin Tones
in Older People

Skin colorations tend to be more brilliant in young people. Its texture is also smoother in appearance. As a person grows older, the skin assumes more complex characteristics. This aspect usually helps out the actor or actress but only creates new problems for the artist. In old age, the skin is more dramatic in value but considerably less dramatic in coloration. It is not easy to handle this lack of coloration, but one of the best methods is to limit the amount of color in sur-

114

rounding areas. This technique has been used successfully in "Mother" (Plate 5), by Constance Pratt. This strong pastel makes excellent use of grays and off-white tones to offset the lack of color in the central area of the face. Only a hint of blue green exists apart from the skin tones. All other areas are achromatic. This contrast between the skin tones and the rest of the surface creates a dramatic tension that enhances the facial area. The combination is further strengthened with the use of solid, confident strokes throughout the design. Strong contrasts of value and hue, combined with a fresh application, give this pastel its fine appearance.

Shadows

Shadowed skin tones give many people trouble. The key is to paint them as a translucent film that just covers the skin but does not block it out entirely. The pigment must be kept thin, similar to a glaze in oil painting. If the color becomes too opaque, the shadow will not integrate properly with lighter portions.

Shadows are commonly rendered too dark. The overall range of values that is established by you, the artist, is what counts. The exact scope of your visions seldom lends itself to translation exactly from nature, so remember, consider the ratio of values on your surface as well as what you see before you.

HAIR

In portraiture, the tendency is to overstate the color of eyes, lips, and especially hair. Mental associations often interfere. Hair may be basically black, brown, red, or blond but it is never entirely one shade or tone. Shadows (grays) play an important and necessary role.

In "Frank" by Rhoda Yanow (Plate 10), the brown tones in the hair are soft, ranging in temperature, hue, and value. At no point do they become too strong. By comparison, the dark of the sweater is much more dramatic. The hair colors are not applied in a delicate, even manner. The strokes are strong and loose, and above all, fresh. When observing hair, look for the general flow of the main body. Concentrate on basic value and

hue changes first. Temperature contrasts can follow afterward. Do not get caught up in detail; only an indication of detail will work.

SPECIFIC FEATURES

The Head

The human skull consists of twenty-two platelike bones that can be categorized into two major divisions. The largest is called the cranial structure, and the smallest is the facial region. The facial region hangs like a mask from the uper cranium. There are fourteen bones, including the only movable part, the mandible (jaw bone). The other bones are all irregular in shape and serve to pro-

Figure 10.10
BERTA R. GOLAHNY
Susan (detail)

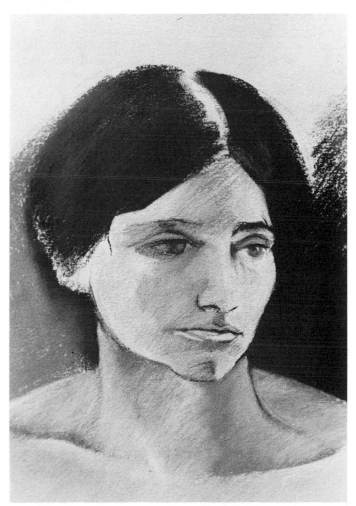

tect and project the facial muscles and organs of sense.

When viewed from the front, the cranial mass and facial mass are approximately equal in size. This measurement actually places the eyes about half way between the top of the head and bottom of the chin. Eyes are frequently placed too high in the head.

From the side view, the cranial mass is almost twice the size of the facial mass, and seldom is enough space reserved for the back portion of the cranium.

As time and interest dictate, the serious artist will become knowledgeable about the most important structural features of the skull. It becomes clear that a major structure such as the superciliary arch (browridge), is almost as important as the eyes are to the whole head.

Simple observation can at times fail, but a working knowledge of the skull's function and form will be serviceable at all times.

Facial Features

Hard and semihard pastels are good for the initial rendering of the specific features. Charcoal, soft pencils, and pastel pencils can also be used. It is vital that all major corrections be made early in a portrait. Use a stick or pencil that will allow room for revisions. As a rule, try to set the basic proportions and shapes correctly before beginning to draw the details of the sensory organs. Only experienced portrait artists attempt to draw these features at the start of a design. Do not start with the eyes.

EYES

The eyes are often overstated in beginning portraits because they are recognized to be the single most important feature of the head. Eyes are capable of expressing a wide range of feelings, and the success of many portraits does depend on how convincingly they are rendered. Just remember that they are still only a part of the whole design. Because of their size and complexity, it is helpful to study them closely. Approach the eye first as a mechanical object, a partially covered sense organ protected by the bones of the brow and cheek. Next, study how the eye appears and functions from different angles. (The eye in profile is often misdrawn.) Finally, consider the eye and its surrounding supports as one entire unit.

OTHER FEATURES

The nose, mouth, and ears are also unique sense organs and vary a great deal from person to person; but they are still only a part of the whole, and the whole must assume priority. Do not draw them separately as though unrelated to the head in general. Only then will they take their proper importance.

When observing, look first at the shadows created by the forms. Color is secondary in the initial drawing of the sense organs.

In summation, continued observation and practice are the only sure ways to become adept at the portrait. Technical skills can only help you to visualize what you must see and understand first.

DEMONSTRATION 6:
"The Civil War Vet"
by Anatoly Dverin

Note: Because this demonstration reproduced rather darkly, the initial drawing was redone on a lighter stock for the viewer's benefit.

Step One

The sketch was started with a hard pastel pencil (Figure 10.11). The basic features were indicated with moderately short strokes. (It is easier to make adjustments with shorter strokes.)

Because of the relatively dark tone of the stock, only a linear drawing was used. The basic contours of the shadows were drawn in without tone. Thus, the first phase was kept two-dimensional.

Note the size and position of the eyes. The temporal region was alloted a proper amount of space. The cap fits loosely upon the head. It, too, has a little space left in the forehead area. A hat or cap drawn tightly on the head does not look natural.

Step Two

In this stage (Figure 10.12), all areas outside the face were left untouched. The face and beard were advanced simultaneously, with broad, flat strokes

Figure 10.11
ANATOLY DVERIN
The Civil War Vet (step one)

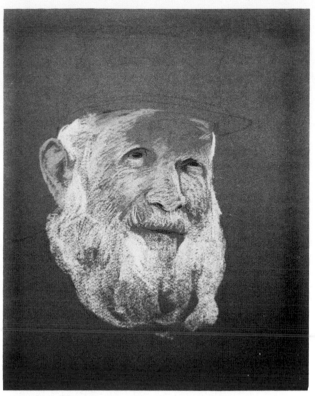

Figure 10.12
ANATOLY DVERIN
The Civil War Vet (step two)

Figure 10.13
ANATOLY DVERIN
The Civil War Vet (step three)

Figure 10.14
ANATOLY DVERIN
The Civil War Vet (step four)

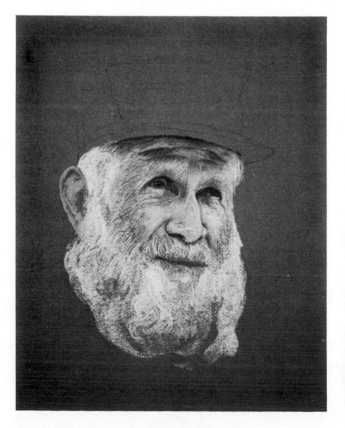

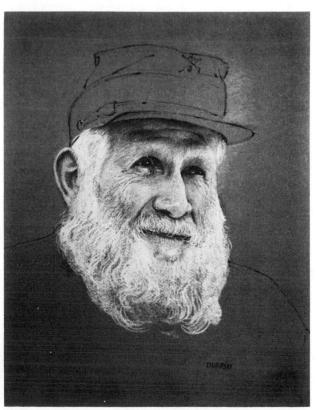

in the beard and more linear strokes in the facial mass. The deep set of the eyes was started as well.

The most significant aspect at this point concerns what was not done as much as what was. In the beard, the textural strokes were laid in with particular care so as not to cover the background surface too much. Shadowed areas were indicated by simply easing up on the stroke. Also in the areas where the beard and cheek meet, the background surface was left showing through, one of the most important decisions made during the process. The surface tone was found to be close enough in value to be incorporated into the heart of the pastel. This is a wonderful effect, particular to pastels alone.

Step Three

The face was developed with flesh tones and a touch of yellow ochre light in the temple and cheek (Figure 10.13). A violet tone was introduced in the shadowed areas, and the eyes were also developed. Note that they have been kept deep in the sockets. Compare the value of the whites of the eyes to those of the beard. The contrast between the darks of the eye socket and lights of the beard give this portrait its impact. The expert handling of the eyelids and the raised browridge lend all the expresison that is needed.

The beard was left basically alone throughout this phase. Slightly more pigment was introduced above the ears, and a few linear strokes were introduced below the chin.

Step Four

Only in the last stage (Figure 10.14) were the linear elements of the beard put in. Even here, they were used sparingly. The tonal foundation that was applied in step one was only built upon. Nothing more was necessary. Overlapping was avoided almost entirely, yet the effect is one of a fully developed beard.

The facial mass was refined and completed, the forehead was softened back, and the eyes were given last details and accents. The ear was left only partially developed, and the cap was added. In fact, all areas gradually build as they center around the eyes.

The most significant aspect of this pastel is the total integration of the background with the portrait. All pigments were used only where needed, and in no areas outside of the eyes were they built up enough to completely block out the background support.

EXPRESSION IN THE PORTRAIT

Labeling works as *expressionist, impressionist,* or whatever is a tricky business. Labels are misleading because most paintings cannot be described by one term alone. Too much overlapping occurs. Perhaps the best way to consider if a label is correct is to determine which characteristic style is dominant. A painting is expressionist if expression is the primary aim. When I painted "Portrait of Lenore" (Figure 10.15), I was more conscious of expressing a feeling than in presenting a naturalistic vision. With this in mind, liberties were taken. Shapes and lines were simplified and stylized. As the design grew more two-dimensional, it also became less representative. This process was not accomplished in just one sketch. Several sketches were made in which the forms became increasingly more animated. An attempt was made to *freeze* the gesture, which is quite different from the

Figure 10.15
RON LISTER
Portrait of Lenore

Figure 10.16
MARY CASSATT
Two Sisters (pastel on paper, 17″ x 17″)
Courtesy Museum of Fine Arts, Boston (Charles Henry
Hayden Fund)

more impressionist technique of trying to capture the subject in a spontaneous moment.

There are several ways to animate expression. The most basic method is to keep synthesizing the vision in your mind until all ornamental elements have been stripped away. What is left is what I call the *heart* of the subject, and it can be visualized in your own style.

One thing that commonly occurs when shapes are simplified is that natural rhythms begin to assume more prominence. I try to follow this flow as much as possible.

SUGGESTED VIEWING

Almost all artists have tried their hand at portraits. Some, like Francis Cotes and Quentin de LaTour devoted their lives to it. For others, it was just one subject among many. For the latter, portraiture may not represent the best of their output, or even second best, but it is still worth considering how each artist adapted his or her style to the subject.

There are also many giants within the field, who are admired by just about everybody. Rembrandt is perhaps at the top of such a list. My own favorite is the Dutch painter Frans Hals (1580–1666) who was a contemporary of Rembrandt. Hal's portraits are known for their vitality and freshness and for the loose, vigorous manner in which they were painted.

Here is a very partial list of other notables:

- Anthony Van Dyck (1599–1664) (Flemish)
- Diego Velazquez (1599–1660) (Spanish)
- Sir Joshua Reynolds (1723–1792) (English)
- Thomas Gainsborough (1727–1788) (English)
- Francisco Goya (1746–1828) (Spanish)
- Gilbert Stuart (1755–1828) (American)
- John Singleton Copley (1737–1815) (American)
- John Singer Sargent (1856–1925) (American)

Of course, in pastels, we can be thankful for the great portraits of Cotes, Russell, LaTour, Chardin, and Cassatt, to name just a few.

119

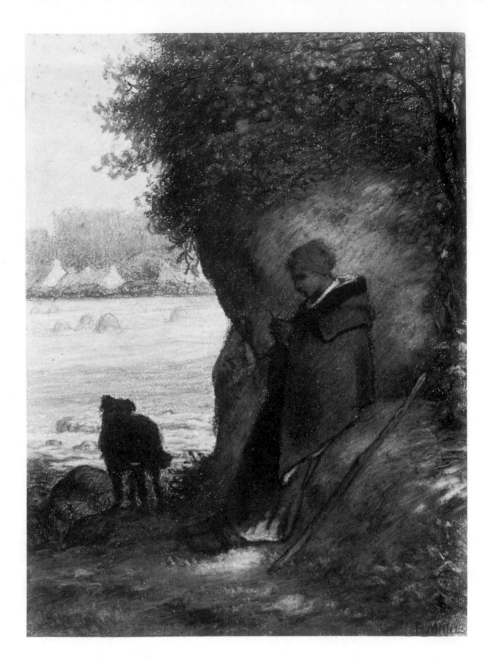

THROUGHOUT THIS BOOK, there have been many references to the words *sketching* and *painting.* I have used both terms interchangeably. A closer look at some of the specific differences between the two will be taken in the following pages.

SATURATION

Sketches tend to be low in saturation, or low keyed. Saturation normally refers to the amount of pigment or the intensity of pigment used. In this context, however, it refers to a more encompassing category that includes both color intensity and overall tonality. A sketch usually limits the range of color and tonality. In comparison, a painting normally implies the application of greater amounts of pigment, and thus, color and tonality.

One reason why I have chosen to interchange these terms freely is the overlapping of meanings in some sketches which incorporate areas of both high and low intensity or unlimited amounts of tonality and color range. Sketches can

CHAPTER ELEVEN

Sketching

be built up entirely with tone, although we normally associate them more with line.

LINE AND TONE

Pastels seldom rely on line without tone. The reverse is even less common. It is most popular to use a combination of the two.

In the late 1700s and early 1800s, purely linear pastels were more typical. Chalk and Conté studies were made with a limited number of colors. The choice often included a single dark crayon for shadows, a white chalk for highlight, and either a gray surface or chalk for the middle range. With this accompaniment, a fully chromatic subject could be simulated. Figure 11.2 shows a typical use of a limited complement of pastels, a sketch of the "Head of the Earl of Bathurst" by John Singleton Copley. It was used as a study for a larger work entitled "Drawing of the Death of the Earl of Chatham."

From the time of the Impressionists onward, line and tone have become interchangeable, and

Figure 11.1
ALBERT HANDELL, P.S.A.
Reclining Female Nude (pastel on sanded pastel paper, 24″ x 28″)

The sketch makes good use of limited pigment. The figure has been simplified, and an impression, rather than a realistic rendering, has been stated.

Figure 11.2
JOHN SINGLETON COPLEY
Head of the Earl of Bathurst (black and white chalk on gray stock, dated 1779–1780)
Courtesy Museum of Fine Arts, Boston

the twentieth century has seen a full utilization of tone over line, especially during the Abstract Expressionist period.

Today, a majority of pastelists use a combination of line and tone, with line work applied over some degree of a tonal undercoat. This process can successfully be reversed if the tones are kept soft (see Figure 12.10). In some cases, purely tonal pastels can still retain properties associated with the sketch. One consideration is the scale of the work.

122

SCALE

I am not referring to physical size when discussing scale; rather I am interested in the amount of information being recorded or presented. A pastel that focuses on a limited subject, without greater pretentions, can still be regarded as a sketch, no matter what style application is used. "Natural Bridge" (Figure 11.3), by Mei-Ki Kam, is an example of this assertion. Although the application of the pigment is entirely tonal, the appearance of a sketch is still retained. The vignetted format, loose handling, and limited scale all contribute to the feeling of an impression.

APPLICATIONS

Good results are possible through any method of application, loose, tight, or in between. When asked, I generally feel committed to support the loose approach. In order to be able to sketch loosely, an artist must be relaxed and confident. These two qualities normally come with experience. My support of the loose approach is based on a certain historical trend that can be traced through the lives of many great artists from Rembrandt to Degas.

Many artists have progressed through styles that start out clear and orderly and develop into a more relaxed and more loose arrangement of elements. For a further discussion of this area, see "The Abstract as Subject" in Chapter Twelve.

Tight renderings imply careful attention to detail and conformity, and although this does not necessarily mean failure, it is usually harder to make the work convincing. Life does not seem to me to be a compact package of closely knit elements or images. Things simply do not fit together that well. Our eyes, for instance, are constantly blocking out what we do not wish to see. Our mind groups together images that we do not need to understand singularly. In essence, our own treatment of what we sense around us is uneven.

Leaving loose ends loose is somewhat natural. A degree of mystery is generally helpful to a pastel. If everything can be learned about a sketch in one glance, there is little hope that the viewer will remain interested in the design for any longer length of time.

Figure 11.3
MEI-KI KAM, P.S.A.
Natural Bridge

Although quite a lot of pigment was used here, this pastel still retains the quality of a sketch.

ONE-COLOR SKETCHING

Little has been written about one-color pastels, possibly because of the great success they normally achieve with full color. However, there have

123

Figure 11.4
JEAN-FRANÇOIS MILLET
The Artist as a Boy (conté on blue paper)
Courtesy Museum of Fine Arts, Boston

been pastelists who have made good use of limited color. Millet was one example. Many of his pastels were accomplished with a limited pallette. Even his full-color sketches were restricted in hue intensity and saturation.

Anatoly Dverin's portrait of the author was sketched in less than half an hour. A sheet of five-ply Strathmore illustration board and a dark brown semihard pastel were used. The illustration board has a nice texture. A slight, even tooth is especially good for working with semihard pastels. The hardness of the stick enabled Dverin to obtain a subtle tonal effect by rolling the side of the pastel over the surface. The hard stick was also useful in controlling the delicate quality of the line work. This pastel is a good example of minimal application and subtle variations combined to produce a strong effect.

SKETCHING WITH MIXED MEDIA

In art school, it seems I naturally inclined toward combining different drawing media. I feel fortunate that my instructors never discouraged me from trying new methods. I was also taught that drawing was a valid medium, comparable with painting, sculpture, and so on. With the freedom to explore and confidence in the medium, I explored a variety of approaches.

It seems that many pastelists have arrived at similar convictions and have tried a variety of different processes. Here are a few of the most popular combinations.

Pencil with Chalk or Pastel

I first became interested in drawing with soft lead pencils and sticks of graphite. At first, I incor-

Figure 11.5
ANATOLY DVERIN
Portrait of Ron Lister

porated white chalk, and later, colored chalks, to stretch the effects. This simple process of mixing different media together became a full-time endeavor. I cannot recall how many drawings were ruined by such attempts, but I do remember that some were successful. Eventually, I tried soft pastels and oil pastels and I did discover the versatility of the former.

"Innsbruck" (Figure 11.6) shows one of my favorite methods. This sketch, with the Alps rising up behind the river Inn, was done with pastel over pencil, and in other places, pencil over pastel. I still tend to go back and forth in this manner to achieve finer subtleties of hue and texture. Basically, however, the pastels in this sketch were used tonally, and the pencil was used for both line and tone.

In "Two Too Many" (Figure 12.10), only white pastel was used over a pencil sketch, with some line work again applied on top.

In "Old Russian Church" (Figure 11.7), an entirely different application was employed.

Figure 11.6
RON LISTER
Innsbruck (pastels and pencils on illustration board)

Figure 11.7
RON LISTER
Old Russian Church

Graphite leads were filed down into a powder and mixed with varying amounts of turpentine. (Oils and other media had previously been tested). The mixture was then applied on illustration board with brushes, sponge, and pencils. Sometimes, pencils were dipped in turpentine. In the last twelve years, this mixture has been applied in other ways as well. I have used my fingers, rags, tissues, and cotton swabs. This particular drawing was accented with soft pastels after the graphite had been applied. The pastel was rubbed in with tissues into the areas with greater amounts of lead, and was applied directly into areas with lesser amounts of lead. This combination, along with a limited use of color, gives the sketch an old hand-tinted quality.

This is a slow process, but it is easily controlled. The variety of effects has enabled me to use this method in both my fine arts and commercial arts.

Remember, only by taking chances are accidental achievements possible. It does take a mental adjustment to try new methods and new combinations, but without the assurance of suc-cess, it seems the rewards are all the more pleas-ing.

Watercolor and Pastel

Watercolor is the most popular medium for mixing with pastels. It is not difficult to see why. A quick undercoat of watercolor or gouache can give needed tonal strength and unity without using up much, if any, of the surface tooth.

Gouache is an opaque watercolor that is good for building slightly heavier areas of pigment than regular watercolor provides. It is sometimes called *Designers color.* Gouache is cheaper than watercolor but has two defects. Although it comes in a variety of colors, several are fugitive. Tubes of gouache are marked with the letter A, B, or C. The first, A, signifies color permanence, B signifies that the color is slightly fugitive, and C that it is highly fugitive. Gouache also dries lighter in tone than it appears when wet. (Actually, all watercolors tend to lighten up as they dry.) Both of these problems can be solved without much fuss, however. I use a combination of regular wa-

126

tercolors and gouache to maintain a palette that is not fugitive. I also allow for some weakening of tone and brilliance when painting.

Normal charcoal weight papers are not suitable for use with water soluble pigments. Heavier pastel papers, illustration boards, and watercolor papers are best. All three types offer a variety of textures to work on. Watercolor paper comes in three basic textures: smooth, medium, and heavy. Pastel papers and illustration boards can be sanded down to suit your needs.

Watercolors can be applied in numerous ways, from heavily diluted to almost dry. In "February at the Arnold Arboretum" (Figure 2.7), a wet solution was applied to establish the large solid masses. Dry brushing and pastel were used to indicate the branches and foliage. Pastels were also blended into the larger portions to heighten the color and to add some subtle changes. Pastels are not as quick in this regard as watercolors, but they are more manipulative.

For other examples of watercolor and pastel, see Albert Handell's "Mary" (Figure 8.13) and M. H. Hurliman Armstrong's "Aspen Ride" (Figure 7.3).

Other Media

"Mulberry Street, Store Front, N.Y.C." (Figure 11.8), by Albert Handell, is a mixed-media sketch drawn on a sanded pastel board. The design was initially laid out with India inks and was then developed and completed with pastel. The result is a wide variety of textures and a strong combination of values. This was the prize-winning picture at the Fourth Annual Exhibition of the Pastel Society of America.

It is quite common to start out with charcoal or Conté, as well as watercolor or ink. Even acrylic paints will do. Personally, I am not very fond of acrylics, but I have found them to be useful on certain occasions. In my sketch of a "Red Winged Blackbird" (Figure 12.3), a touch of acrylic was used for the spot on the wing. Watercolors and pastel make up the rest of the design.

I hope I have made the point that pastels are versatile, whether used separately or in mixed media. A great deal of fun can be had experimenting with these different combinations. The only problem may be choosing how to use them best.

Figure 11.8
ALBERT HANDELL, P.S.A.
Mulberry Street, Store Front, N.Y.C.

THE ABILITY TO DRAW AND PAINT simultaneously is an advantage pastels have over other media. This attribute has been discussed previously and needs no further description except to point out the particular benefits this combination offers when one is sketching animals and wildlife. Animals for the most part must be sketched quickly, and being able to render form and color together is a considerable advantage.

There are basically two approaches to animals as a subject. The most common usage is in landscape painting, where they are normally found in a secondary role. This role does not re-

quire a full understanding of anatomy, character, or function—just the ability to capture basic features. Even so, I have long admired the exceptional powers great landscape artists have shown when using animals in a supporting role. The most simple of forms—cows, sheep, and pigs—are rendered with an expressive quality that the casual observer can seldom, if ever, duplicate.

The second usage for animals is that of the primary subject. Whereas landscape painters normally employ domestic animals, for obvious reasons, the animal painter is more apt to explore the entire range of the animal kingdom.

CHAPTER TWELVE

Animals and abstractions

It is only natural to try to be specific when drawing a particular animal. Yet I should caution against focusing too much attention and effort on characteristic details. Animals, like all other subjects, must be integrated into the composition. Otherwise you may end up with a well-drawn subject but a poor pastel nonetheless.

One suggestion to help overcome this tendency is to study the masters of the genre. The good bird or animal painter is capable of illustrating physical accuracy in an artistic fashion. Be critical when looking at specific wildlife magazines. Many technical illustrators are forced to concentrate their efforts on depicting accurate physical details. They often present their subjects in a frozen format, devoid of motion and life. Only the best wildlife illustrators surpass this problem.

When drawing animals, always try to relate them to the environment. Posing the subject as you would a human model is not necessarily the best way. Let nature balance things for you. If you do too much on your own, the design may take on a contrived appearance.

In the past few years, I have become increasingly interested in a wide variety of animals, do-

Figure 12.1
EDGAR DEGAS
Cheval
Courtesy Isabella Stewart Gardner Museum, Boston

This simple study shows that even Degas was subject to faltering once in a while. Note here the oversized head.

Figure 12.2
JEAN-FRANÇOIS MILLET
Watering the Cows
Courtesy Museum of Fine Arts, Boston (Shaw Collection)

This is a typical example of Millet's love for the ordinary chores of rural life. Here strong forms and values abound, and the subjects take on a noble significance.

mestic and wild. I am a frequent visitor to the local refuges and reserves. Much of what I have learned about exotic animals has come from my visits to the Stoneham Zoo, a small public zoo in Massachusetts. This zoo has a good selection of animals, and the Siberian tigers are probably the most beautiful creatures I have ever seen. Yet it is the smaller animals and birds that attract me artistically. Zoos are able to maintain larger numbers of these smaller species, and this in turn creates an atmosphere with more social interaction. The monkeys, small cats, and birds live and function within a social order that seems to be closely related to their natural habitats. The large predators and other large species simply do not have the

Figure 12.3
RON LISTER
Red-Winged Blackbird (watercolor, acrylic, and pastel on illustration board)

I first got the idea for this subject on a visit to Plum Island, a wildlife sanctuary off the coast of Massachusetts. Here countless species of birds can be found, many of them swaying gracefully among the reeds.

Figure 12.4
RON LISTER
Sketch of an ostrich

necessary room and social contact in which to interact. Fascinated by one group of Colobus monkeys in particular, I have sketched them numerous times.

DEMONSTRATION 7: "Colobus Monkeys" by Ron Lister

Colobus monkeys come from East Africa. The family at the Stoneham Zoo consists of six members. The largest of the group measures about three feet, not counting the long white tail. The oldest member is especially communicative and will interact socially with humans for long periods of time. On this day, however, none of the family

131

was very social. In this picture they are trying to maintain a little privacy while grooming one of the family. The pose struck me as a potential painting. I took several snapshots and a couple of quick sketches, and a composite design was created.

Step One

A full sheet of warm gray Canson pastel paper was sanded and mounted on a sheet of illustration board (Figure 12.5).

The first consideration was to choose the best division of space. Because the tails are quite long, it was necessary to keep the bodies fairly small and to position them in the upper half of the picture plane. I decided to leave out several small branches and a large tree trunk from the view. One branch was modified and repositioned in the composition for balance.

The initial drawing was made with a dark gray pastel pencil (a white pencil was used for portions of the tails). When drawing in the main forms, I was careful to include enough gesture. For this aspect, I followed the curvature of the spinal column just as I would for the human form.

A rough contour drawing was made. Then, a dark gray black pencil was used to indicate the

overall tonality within the black portions of the bodies.

Step Two

The deepest values were established with black, ultramarine blue, and latter deep umber (Figure 12.6). The highlighted areas were left uncovered temporarily. Some dark tones were then rubbed in to deepen the overall value of these areas, but no white or lighter colors were used. This rubbing in served as an undercoat for highlighted tones.

The foreground was developed with shades of gray, yellow ochre, and several other colors in very small amounts, including both blue and red tones. The darker values were laid in behind the monkeys.

Step Three

The darkest values within the bodies were brought up to full value (Figure 12.7). Next, the shadowed portions of the white hair were accented with a little blending of deeper tones (the same as in the dark portions of the hair). This work was used as an undercoat.

The back wall was begun. Several things

Figure 12.5
RON LISTER
Colobus Monkeys (step one)

Figure 12.6
RON LISTER
Colobus Monkeys (step two)

Figure 12.7
RON LISTER
Colobus Monkeys (step three)

were excluded from the view, including a feeding door, an air vent, and the light green walls on the sides of the cage. The painted foliage on the back wall was indicated with a rough sketch. Much of the detail and form of this foliage was reduced or simplified. The deep greens were sketched with muted olives and permanent green deep.

With the back wall partially completed, I continued to fill in the floor coloration. The same ochres, grays, and reds were blended and overlapped to simulate the subtle but varied colors of the actual floor.

Light greens, olive and permanent, along with yellow greens were used to finish the far wall.

133

Ochres were added for warmth, and grays were added to help neutralize the strength of the colors at that distance.

Both foreground and background areas were kept simple so as not to interfere with the main subjects. I was interested in giving the overall feeling of the cage without all the details of life in the zoo.

When all the full-color portions of the picture plane were completed, the white areas of hair were begun. A semihard white pastel was used first, and a soft white pastel was applied to highlight the purest areas. Both whites were drawn over the preexisting gray undercoat. Touches of cadmium yellow light and yellow ochre light were added to the tails. Yellow ochre and marigold orange, in very small amounts, were also applied to the ends of the tails.

When the white hair was sketched in, a final analysis of the overall range of values was made. A few accents were given and a couple of areas were softened. The picture was then sprayed lightly and covered for protection.

THE ABSTRACT AS A SUBJECT

The term Abstract Expressionism is relatively new in the art world, being less than one hundred years old. It implies a decorative surface, sometimes amorphous shapes, and sinuous lines. The process of abstraction can be a complex one. It can end with a semirepresentational subject (semiab-

Figure 12.8
RON LISTER
Colobus Monkeys (detail)

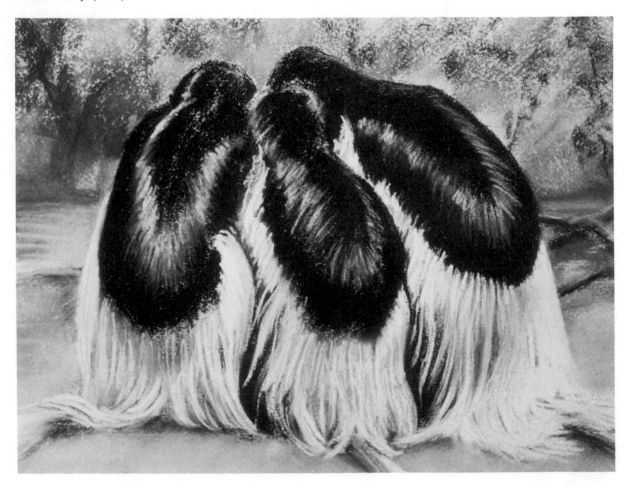

Figure 12.9
RON LISTER
Drawing from a Gauguin Ceramic

This is one of about two dozen drawings I made from Gauguin's wonderful ceramics, which he made while living in Brittany in the 1880's.

stracted) or may be abstracted until any recognizable subject has dissolved. Abstract designs can of course start out in a fully dissolved manner as well.

The pastelist can take advantage of either method of abstracting, from nature or from the imagination. "Two Too Many" (Figure 12.10) represents a semiabstracted design that is derived from nature. The expression developed spontaneously, and only a simple theme (attraction versus indifference) was kept in mind. Although the symbolism was applied loosely, the design still had its foundation in the natural world. This affected the course of the design by letting me pick

Figure 12.10
RON LISTER
Two Too Many

and choose shapes and spaces to fill in where needed. In this case, the surface became two-dimensional, the description of detail lessened, and the overall process led to a simplified and partially dissolved subject.

Pastels are well suited for the process of abstracting forms from nature. They are very flexible and can be manipulated with ease. Layers of pigment can be applied quickly in succession, and lines and tone can be built simultaneously. The later works of Degas illustrate this. As Degas became more involved with different types of application, his pastels began to loosen up. His colors and forms became more and more abstracted, which is what gives so much life to his later pastels, especially when compared with his earlier oil paintings. The ease of manipulation and the versatility of pastels allowed Degas to develop so individually. Even a casual comparison be-

tween pastels shows his development. In "Dancers Resting" (Figure 9.7), the figures and shapes are somewhat flat, and the space is somewhat dissolved, but generally the design is still representational. In "Danseuses Roses" (Figure 9.8), the abstraction is clearly more developed. A great deal of texture and pigment are evident, and the forms are no longer realistic in any sense. They are flat, simplified designs. Both pastels show Degas's willingness to leave the world of naturalism behind, and each design represents a different stage in that development.

TOTAL ABSTRACTION

With Degas, the process of dissolving forms and colors never reached a fully abstracted form. Had

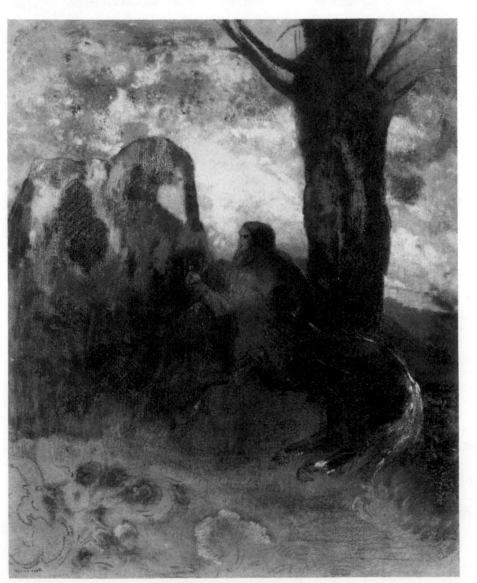

Figure 12.11
ODILON REDON
Centaur (pastel on canvas)
Courtesy Museum of Fine Arts, Boston

In this pastel, forms can be seen in the last stages before becoming totally abstracted.

Figure 12.12
BERTA R. GOLAHNY
Sinai Sumit

he lived longer, perhaps he would have done so. We will never know for sure. Redon, in comparison, went through a similar distillation of ideas, and like Degas, his style became less naturalistic as he progressed. By 1910, he did in fact paint a pastel in which the subject was totally abstracted. The point must be made, however, that Redon's choice of subjects always remained less conventional than Degas's, so the comparison is incomplete at best.

During the twentieth century, the process of artistic development quickly arrived at full abstraction, but it was the early pioneers (Kandinsky, Picasso, and Mondrian) who went through the old process of arriving at abstraction by degrees. By the time Abstract Expressionism arrived in full force, there were a number of artists who had grown up artistically without the old academic roots. Or had they? There was still the history of art and life in general from which to observe the natural order. It is difficult to generalize about this, but I feel that most great abstract artists did in fact draw on nature in ways that are not always visible in their paintings.

Today, it is too easy to paint an abstract and then to reflect on what has been created. This reversal of the old process can be fun, but little is gained in the long run. Discipline has become an antiquated word in today's art world. Things are said to be moving too fast to go back to the old ways. Still, taking the time to solve abstraction by degrees will serve you better when and if you do choose that course. I fear that skipping those stages of development now associated with academic art will lead to confusion and disappointment in any degree of abstraction.

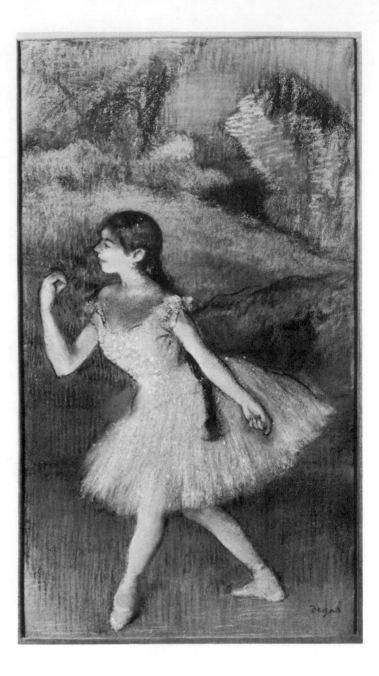

AS TECHNICAL ABILITIES ACCUMULATE, so do the number of ways in which new skills are put to use. Art is science in the sense that the true creative process involves continual problem solving. If more difficult problems are not attempted, new skills are not likely to develop. When a pastel is completed, try to look ahead to the next one. There is no harm in taking satisfaction in your work, but being overly satisfied with a finished pastel will not necessarily motivate you to do more or better work. In fact, it can be detrimental. A balance should be maintained.

MOTIVATION

Artists are constantly judged by their work, and criticism can come from any direction, including from oneself. At times, tension and doubt can build, and even constructive criticism may become annoying. The worst situation is one in which you become deflated without outside help. Artists, like all people, need support. As a safeguard, try to keep in touch with other artists. Their assurances can help you to maintain confi-

CHAPTER THIRTEEN

Continuing the process

dence in your own work, and the interaction helps to create motivation.

Another motivational problem may arise when a particular goal has been reached. A good pastel can inspire doubt that the problem can be successfully repeated and can lead to indecision. It is a good idea to have something else to fall back on. Even switching from one medium to another can help. In this way, newly discovered skills can be tested without jeopardizing what has already been achieved.

Outside interests are a further safeguard.

Hobbies or professional endeavors bring in new experiences, which in turn give added fuel to the artistic process. Any way of learning or experiencing something new will give you more to draw on. Books, museums or galleries, good conversation, or just close observation all feed directly into our visual output.

Museums

We are fortunate in this country to have so many fine public and private museums to choose from.

Figure 13.1
ALBERT HANDELL, P.S.A.
The Young Couple

Figure 13.2
RON LISTER
Back Bay with Blue Trees (pastel on paper, 18″ x 24″)

The Museum of Fine Arts in Boston, for example, has the largest collection of Millet pastels in the world. American museums own a surprisingly large number of great pastels. There are as many fine works by Degas, Redon, and other Impressionist painters on this side of the Atlantic as there are on the other side. We have Mary Cassatt to thank for much of the interest shown here toward purchasing these works from Europe. I do not mean to imply that European museums are not to be taken seriously. The history of pastels belongs to England and France, and the Louvre is still the finest place in the world to see LaTour, Chardin, Perroneau, and Carriera. My point is that the serious student of pastels need not travel as far as perhaps was thought in order to see the great pastels of the past. I should mention that all the historical photographs reproduced in this book were obtained from American museums, and you can judge their quality for yourselves.

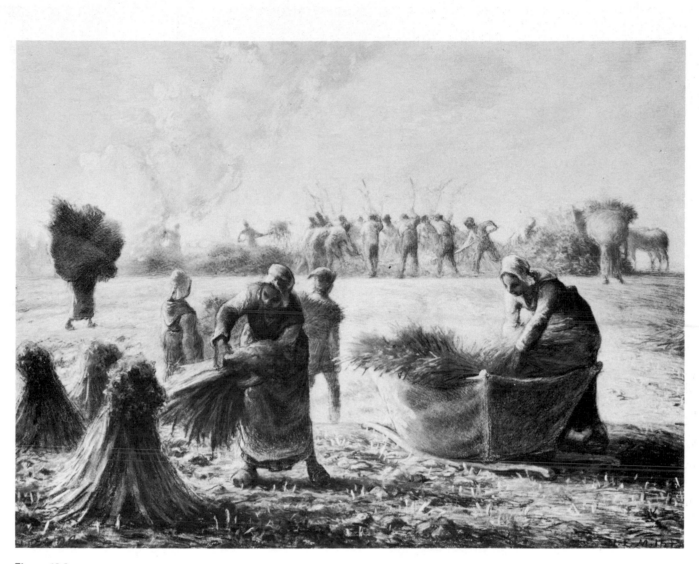

Figure 13.3
JEAN-FRANÇOIS MILLET
The Buckwheat Harvest (73 x 95 cm.)
Courtesy Museum of Fine Arts, Boston (bequest of Mrs. Martin Brimmer)

Remember, most pastels cannot be reproduced, regardless of printing cost, in a manner that does justice to the original art. The pastels of certain artists are especially difficult to reproduce. The effects of Chardin, with his exceptionally deep and subtle tones, LaTour with his delicate variations of detail, and Degas with his never ending manipulation of surfaces cannot be reproduced without some loss of visual information. However, reproductions and art books in particular have great value when compared with the alternative of having nothing at all. Art books have the advantage of describing what it is we see and also something about the people who created the images. Reading about the lives of the masters can help give an understanding of how great art is made. When artistic motivations cannot be determined by direct observation of the art, insight can be gained from a knowledge of the personal environment that surrounded the artist at the time. Besides, many pastels are of such high caliber it is hard to comprehend their being painted by people like ourselves. Reading tends to connect the art with the understanding of what we see.

For a list of some recommended reading, see the Bibliography.

Photographs as Reference

Artists have used photographs since the early days of their invention. As the camera became more sophisticated it was discovered that it could record movements much faster than could the eye. Thomas Eakins was one of many artists who

Figure 13.4
ANATOLY DVERIN
Faded Photo

This quiet pastel uses limited color and values to make a very expressive and sympathetic statement. The artist, painting from an old photograph, has altered the impression by giving full expression to the line and by integrating the paper's surface with the pastel. The result is a transformed picture.

became fascinated by this development, and he took advantage of it.

Today, cameras function in a wide range of areas. They can go where artists cannot, because of poor lighting, lack of time and space, and so on.

However, artists can be trapped or cornered by photographs, and individual styles can be hindered by excessive reliance on them. Cameras do not record images exactly as we see them with the unaided eye. Our eyes see the world through a sort of subjective filter, one that focuses on objects deemed significant and excludes or simplifies those that are not. Cameras treat all images evenly. In fact, all elements are "squeezed" together by the camera. Distances are reduced, colors are altered, and an entire range of subtleties is lost. In a technical sense, this can help artists by doing some of the work for them. Photographs do make images easier to interpret. But is this a blessing or not? The answer lies in the degree of information that is transferred from the photo to the pastel. Reliance on the photo as the sum total of reference material is likely to be harmful in the long run. Continue to use your eyes whenever possible, and, when using photographs, do not

simply transfer the information from one surface to another. Use your imagination and intellect and add them to the references you are using.

Keeping A Record

Any record of your art is better than no record at all. In the beginning it may be enough just to store your pastels in a drawer or on a closet shelf. However, time takes its toll on unprotected drawings, and periodically the oldest and most ragged of the lot get thrown out. Besides, this system concerns only those pastels that are not sold or otherwise loaned out. Photographs and slides are the only way to preserve such works. An expensive camera is not necessary for recording pictures for your personal files. Naturally a good camera is desirable, but the main thing is to record the art any way you can.

When taking your own photographs, the most important factors to consider are lighting and camera angle. Be sure to have an even light source. I shoot outdoors in direct sunlight if the day is not too bright. I also make certain I am positioned squarely in front of the design. Since

142

most pastels are set leaning against a wall or prop it is necessary to elevate the camera slightly above the pastel and to shoot downward.

KEEPING SKETCH PADS

Filling sketch pads or books is fun and useful. With pastels, even full color is possible. The intention of such pads should not be for completing "finished"-type designs but for recording impressions, details, or specific subjects. This use helps restrict the artist to recording only essential elements—a good habit to get into.

I filled several sketch pads throughout my college days and for a few years after. Today, I am very glad I did so. I still find useful references in

Figure 13.5
AMERICO DIFRANZA, P.S.A.
Patio Planter

Figure 13.6
RON LISTER
Portrait of Jan

This two-color pastel was made from an old sketch originally in pencil.

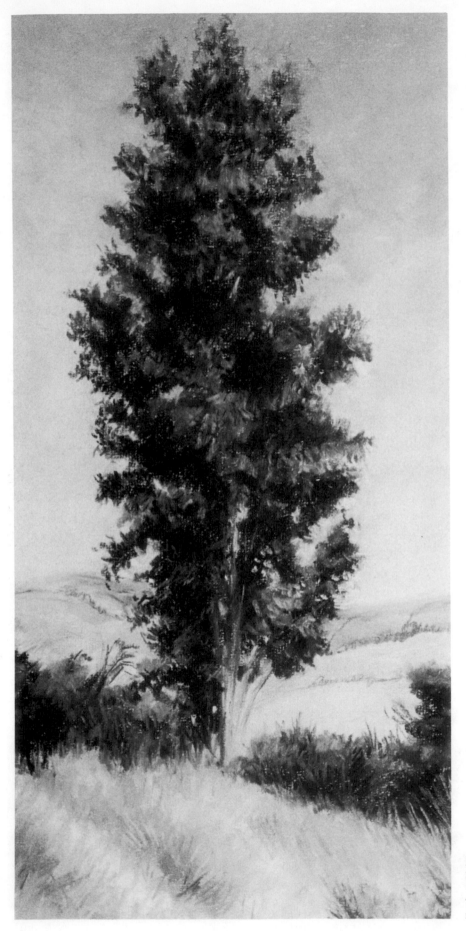

Figure 13.7
RON LISTER
Eucalyptus Tree
This sketch shows the golden hills of
northern California.

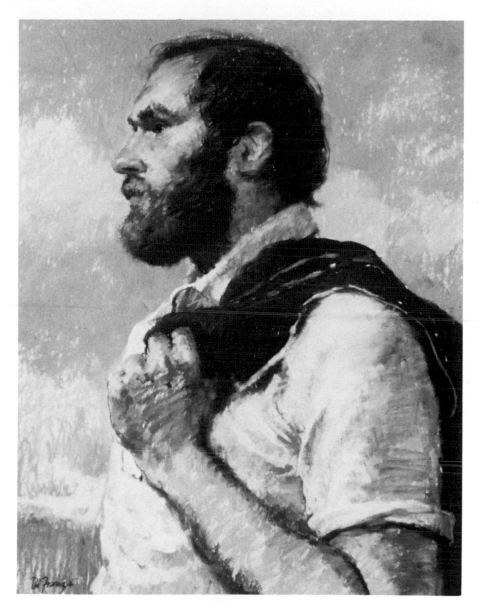

Figure 13.8
AMERICO DIFRANZA, P.S.A.
George Schulman (28" x 22")

them. Moreover, I now have a visual diary of those years. It is a subjective interpretation of how I once saw the world, one that could not have been preserved in any other way.

Pricing and Selling

I do not have any statistics on this topic, but experience dictates that most artists do not make very good business people. Pricing pastels is considered a chore. Because the selling market and your own market value will change, pricing must be done on an individual basis. Where the painting will be sold, and to whom, and your own opinion of the work—all are things that must be considered.

With these facts in mind, try to be as objective as possible and do not undersell your work. If

a buyer really likes the pastel, he or she will pay the price; and pictures that cost more are generally more revered. The only time I go against this principle is when I feel it is more important to "move" a pastel than to keep it. A house or studio full of old pastels is not conducive to the creation of new ones.

Exhibiting

Showing your work is the best way to achieve recognition, to establish a reputation, and to gain contacts. There are several options available. Pastels can be shown individually in galleries, they can be entered in competitive shows, or they can be shown collectively in private exhibitions. I have found that open competitions can be frus-

145

trating. Even the judging is sometimes questionable. A few years back, I entered a statewide competition at a major museum. Seven other friends also submitted work. All but one of us was rejected by the jury. At the opening of the show I was stunned to find an exhibition of nearly all illustrative art and only a handful of painterly designs. Later, in a discussion with the curator of the museum, I discovered that the show had been judged according to what might be sold to a group of corporations that were scheduled to purchase from the exhibit. Such things can be frustrating indeed.

On the other hand, a good deal can be learned about your general marketability. You will find that certain areas of the country and certain galleries and museums favor one type of art over another. Some areas are more traditional than modern, more representational than abstract, or more illustrative than painterly.

Showing your work is necessary despite individual tastes and preferences. Most of us must choose the best manner of doing so because time does not allow us to exhibit in all the various places we would like to. I personally favor private exhibitions. These take a lot of time and energy to set up, but the rewards are great. For my shows, I do most of the planning and execution myself. I do the framing, labeling, and promotions to help keep the overhead down. Even so, a risk is taken,

and a financial loss is always a possibility. Still, it is the feedback that interests me. Even negative criticism can help; sometimes it motivates me to prove a certain point. The greatest value of private shows is the amount of art that must be produced to have one.

Whatever path you decide upon, be sure to choose something. Do not keep your pastels locked away. Show often and seek out opinions.

CONCLUSION

By this time, I hope you have gained the respect and enthusiasm for pastels that I have.

As I wrote at the beginning of this book, don't worry about being yourself; you have no choice in the matter. So, when planning a pastel, do not concern yourself with what has been done before you. Enjoy such things for what they are, but do not let them affect your own approach. Style will come naturally with experience and patience. Remember that what you see and what you paint will always be unique, provided you do not copy someone's work.

Most importantly, whatever happens, keep painting and sketching. Only by doing so will you gain the confidence to continue.

Figure 13.9
CLAUDE MONET
Etude de Soleil
Courtesy Museum of Fine Arts, Boston

Bibliography

ANATOMY AND FIGURE DRAWING

GOLDSTEIN, NATHAN. *Figure Drawing,* 2nd ed. Englewood Cliffs, N.J.: Prentice-Hall, 1981.

NICOLAIDES, KIMON. *The Natural Way to Draw.* Boston: Houghton Mifflin, 1941.

PECK, STEPHEN. *Atlas of Human Anatomy For The Artist.* New York: Oxford University Press, 1951.

RICHER, PAUL. *Artistic Anatomy.* Trans. Robert Beverly Hale. New York: Watsun-Guptill, 1971.

SHEPPARD, JOSEPH. *Drawing the Female Figure.* New York: Watson-Guptill, 1968.

DRAWING AND PAINTING

CHAET, BERNARD. *The Art of Drawing.* New York: Holt, Rinehart & Winston, 1970.

COLLIER, GRAHAM. *Form, Space, and Vision*, 3rd ed. New York: Prentice-Hall, 1972.

GOLDSTEIN, NATHAN. *The Art of Responsive Drawing*. 2nd ed. Englewood Cliffs, N.J.: Prentice-Hall, 1977.

HALL, CLIFFORD. *How to Paint Portraits*. London: Bodley Head, 1932.

HILL, ADRIAN. *You Can Draw*. New York: Hart Publishing Co., 1963.

SIMMONS, SEYMOUR, III, and MARC S.A. WINER, *Drawing: The Creative Process*. Englewood Cliffs, N.J.: Prentice-Hall, 1977.

HISTORY

COGNIAT, RAYMOND. *Pissarro*. New York: Crown Publishers, 1975.

HAUSER, ARNOLD. *The Social History of Art*, Volumes 1–4. New York: Random House, 1951.

HUTTINGER, EDUARD. *Degas*. New York: Crown Publishers, Inc., 1981.

GOODRICH, LLOYD. *Albert P. Ryder*. New York: George Braziller, Inc., 1959.

KONINGSBERGER, HANS. *The World of Vermeer*. New York: Time Inc., 1967.

ROSKILL, MARK. *Van Gogh, Gaugin and The Impressionist Circle*. Greenwich, Conn.: New York Graphic Society Ltd., 1970.

SELZ, JEAN. *Odilon Redon*. New York: Crown Publishers Inc., 1975.

SIREN, OSVALD. *The Chinese on the Art of Painting*. New York: Schocken Books, 1963.

STANG, RAGNA. *Edvard Munch*. New York: Abbeville Press, Inc., 1977.

WERNER, ALFRED. *Degas Pastels*. New York: Watsun-Guptill Publications, 1977.

MATERIALS AND REFERENCES

HERBERTS, K. *The Complete Book of Artist's Techniques*. New York: Frederick A. Praeger, Inc., 1958.

ITTEN, JOHANNES. *The Art of Color*. New York: Van Nostrand Reinhold Company, 1961.

MAYER, RALPH W. *The Artist's Handbook of Materials and Techniques* (rev). New York: The Viking Press, Inc., 1970.

PASTELS

RODDON, GUY. *Pastel Painting Techniques*. New York: Larousse and Co., Inc. 1979.

SEARS, ELINOR L. *Pastel Painting, Step By Step*. New York: Watsun-Guptill Inc., 1968.

SINGER, JOE. *How To Paint Figures in Pastels*. New York: Watson-Guptill, Inc., 1976.